DATE DUE

THE REEFS OF TAPROBANE

THE REEFS
OF TAPROBANE

Underwater Adventures Around Ceylon

BY

ARTHUR C. CLARKE

With color and black-and-white photographs
by Mike Wilson

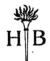

HARPER & BROTHERS PUBLISHERS NEW YORK

TO THE PEOPLE OF CEYLON,
WHATEVER LANGUAGE THEY SPEAK

CONTENTS

LIST OF ILLUSTRATIONS

The full-color plates listed below will be found in a group following page 82.

Following page 50 appear the photographs listed below:

Following page 146 appear the photographs listed below:

ACKNOWLEDGMENTS

Among the many people who assisted us in Ceylon and on our way there we would like to give special thanks to the following:

Walter and Gloria Mishkoff, for hospitality and encouragement in New York.

Paul Cherney, Cinefot International Corporation, New York, for advice on underwater cinephotography.

E. H. Rechberger, Ansco Motion Picture Laboratory, New York, for rushing film back to us.

Life Color Labs, Saratoga Springs, N.Y., for duplicates better than the originals.

Arnie Post, of Richard's Sporting Goods, New York, for fitting out the expedition.

Lee Grubman, of Peerless Camera Stores, New York, for stretching dollars.

Milton Snedeker Corporation, New York, for seeing that everything arrived safely.

C. H. McCleod, of Lillywhite's, London, for technical assistance.

Dimitri Rebikoff, Cannes, for practical instruction in underwater movie making.

Montres Rolex, S.A., Geneva, for a "Submariner" watch.

The Ceylon Reefcombers, for making us honorary members and lending us their rubber dinghy.

Natural History Magazine, for permission to reprint Plates X and 40, which have already appeared in that magazine.

Rupert Giles, Secretary of the Reefcombers, and his wife Isabel, for hospitality and help.

Rodney Jonklaas, for establishing a base for us and acting as our above- and below-water guide.

Acknowledgments

J. O. Ebert, Shipping Master of Colombo, for looking after our photographic education.

D. C. L. Amarasinghe, Director of the Ceylon Tourist Bureau, for help in his official capacity and also for many hours as our darkroom assistant (unpaid).

The Photographic Society of Ceylon, for the use of their darkroom facilities.

M. Chandrasoma, O.B.E., Port Commissioner and Principal Customs Collector, for the loan of a launch.

Mr. Shirley Corea, Minister of Commerce and Fisheries, and H. C. Goonewardena, Director of Fisheries, for the loan of another.

George Tame, for marine transport and land hospitality.

Hubert Paterson, for his tales of seventy years in Ceylon.

Jock Muir, for repairing things in a hurry and giving the expedition a slogan.

C. M. W. Davis, for the use of house, workshop and boat at Kalkudah.

The Senior British Naval Officer, Trincomalee, for an eye-witness account of the sinking of A.F.D. 23.

THE REEFS OF TAPROBANE

1

CAPRICORN TO CANCER

THE best way to get from Australia to Ceylon is not usually considered to be *via* Fiji, Honolulu, San Francisco, New York, London, Naples, Port Said and Aden. In taking this roundabout route, my partner Mike Wilson and I were not motivated by sheer contrariness. Having spent a year on the Great Barrier Reef gathering material for *The Coast of Coral*, we felt we could not breathe happily until all the irreplaceable photographs had been delivered safely to our publishers in New York. And when we found that if we booked a through passage to London we could fly the Atlantic for a hundred dollars, the bargain proved irresistible. We decided to go round the world from left to right instead of from right to left.

On a dismal, rainy day our Australian friends gathered to see us off at Sydney airport. They looked disapprovingly at the Constellation that was to carry us across the Pacific, and someone started to whistle the theme from *The High and the Mighty.* "She looks a bit skinny in the rear," remarked another helpful character (though "rear" was not exactly the word he used). "Why are they wrapping Scotch tape round the tail?" But despite all this encouragement, we got aboard, and soon saw for the last time the great steel bow of the Harbour Bridge under whose shadow we had lived for the past few weeks. Dominating the ships and the tiny houses below it, the bridge swung beneath us as we climbed into the misty sky, and in minutes the city which had been our

second home was lost behind us. For a little while the superb beaches of the New South Wales coast paraded below; then Australia was gone, carrying with it memories and friendships which we would never forget.

Fiji seems such a remote and romantic place that I cannot really believe that I have been there; perhaps if we had stayed for more than a couple of hours on a rainy night it would have made more impression. It sometimes seems a pity that the age of flight has reduced so many once-glamorous places to wayside stops where planes and passengers pause for brief refreshment, and continue on their way with as little waste of time as possible.

We were determined, however, not to treat Honolulu in this casual fashion, and broke our journey there for three days, most of them spent lazing on Waikiki Beach. Though we had taken no steps to contact the local skin divers in advance, our belief that this wouldn't be necessary was soon justified. In next to no time we were swapping tales with Val Valentine, whose sports store is a rendezvous for all visiting divers. Gregariousness and eagerness to help one another is one of the chief characteristics of underwater explorers the world over; even those who, like Val, depend on the sport for a living seem willing to spend unlimited time and effort assisting other people. Val drove us all over the island of Oahu, took us on a conducted tour of his favorite hunting spots and did his best to make our brief stay an enjoyable one.

Val's charming wife Lorraine is a decorative addition to the rapidly growing international society of lady divers—founder member, Lotte Hass. In the course of our travels we have met some marriages where both partners were equally at home under-water, others where the wife could occasionally be persuaded to take a dip but would rather not, thank you—and some where the wife regarded the sea as an active rival. One of these days we may

run into a marriage where the wife spends all her time under-
water and the husband is scared of getting wet, and at any moment
we expect to hear of excessive skin diving being given as grounds
for divorce.

Also at Val's we met the well-known diver Jim Oetzel, who has
been able to combine his hobby with his business in a very efficient
manner. By working as a steward on Pan American Airways, Jim
has managed to spend a good deal of his spare time on most of the
interesting islands in the Pacific.

The last lap of our journey to the States provided an experience
which I shall treasure all the more because it is unique to our
generation, being something that the past never imagined and the
future will have left behind. Determined to arrive refreshed and
full of energy in San Francisco, we had booked sleeping berths,
and drifted dreamlessly in our comfortable cocoons while the dawn
broke across the ocean four miles below. When I awoke and pulled
the curtains of my little cubicle, the California mountains were
lying along the horizon, wreathed in a pale mist that was slowly
dispersing before the sun. I lay, sleepily propped up on the bed,
while the Golden Gate came closer and clearer, until presently the
two greatest bridges in the world were passing beneath me and I
could see the morning traffic pouring along the maze of super-
highways and cloverleafs on its way to begin another day in San
Francisco. As I watched entranced, feeling like Zeus reclining on
a cloud, I felt sorry for the travelers of the jet age who would never
stay aloft long enough to spend a night sleeping among the stars.

It had been four years since I had last seen San Francisco; on
that earlier visit, my one disappointment had been that the earth-
quake had waited until I was safely airborne and so I had missed
it completely. This time the San Andreas Fault behaved itself,
and there was not even a small fire. We were entertained by the

3

erudite and hospitable Tony Boucher, editor of *The Magazine of Fantasy and Science Fiction;* then, with hardly time to pause for breath, we were greeting the unbelievable skyline of New York— and the lonely, sun-drenched islands of the Great Barrier Reef seemed already half a lifetime and more than half a world away.

Our weeks in New York were a time of consolidating the past and preparing for the future. Australia was behind us; Ceylon ahead. While analyzing the results of the last expedition, we had to make plans for the next.

You can arrange anything in New York if you have a checkbook; a bank account also helps, but is not essential if your visit is a very short one. We were lucky enough to make contact with Arnie Post of Richard's Sporting Goods, who was kind enough to let us test our gear on his boat *The Flying Frogman* while we decided just what diving equipment our expedition would need. The Australian-built Porpoise lungs which had served us so well on the Great Barrier Reef had been returned to the manufacturers; though we considered them unbeatable in many ways, we were now on the other side of the world and thought it best to avoid supply problems by ordering all our equipment in New York. To make ourselves completely independent, we bought not only twin-cylinder Aqualungs but also a Cornelius air compressor so that we could pump up our tanks wherever we went. The problem of obtaining air at two thousand pounds per square inch was one that had haunted us throughout our Australian trip; thanks to this compact and portable gas-driven unit, we now had that solved.

It was while under the influence of the persuasive Arnie Post that we made another important decision. Until now we had been exclusive Leica users, regarding any photographers who employed film bigger than 35 millimeters as contemporaries of Daguerre. But one day Arnie showed us a Rolleimarin—the su-

perbly engineered underwater housing for the Rolleiflex—which had been used only three times on a special press assignment and was now going cheaply. We couldn't resist the temptation; for the happy results of our weakness, see Plate VIII *et seq.*

Having acquired all our gear, the problem then arose of shipping it safely to Ceylon. There were scores of agents who would gladly undertake the commission, but we wanted one who had proved that he could handle delicate scientific equipment. Luckily our friends Frank Forrester and Joe Chamberlain, the energetic directors of the American Museum's Hayden Planetarium, answered that question. Earlier in the year they had organized an expedition to Ceylon to observe the longest total solar eclipse for more than a thousand years, and this had involved shipping out a fortune in astronomical equipment. We gladly handed over our problem to the museum's agent.

One of the great mysteries about New York is the way in which one can spend hours, days and eventually weeks there without actually doing anything. Looking back on the seven weeks spent there, I can account for few of them; only a few unrelated cameos come to mind. Such as, for instance . . .

Leaving my brief case with all the priceless Barrier Reef color slides in a hotel lobby and not discovering the loss until we were on the other side of Manhattan; dining in Toots Shor's as a guest of the "Woman Pays" Club; attending the world première of Sam Goldwyn's *Guys and Dolls,* and rounding off the evening at the original Lindy's; watching Antonio and his dancers being introduced to the *Omnibus* cameras in the C.B.S. Studio by Alistair Cooke; seeing Diane Cilento in Christopher Fry's translation of *Tiger at the Gates* and remembering the witty vote of thanks her father Sir Raphael had made when we gave the farewell screening of our films in Brisbane; and reading in the *New York Times* the

headline—from Salem, where else?—"Witchcraft Center to Provide Research Facilities."

It always seems to be raining when we shake the dust, or rather the mud, of one continent from our feet and head for another. The day we left Idiewild, the first blizzard of the winter had struck New York, and the unfamiliar snow was eddying round us as we took off for the Atlantic. Gander gave its usual imitation of the Last Outpost on Pluto; we snored fitfully across the Western Approaches—and then we were touching down at London airport, each of us having completed his first circumnavigation of the globe.

Though England was home, this time it was only a temporary resting place while we dealt with essential business and got together the new expedition's final items of equipment. We were not rushing madly round the world because we liked doing so; in Australia, we had learned how vitally the weather can affect any underwater enterprise, and we knew that the earlier in the year we could get to Ceylon the better our chances of success.

During our stay in London, we settled the important problem of transport in Ceylon by purchasing a Landrover, the British equivalent of the jeep. We soon discovered that it was about the largest vehicle one could comfortably drive in metropolitan traffic or insinuate through the tortuous alleys of Mayfair. And it bounced off buses with a fine abandon, without the slightest damage—to itself, at any rate.

There then remained only one matter to settle. We had our still cameras and our "dry" movie camera, but what about underwater movies? After looking at the available models, we decided that much the best one at a price we could afford was the electrically driven Beaulieu in the case designed by Dimitri Rebikoff, the famous French underwater engineer and photographer. This gave Mike an excuse to fly to Paris, and no sooner had he got there than

Dimitri inveigled him down to Cannes to see his workshop and to watch the Club Alpin Sous-Marin at work.

The ingenious Monsieur Rebikoff has designed an entire arsenal of underwater cameras and their accessories. In particular, he has solved the problem of taking movies in natural colors at great depths. The main problem of underwater color photography—once the technical difficulties of making a water-tight camera case have been overcome—is not the faintness of the light at depths, but the fact that it is essentially monochrome. The fast modern color films have enough speed to take satisfactory photographs at least a hundred feet down in natural light, but such photographs will contain nothing but blues and greens and might almost as well have been taken on black-and-white film.

The reason for this is that even the purest water acts as a blue filter, so that all the red and orange rays are lost as soon as one descends a few feet below the surface. Many a diver, sixty feet down, has been disconcerted to discover that he bled green blood when he cut himself.

To reveal the true beauty of the submarine world, therefore, it is necessary to take a source of light underwater to restore the missing reds. In the case of still photography, this can be done by using flash bulbs—and it seems surprising to land-based photographers that ordinary flashbulbs can be fired and changed underwater without any protection from the medium around them.

For movie photography, the problem is more difficult, as a continuous source of light is needed. Rebikoff has solved it with his "Torpille" or photographic torpedo, a streamlined housing with powerful headlights at the front, a high-capacity battery inside, and the movie camera at the rear, so arranged that the lens looks toward the area illuminated by the lamp. Switching on the electrically-driven camera automatically turns on the light.

Going a stage beyond this, the later models of the Torpille are fitted with an electric motor and a propeller, so that, far from the diver having to push his photographic equipment through the water, it actually tows him along.

We decided that we would have to forgo these fascinating— and expensive—complications on this trip. Most of our movies would be shot in relatively shallow water, where part of the red light still remained. Moreover, we were able to restore some of the missing color by a very simple but effective trick.

No one can have failed to notice the fluorescent or day-glow paints which have appeared on advertisement boards and rear bumpers during the past few years. These paints use the property which some chemicals possess of absorbing light at one wave length, and re-emitting it at a longer one. In a sense, they are color transformers. By painting our Aqualung tanks with red fluorescent paint, we were able to ensure that they still looked bright red even at depths where most of the natural red had vanished. This was because the blue and green light—of which there was plenty —was being "converted" by the paint of the tank. The effect was quite striking and often very beautiful, providing color and warmth where it would otherwise have been missing.

To our considerable relief, Mike had no trouble at all at the British customs when he flew back from France with the brand-new electric underwater movie camera beneath his arm. But we have always found, in every country we have so far visited, that the customs officials have never raised any difficulties over our photographic equipment. Indeed, they have been so interested in our pictures that we have sometimes had to give impromptu lectures which we hope may have sold a few copies of our books.

After spending almost a year inside the Tropic of Capricorn, our greatest fear when we got back to London was that the Eng-

lish winter would catch us before we could escape. Our tickets were booked on the Orient liner *Orcades* for the first week in January, which seemed to be cutting it pretty fine. But we were in luck; it was still mild and pleasant when we saw the sun setting behind the cranes of Tilbury dock, and knew that the blue seas and palm-fringed beaches of Ceylon were only two weeks away.

And having come thus far in describing our preparations, I realized that I have overlooked one important detail.

Why on earth did we want to go to Ceylon, anyway?

2

KEEPING HOUSE IN COLOMBO

THE idea had been growing in our minds for almost two years—even before, in fact, our expedition to the Great Barrier Reef. We knew that if we survived that project, we would not long be content before we started on another. Ceylon was the right size and in the right place; moreover, we had made friends there who, besides imparting some of their own enthusiasm for the country to us, could show us the way around and take us to the most promising underwater spots.

Our encounter with the pearling industry in the Torres Strait had also aroused our interest in the far older pearl fisheries of Ceylon, and we were anxious to discover how the Ceylonese divers—who use no equipment whatsoever—compared with the helmet divers we had watched operating in northern Queensland.

Another factor encouraging us to visit Ceylon was the shark situation. The Australian sharks had been shy and, even when they had turned up, disinclined to pose for photographs. In Ceylon, we were promised, matters would be different. Sharks could be whistled up at any time and would perform without inhibitions in front of our lenses.

Yet, in the long run, these reasons were partly excuses. What really drew us to Ceylon was a hunch which we both shared but which we found it hard to analyze. It was based on the briefest of visits, for like all travelers making the sea voyage to Australia we had both spent a few hours in and around Colombo.

There are some countries which a traveler, having visited them once, forever afterward takes particular care to avoid. The reverse is true of Ceylon, or so at least we discovered. One brief encounter was enough to make us fall in love with the place, and we knew that we would never be satisfied until we had returned for a prolonged stay. Having realized this, we had a year in which to concoct valid excuses for going there, and long before we had left Australia that particular task was accomplished to our complete satisfaction.

There were times, however, when we had qualms. We had gambled all the money we had earned and a lot that we hadn't on this trip. Suppose the monsoon decided to come a few months early and conditions underwater were hopeless? We knew a case of one famous skin diver who had come to Ceylon the previous season and had never even been able to get into the water. Suppose the customs officials decided to ask an exorbitant bond for our equipment; suppose the Landrover was dropped into the harbor while being off-loaded; suppose the crate containing all our color film was stored near the boilers and the entire consignment cooked to a turn; suppose . . . suppose . . . suppose . . .

Despite these nagging doubts, we had an enjoyable enough journey through the Mediterranean, spending much of the time building up that protective suntan without which no one can safely dive or swim in tropical waters. We looked at the Rock of Gibraltar and calculated what an H-bomb would do to it; we looked at Pompeii and saw what Vesuvius *had* done to that. The ruins were impressive, the vistas of roofless walls reminding me of the wartime photographs of gutted German cities. We never imagined that in a few months we would be looking at the far greater ruins of a civilization of which we had never heard.

It was dull and misty when we left Naples, and Capri was

nothing more than a few rocks wreathed in fog. But that night it cleared, and against the darkness we saw a thin line of fire crawling down the sky—the lava flow from Etna, reminding all who saw it that the forces which overthrew Pompeii were still sleeping beneath this land.

Then came the slow passage down the Suez Canal, with Mike pointing out landmarks that he remembered from his days in the army. From time to time he would make nostalgic comments such as "That's where we blew up the police station," or "You should have seen the fight we had in that café," all of which enabled me to understand more clearly why the British are so well loved in the Middle East.

The great oil refinery at Aden, its storage tanks and distillation towers gleaming like silver against the utterly barren background of craggy mountains, always seems to me like an illustration from a science-fiction story. The feeling that I was on a strange planet was heightened when I went ashore and drove into the town, which is situated inside the crater of a huge volcano. If the sky were black instead of blue, the illusion that one was on the moon would be almost perfect. I could not imagine what it must be like here in summer, when the vertical sun shines straight down into the crater cup and the reflected heat is concentrated onto the town. But my sister, who had been there for over a year as an R.A.F. officer, said that the place was not at all bad—which in the Clarke vocabulary is high praise indeed.

Aden is a free port, with no customs duties, and such items as cameras may be bought there at about half the price they would cost in London. But, like many other tourists, I discovered that some bargains were not all that they seemed. A pair of shorts, labeled "100% Dacron," emerged from their first wash looking like crumpled paper; two pairs of pants, in quick succession, split

along the seams as soon as I put them on—a mishap for which I refuse to accept more than a very small share of the responsibility. Aden is now firmly crossed off my list of shopping centers.

The final lap of the voyage passed swiftly enough, but gave me a chance to catch up on arrears of reading. There is nothing like a long sea journey for dealing with *War and Peace* and similar examples of the least-read classics. The library of the *Orcades* was an excellent one, but the Orient Line had better rectify one serious oversight if they want to retain my patronage. They will be hearing from my publishers shortly.

I had just managed to finish volume three of J. R. R. Tolkien's epic *The Fellowship of the Ring* when Colombo came in sight. By this time both Mike and I were well tanned and ready for immediate action. As we listened to the radio news from home, we managed to spare a silent tear for our friends back in England who were now enduring (as usual) the worst winter in living memory.

Colombo is one of the great crossroads of the world, for every liner on the England-Australia run touches here and shipping lines radiate to all the countries of the Far East. The number of travelers who disembark here is small compared with the number of tourists who spend a few hours in the city on their way to somewhere else —as we ourselves had done on our first visit.

We were met on board the ship by Rodney Jonklaas, one of the world's leading underwater hunters, whose advice before and after we came to Ceylon was invaluable. By one of those coincidences which have convinced me that the world is nothing like as big a place as it is supposed to be, Mike and Rodney discovered that they had met before. On his way to Australia two years earlier, Mike had spent a couple of days in Colombo and had not missed the opportunity of doing a little skin diving. He was swimming around a reef off Mount Lavinia, the popular bathing beach of Colombo,

when he met two other divers and waved them a friendly greeting. Rodney, who keeps a log of every dive he makes, was able to confirm that he was in the area at the time, and distinctly remembered meeting this lone swimmer and wondering who he was.

(Yet that was a trivial coincidence compared with the fact that the man who shared my cabin with me when I sailed out to Australia from England was sitting in the next seat a year later when I flew from Australia to the United States. What are the chances of *that* happening in a well-shuffled community?)

At the time of our arrival, Rodney Jonklaas was working in the Department of Fisheries, having previously been Deputy Superintendent of the Colombo zoo—and, in his own words, chief exhibit in the Anthropoid Section. He had managed to arrange his vacations and his official duties (it was not always easy to tell which was which) so that he could conduct us to the most promising underwater sites in Ceylon.

His first problem was to assist us in getting all our gear ashore. Luckily, our mountain of diving and photographic equipment so overwhelmed the customs officials that they threw up their hands, and in the end merely made us pay a couple of dollars as license fee for our transistor pocket radio. They also relieved Mike of his Luger pistol, though he got it back again after a certain amount of form filling. Small side arms are not popular with the authorities, who are justifiably scared that they might enhance what is already the highest murder rate in the world. However, there is no reason why this should worry the visitor; the Ceylonese are very clannish in these matters and keep all their quarrels inside the family. (Incidentally the government has, with irrefutable logic, taken steps to abolish the death penalty, since it was obviously not doing the slightest good.)

Ceylon is very short of good hotel accommodations, and in any case we would not have been popular with the other residents

when our air compressor started to pump up the Aqualungs. To our great relief, the indefatigable Rodney had found us a small but pleasant apartment and a first-class cook-servant, all at an inclusive cost of about ninety dollars a month. (London and New York papers, please copy.)

As soon as we moved into the apartment, the garage floor immediately disappeared beneath flippers, underwater camera housings, weight belts, pressure gauges, snorkel breathing tubes and the countless other items without which no one is really well-dressed beneath the sea. There was no hope of using the garage for its proper purpose: the Landrover had to take its luck outside.

In addition, cameras, developing tanks, processing kits, spare lenses, thermometers, flash units, movie editors, slide projectors, and stocks of film invaded bedroom, kitchen and bathroom. Since Mike is one of the untidiest people I know (I, of course, am one of the tidiest) life in the apartment was to be a constant battle against chaos. Equipment was constantly vanishing; with each day's mysterious disappearance, or equally mysterious reappearance, we had another proof of the Second Law of Thermodynamics. It needed no mathematical treatise on entropy to tell us that the disorder of the universe tends to increase.

Our ally in this ceaseless war was our houseboy Carolis—though "boy" was a slightly misleading term as by the time he entered our employment he was forty years old and had nine children. An alert, dark Sinhalese who barely topped the five-foot mark, he arrived one morning with a letter of introduction from Rodney and a document which might well be adopted in the few remaining countries where it is still possible to obtain domestic help. This "Servant's Pocket Register" was nothing less than a log book of all Carolis's previous positions, with dates, salaries and the comments of his employers. A government-issued document, not unlike a passport in size and layout, the register appears to have been in-

vented by the British for self-protection in 1870, and every servant in the island was once supposed to have one.

We thought it a little hard on Carolis that, at the age of twenty, the registrar who had filled in his description had written against "Usual expression of countenance" the single word "Morose." This seemed an unjustified burden to carry through life; how many people retain their "usual expression" when they are being quizzed and fingerprinted?

We had no hesitation in engaging Carolis when we read his previous employers' testimonials, beginning with the one that concluded regretfully: "He leaves me to try and get better pay. Present salary 20 rupees" (i.e., four dollars a month). I am glad to say that he did get better pay with us.

In the East, of course, a servant is a necessity, not a luxury. Carolis probably saved us more money when he went shopping than we paid him in wages. The local storekeepers would have made quite a killing had we two British innocents dealt with them directly.

Every morning Carolis presented us with the accounts for the previous day, neatly drawn up in a cash book. As he could not write English, one of his numerous sons did the job. The standard of education and literacy in Ceylon is very high, and most of the rising generation understand English in addition to their native tongue. After going through some scores of pages of Carolis's account book I have managed to extract these etymological novelties, which quite unfairly I reproduce in one concentrated dose:

To Cash R.10/–	
One pinapple	90
5 pairs	50
1 lb Coly flour	1.50
Soup vegitable	40

6 grapes fruit	1.50
½ lb kindneys	75
1½ lb pork chups	2.25
1 tin corn mutton	2.75
Spents	10.55
I want's balance	55

I only hope that I can do a quarter as well when I start trying to write Sinhalese. . . .

3

THE REEFCOMBERS' DERBY

Colombo is not a particularly beautiful city, but it is a very spacious one. Our little apartment was four miles from the business center, being not far from the beach in the suburb of Bambalapitiya. Ceylonese place names, except when of European origin, tend to be terrifyingly polysyllabic. I mumbled for about a week before I could tell a cab driver where I lived, and even now I would hate to tackle such names as Illuppadichchenai, Angunakolapelessa, Kahatagasdigiliya or Puwakgahakotuwa without the opportunity of a little quiet practice.

If there were any Europeans living within a quarter of a mile of us, we never saw them; indeed, during the whole of our stay in Colombo practically the only Europeans we came to know were the dozen or so British members of the Ceylon Reefcombers Club, who shared our interest in underwater exploring. Though we did not wish to be unsociable, this suited us very well. We knew that we would be extremely busy organizing our expedition and analyzing the results, if any, and had something like a horror of becoming involved in the parties, receptions and similar social functions which we naïvely imagined would be occupying the spare time of our exiled countrymen. As it turned out, no one invited us to anything of the sort, so our fears were groundless.

We were also glad to be living entirely surrounded by Ceylonese, since there was no point in traveling a quarter of the way round the world if our neighbors were going to be unchanged. Watching

the varied life in the streets, from the yellow-robed Buddhist monks to the urchins selling lottery tickets, gave us endless pleasure and amusement. I am glad to say that we afforded quite as much in return.

It took us a few days to become properly organized and to learn our way about the city. Without the Landrover, we should have ‍ en in a sorry plight, for the public transport system of Colombo has to be seen (and heard) to be believed. Apart from the rickshaws which we never patronized because (a) we felt it wrong to employ men as beasts of burden and (b) we were sure we would look pretty silly bobbing along the street perched up in the air, the choice lies between buses and cabs. The cabs are easy enough to get hold of, and about half the price of those in London or New York, which means that they are all right for occasional use but ruinous if one has to employ them constantly. As for the buses—they are unspeakable. Elephants are supposed to have a mysterious graveyard where they all go to die, and the same is true of London Transport's unwanted derelicts. That graveyard is Colombo.

To make matters worse, the buses are run by so many fiercely competing private firms that they present an incredible chaos of inefficiency, dirtiness and unpunctuality. The bus companies are so busy fighting each other that the unfortunate customer is often ignored in the battle. When you stand at a bus stop, there is no guarantee that the driver will condescend to pick you up; he may be racing another company, or in a hurry to see his girl friend— or he may just dislike the look of your face.

It has been said that the Ceylon bus system will turn any believer in private enterprise into an ardent Socialist—and the state-owned railway system will convert him back again.

There are also trams in Colombo, which are worse than the buses. I never got aboard one, or even understood how it was phys-

ically possible for another passenger to insinuate himself into the seething mass of humanity. Luckily, improvement is on the way here as the trams are being replaced by trolley buses.

The main commercial area of Colombo, known as the Fort, occupies the quarter square mile immediately adjacent to the harbor and is well laid out with wide streets and good modern buildings. Almost any day of the week it is crowded with sightseers from the liners which carry two great streams of humanity in either direction across the Equator. There will be wealthy sheep barons from western Australia going "home" for a visit to England —and eying with a shock of recognition their almost indistinguishable counterparts from the cattle ranches of Texas, touring the mysterious East with Mom and Junior; there will be sturdy Italian farmers on their way to seek better livings in the rich soil of Queensland than they can find in their own country; there will be young rocket engineers and electronic technicians, barely out of college, heading for the desert secrecies of Woomera; there will be administrators, businessmen, retired civil servants, UNESCO officials—an entire cross-section of mobile humanity.

Most of these transients will see no more of Ceylon than the purely European area of Colombo, but some will take trips farther afield and may penetrate as far inland as Kandy, the romantic hill capital with its Temple of the Tooth and the 2,240-year-old sacred bo tree grown from a cutting of the very tree under which Buddha received his revelation. Everywhere they go they will be fascinated by the inextricable mixture of East and West, perhaps best exemplified by the rickshaws and bullock carts which share the streets with the Fiats and Volkswagens.

Though the climate of Colombo has only two phases—hot and dry, and hot and wet—we soon grew accustomed to it and very seldom felt uncomfortable. That was partly because, as mentioned

in more detail later, we were able to dress sensibly; if like most Western visitors we had stuck to shirts and long trousers, we should often have been very unhappy indeed. We had soon grown so acclimatized that we would start to shiver and reach for our warm clothes when the thermometer dropped below eighty-five.

One consequence of the climate is that no houses in Colombo have any form of heating except in the kitchen. Having cold showers instead of hot baths was no great hardship when the water was at no more than ten degrees below body temperature, and after the battle to keep warm in higher latitudes I think the single feature of the Ceylonese home which I most appreciated was its freedom from fires.

But there was one feature of life in Ceylon to which I could never accustom myself, though Mike took it in his stride. Before leaving England, I had made a few abortive attempts to eat curry, having been warned that it was impossible to travel in the East and avoid this fate. Like many similar warnings, this proved to be exaggerated; even in the remotest parts of the country I could always avert starvation by asking for eggs.

Sometimes, however, there was no escape from curry. One evening the charming young couple who lived in the house across the road invited us in for dinner, and the table was soon covered with mysterious dishes full of quite unidentifiable substances. I took small samples of each, hoping that I could find one which was edible. With my first cautious nibble, something went wrong with my windpipe and I felt as if I were a couple of hundred feet down with a broken Aqualung. Without losing control, however, I managed to reach for the water and sluiced down a tumblerful to try to dislodge the fission fragments now bombarding my gullet with neutrons and gamma rays. When I could breathe again I tried another micro-sample from somewhere else on my plate; this

time I did not exactly choke, but was merely unable to speak. When anyone tried to keep the conversation going, I sounded like an acute case of laryngitis.

It was quite obvious that the ratio of one tumblerful of water to each cubic millimeter of curry was not economic, and when an uncontrollable fit of coughing supervened I finally had to give up, to the great embarrassment of my poor hostess. She blushed as pink as her sari, and after we had departed Mike said to me: "I think you were very rude, leaving your dinner like that." I was so stunned with the utter injustice of the charge that I started to choke all over again.

After a year in Australia, during which time we had barely touched the eastern seaboard and come to grips with rather less than one per cent of the Great Barrier Reef, Ceylon seemed incredibly tiny and compact. Indeed, we soon decided that as a country it was just about the right size. Since it is less than three hundred miles from the extreme north to the extreme south, and half this in width, no spot in the country is more than a day's travel from any other, and most journeys require only a few hours' motoring over excellent roads.

It was partly because of this scale factor that, whereas in Australia it had taken us four months to get from Sydney to the Great Barrier Reef, in Ceylon we were operating two days after coming ashore. Or, to be strictly accurate, Mike was; I remained on land with the cameras to record the results.

On the first Sunday after our arrival, the local underwater hunters had their annual spear-fishing "Derby," and Mike went out with the contestants to observe their techniques. Spear fishing, as practiced by the Ceylon Reefcombers, is certainly a rugged sport, and seems to break many of the safety rules regarded as sacrosanct in the rest of the world.

The favorite spear gun among the Reefcombers is the simple but highly effective Cressi "Cernia," which is powered by the compression of a long spring. When a Reefcomber gets a new gun he promptly throws away the spear that goes with it—which he contemptuously regards as a toothpick—and get one made locally of ½-inch steel. To this he attaches twelve feet of steel cable having a breaking strain of five hundred pounds—but, very wisely, he does not fasten this cable directly to the gun, but to sixty feet of strong nylon line. The junction of the two lines is then wired to the tip of the gun in such a way that it will stand a pull of perhaps forty pounds.

In this manner, if a Reefcomber hits a moderate-sized fish, he can handle it with the twelve-foot steel cable alone; the long nylon line remains coiled up out of the way. But if he spears something big, which might tow him down into the depths, the fastening at the end of the gun breaks and the whole seventy feet of line are available. He can then remain near the surface while the fish tires itself out in fruitless dashes around the seabed.

That is the theory, and it usually works out in practice. Of course, if the hunter is foolish enough to spear something too big to handle, he has to cut his line. And if he hasn't got a knife, then it is good-by to his gun.

Using Aqualungs for hunting is regarded by the Reefcombers, as by most spearmen, as being in very bad form, and indeed is forbidden by the club rules. There is no sport in sitting on the bottom waiting for the fish to come up to you and then shooting them at your leisure, though it is only fair to point out that it will not always work this way. Hampered with his heavy equipment, an Aqualunger has no chance of catching many fish which an unencumbered skin diver can easily land. So using a lung for hunting is not only bad sport—it is often bad sense.

There was a large crowd on the beach at Mount Lavinia (a very misleading name for a coast resort) when the hunters began their contest. All we could see of them for several hours was an occasional figure scrambling over some rocks half a mile out; their fortunes or misfortunes were concealed from view until they got back to land.

When they finally returned to the beach after swimming for three hours a mile out at sea, some of the competitors were half hidden by the speared fish they had draped round themselves. Rodney Jonklaas was wearing a complete skirt of fish—fifty pounds of them in all—and was complaining bitterly that he hadn't seen a thing worth shooting.

Now all the books on underwater hunting emphasize that you should *never* swim with dead fish tied to your waist, and to carry bleeding fish in this fashion in shark-infested waters is regarded as nothing short of suicidal. There was no doubt that the sharks were around; one competitor found that one of his fish had been bisected with a neat, crescent-shaped bite.

I merely record this fact for the information of hunters elsewhere; for at least ten years Rodney Jonklaas has been spear fishing, often alone, and miles out at sea, in the middle of a gory circle of victims. Several times he has had fish taken from his waist, but the sharks have always stopped before they come to him. Perhaps they regard him as a public benefactor; he has known them to hang around, waiting for him to make a kill, and then rush in before he could secure his catch.

Being one of those people who is much too fond of fish to stick harpoons into them, I at first regarded this sort of activity with some distaste. However, I soon learned that—whatever might happen in other countries—the hunters here were not indiscriminate piscicides. Everything they caught was eagerly snapped up by the dealers, and quite a number of the Reefcombers relied on the sale

of their catches to enable them to pursue their hobby. Despite the fact that Ceylon is surrounded by fish and has thousands of fishermen, fish are expensive and in short supply, and any additional source is welcomed.

Another novel way of getting food from the sea was demonstrated to us a couple of days later by Rodney Jonklaas and Rupert Giles, the secretary of the Reefcombers, who was later to accompany us on several of our expeditions. Soon after sunset on a clear, calm evening we drove to one of the breakwaters at the northern end of Colombo harbor. Carrying sealed electric torches, Rodney, Rupert and Mike scrambled down the rocks and dropped into the inky waves. From a vantage point on the harbor wall twenty feet above, I could see the torches moving underwater—an eerie sight, like a drowned moonrise.

Every few minutes one of the hunters would emerge and fling a twitching crayfish onto the rocks, where it would thrash about desperately like some giant, armor-plated insect. In an hour they had caught over thirty of the crustaceans, which they had found sitting outside their caves or perched on the tops of boulders, never imagining the dazzling doom which was now to come upon them out of the night. Perhaps it was not a very sporting way to catch fish, but a crowd of hungry Reefcombers had to be provided for at their monthly meeting on the next day, and we could not afford to be too particular.

Swimming at night, in tropical waters, and waving torches which might attract large and inquisitive beasts, seemed to me an occupation with an uncertain future. I was content to let the others do it, while I stood on the shore and took flashlight photos as they emerged with their squirming victims. Apart from this, my only share in the enterprise took place the following evening. I may not have been much help at catching those crayfish, but no one was better at eating them.

4

REST HOUSES,
CATAMARANS AND SHARKS

It was on a hot and brilliant Saturday afternoon that we set out from Colombo on our first major expedition to the sea. Our unusually late start had a simple explanation—the Landrover had arrived in Colombo harbor only the day before, and it had taken a miracle of bullying and cajoling on Mike's part to get it unloaded, checked and licensed inside twenty-four hours. (A month later we discovered that in the rush we had neglected to get it insured. . . .)

A good coast road runs south from Colombo, and we were soon winding our way through the mingled files of bullock carts and Volkswagens. At one spot a giant bo tree straddled the road, its enormous roots forming an archway big enough for anything except a double-decker bus to pass through.

Two hours after leaving Colombo we arrived at the little village of Ambalangoda, and more or less took over the local Rest House. It was our first contact with one of these national institutions, which outside the half-dozen main towns provide the only accommodation for travelers. They serve the same purpose as motels in the United States—but there the resemblance ends.

Government-controlled and owned, some of the Rest Houses have been operating continuously for two centuries, often with no more than minor repairs to the original structure. The Dutch were splendid builders, and as far as design and construction are con-

cerned much of their handiwork still looks perfectly modern. The only important improvements which our age has added are plumbing and electric light.

The Ambalangoda Rest House had the latter, but the former was still in the process of being installed. When we wanted a shower, we had to go to the well in the courtyard and pull up the bucket, then get a friend to pour the icy water over our heads.

The Rest House was beautifully situated on a headland over-looking the sea and had a picturesque, rock-enclosed bathing pool below it. It was a large, single-storied building divided into a dozen bedrooms, dining room, kitchen, and accommodation for the staff. The bedrooms were high and well ventilated, though the loosely curtained windows provided minimal privacy. At the time of our visit, the "other offices" had not advanced appreciably be-yond the classic designs of Chic Sale, the well-known specialist.

Although the Rest Houses are under state control, each estab-lishment is run by a keeper (usually with the help of his numerous family), whose personality stamps itself upon the place and who is responsible for the catering. The price of the accommodation is fixed; that of the meals isn't, and this gives the Rest House keeper interesting opportunities for private enterprise. In our case, this worked both ways, since we often sold our catch to the Rest Houses we frequented—and were sometimes sorry we had done so when the fish course came on at the next meal.

By the time we had unpacked our equipment and had tea it was too late to consider diving, and we resolved to have an early night. Unfortunately the local Communist party, slightly drunk, decided to have a meeting in the dining room, and we had to try and woo sleep to the accompaniment of loud speeches (in English) de-nouncing the English. We did not grudge the comrades this healthy exercise, but what we *did* resent was their habit, when

27

anyone made a particularly telling point, of applauding by taking the tops off the tables and banging them against the floor. At least, that was what it sounded like to someone who was trying to get to sleep.

I was still cursing Karl Marx when it was suddenly daylight and Rodney Jonklaas arrived to drag us out of bed. Our jumping-off point into the sea was to be a small fishing village about three miles south of Ambalangoda; when we arrived there with our two cars, practically the entire population had surrounded us before we had switched off the engines. It is hard to believe that anywhere in the world there can be a more inquisitive people than the Ceylonese; one would have thought that these villagers had never seen an automobile before, whereas in fact they lived on a busy highway with a car passing every few seconds.

When we started to unload our photographic and diving equipment, it would have taken dynamite (a substance of which much more anon) to prize them away from us. We had to keep a constant watch on the numerous small children who were obviously itching to play with the shiny knobs of our cameras and the intriguing taps on our air cylinders. By unceasing vigilance, we were able to cut our losses over a period of five or six visits down to one pair of flippers, a diver's knife and an exposure meter. We particularly regretted the meter, which had been bought only the week before.

Since the reef we proposed to visit was half a mile out at sea, our first problem was to hire boats. Without Rodney, this would have been an expensive undertaking. After torrents of impassioned Sinhalese had flowed in both directions, we secured two boats and their crews, for ten rupees (two dollars) each. This did not seem much of a bargain when we had a good look at the boats.

The fishing vessels which are the standard craft on the southern part of the island are primitive catamarans, designed with no con-

cessions to comfort whatsoever. The main hull is so narrow that it is impossible to get inside it; the crew have to squat on top of the two vertical planks, about a foot apart, which form the sides. The outrigger float consists of a streamlined log lashed at the end of a couple of curved poles, which flex and twist disturbingly in rough water.

We were not at all happy about loading our thousands of dollars' worth of equipment into these crazy craft, but there was no alternative. Four Aqualungs, all our diving gear, a couple of dozen flashbulbs and four underwater cameras were somehow stowed away in various corners of the boats. The catamarans were pushed down the sloping beach and launched out into the sea, crew and passengers jumping aboard as soon as they were waterborne.

Getting away from the beach, however, was not an easy operation. Only fifty feet out a wall of coral, barely submerged, ran parallel to the shore. In one spot a passage had been blasted through this natural barrier; to reach the open sea, it was necessary to run this gauntlet. The four rowers who provided the inadequate motive power for each boat had to paddle frantically in the face of the advancing waves, but eventually we were through the gap and heading in the general direction of Africa.

Our goal was the Akurala Reef, its location marked by an occasional efflorescence of breakers half a mile out at sea. It took us forty minutes to make the journey—forty minutes of trying to find a comfortable resting place on planks which seemed to grow more sharp-edged every minute. But we had really nothing to grumble about on this lovely, calm morning: the unfortunate fishermen who relied on these craft for their livelihood were sometimes out in them, in rough weather, throughout an entire night.

When we came to rest upon the heaving waters round the reef, we had been so well cooked by the sun that we expected clouds of

steam to rise the moment we quenched ourselves in the sea. The palm-fringed shore was a remote green paradise that had nothing to do with us; we felt as isolated as the Ancient Mariner, caught between empty sea and empty sky.

We wasted no time getting into the water, leaving the Aqua-lungs in the boats while we did our reconnaissance. Before anyone could join him Rodney had already speared his first fish—a fifteen-pound caranx or horse mackerel (Plate 7). Though ours was primarily a photographic, not a hunting, mission there was a good reason for doing this; within seconds, the vibrations of the captured fish had brought sharks racing toward us from all directions. And so, by a fantastic stroke of luck, the very first movie footage I was to shoot in Ceylon was a lovely sequence of a shark swimming around Mike—something we might have waited a lifetime to get.

Then followed a scene which would have appeared utterly in-credible a few years ago, and which was a little alarming even to blasé underwater explorers such as Mike and myself. With five sharks—from small six-footers to an occasionally glimpsed brute about twelve feet long—circling hopefully around him, Rodney tied the bleeding caranx to his belt and continued calmly on his way in search of further victims.

It was not long before we too became almost indifferent to the sharks sharing the water with us. If they were close enough to make good photographic subjects, we would dive on them in an attempt to make them fill the camera view finder before we clicked the shutter. This direct approach, however, seldom worked; the shark would not stay to see if our intentions were peaceable, but would vanish with an effortless flick of its tail.

I never thought, when I started underwater exploring, that the time would one day come when I would take sharks for granted as part of the scenery. But after fifteen minutes on the Akurala

Reef, that is exactly what happened. I would find myself catching sight of a lean gunmetal shape sliding below me, would think, "Ah, yes—shark—very interesting," and would continue with some other business, just as if I was back in the London swimming pool where I had learned the elements of skin diving.

Presently the sharks decided that the water was a little too crowded, and disappeared as quickly as they had arrived. My companions, anxious not to waste all the carefully bottled air we had brought with us, swam back to the boats to put on their Aqualungs, but I thought it best to stick to my snorkel tube. I had never tried out the twin-tank units we had brought with us, and it would be foolish to do so half a mile out in the open sea.

So I followed Mike and Rodney at high altitude as they explored the rocky bottom forty or fifty feet below. Sometimes I did a little forced breathing to flush the carbon dioxide out of my lungs, and went down to join them for the few seconds which was all I could manage at that depth without artificial aids. It is a source of some annoyance to me that, though I have several times stayed underwater for more than three minutes, I have never been able to combine depth with endurance. Much though I hate making the confession, I don't suppose I have ever touched the fifty-foot level under my own power.

It was on this dive that I noticed a phenomenon I had never before observed. The intermittent cascades of bubbles rising from the two Aqualungs below swept past me to the surface, and every one of those tiny bubbles was a beautiful, delicate shade of pink. I floated in the ascending stream, and the storm of bubbles hitting my skin as they passed over my body produced an indescribably delightful tingling sensation which I did my best to prolong by carefully stationing myself above the divers.

Once the sharks had gone, we saw few large fish, with the ex-

ception of a splendid two-hundred-pound parrot fish which Rodney said was rather rare and promptly tried to make rarer, without success. After two hours' continuous swimming and diving, I decided that I had had enough for one day, and resumed my precarious perch in—or rather on—the catamaran. By this time many of the villagers back on the shore had been unable to restrain their inquisitiveness any longer and had put out to sea to find exactly what we were doing, so we were now surrounded by a small fleet of sightseers.

When our armada got back to shore, another bargaining session promptly started as Rodney put his fish up for auction. It appeared a little odd to sell the fishermen our catch; at first sight it seemed almost as if we were expecting them to pay for the privilege of being deprived of their livelihood. But this was too naïve a viewpoint; the shrewd villagers knew what they were doing. The fine caranxes which Rodney had speared were very seldom caught by nets and lines, and were accordingly much prized by the fishermen. When the dealers from Colombo arrived, they would resell our fish at a handsome profit, and everyone would be satisfied.

Meanwhile we could hardly wait to get home and see what our cameras had caught. As if to discourage us, the skies opened soon after we had left Ambalangoda and headed back to Colombo; we had almost forgotten what rain was like, having seen none for weeks, and now our memories were refreshed. We had neglected to bring the Landrover's canvas hood with us, so by the time we had reached the city we were both sodden. We had spent a large part of the day immersing ourselves in salt water, but did not enjoy the experience of having fresh water poured upon us in large quantities.

As soon as we had wrung out our clothes and dried ourselves, we

started to develop the films we had taken. And by the time we crawled to bed, totally exhausted, we had the satisfaction of seeing our first shark close-ups and knowing that our visit to the Akurala Reef had given us results which we had never been able to obtain during a whole year in Australia.

5'

THE FIRST WRECK

AN EXPEDITION like ours, however carefully planned in advance, could only succeed with the co-operation of the local authorities. There were many places which we wished to visit where the only suitable vessels were government ones, and there were other places —such as the pearl beds—which were strictly out-of-bounds unless one had official permission to go there.

One of our first moves on reaching Colombo, therefore, was to call upon the friendly and energetic Director of the Government Tourist Bureau, Mr. D. C. L. Amarasinghe—and this is as good a point as any to mention an important point concerning Ceylonese names. Ceylon suffers from an unusual shortage; there simply aren't enough names to go around. Since most of the population appears to be called Fernando, Perera, or de Silva, the habit has grown of referring to people by their initials and dropping their last name if it is too common to serve as any identification. What happens when the initials also duplicate themselves I do not know; presumably the situation is resolved as in the American examples of "Engine" Charlie Wilson and "Electric" Charlie Wilson, which in turn may have derived from the Welsh usage of "Mrs. Jones the Post Office."

D. C. L. was not only helpful to us in his capacity as Director of the Tourist Bureau; he turned out to be another camera enthusiast and promptly introduced us to one of Ceylon's leading photographers, J. O. Ebert, whose studies have been exhibited and pub-

lished in photographic journals all over the world. It was Jo to whom we were continually running when strange things happened in the processing tanks, and he always had the answer.

But Jo was not merely invaluable to us as a photographic consultant, badly though we needed one. (Let's be frank about it; Mike and I can only take good pictures underwater, and not always then. On dry land something invariably seems to go wrong.) Jo was also the Shipping Master for Colombo, holding court in a little subterranean empire beneath the white customs building through which pass most of the ocean-borne arrivals to Ceylon. Even when large liners were hooting impatiently in the harbor, Jo was never too busy to attend to our woes and to give us advice or information.

And he had some information which we could have obtained nowhere else—a complete register of all the ships that had gone down in Ceylon waters during the last hundred years. Mike was to make a special study of that register, in an attempt to find interesting and accessible wrecks.

We had not come to Ceylon to look for wrecks; we just happened to run into them, and thereafter they grew on us. As the later chapters of this book will record, we started with small freighters and eventually worked our way up to the fifty-thousand-ton class.

Leaving Jo's office, after one of our consultations, was frequently a matter of running the gauntlet. There would often be hopeful seamen of indeterminate nationality hanging around the entrance, and it was sometimes hard to persuade them that I was not a skipper looking for crew replacements. I still wonder what would have happened had I succumbed to the temptation of signing on a crew for Patagonia and ordering them to report to Jo next morning.

We found our first wreck on our next visit to Akurala Reef, the weekend following our meeting with the sharks. Once again

we descended upon the Ambalangǫda Rest House and took the place over; this time, luckily, there was no competition from the local Communists and we were able to sleep undistracted. Immediately after breakfast we hired a catamaran from the fishermen we had patronized the week before; they made a determined attempt to put up the price, but they had met their match in Rodney. He just went on saying, "Ten rupees," until they got fed up and capitulated.

The slow journey out to the reef was as tedious as ever, but I had now learned how to fit myself into the nooks and crannies of the boat. I had even discovered the art of lying flat on my back, balanced on the narrow edges of the two vertical planks forming the sides of the catamaran. A medieval philosopher (St. Thomas Aquinas, I think) was once asked by one of his pupils whether a good man could be happy on the rack. His reply, "Yes, if he was a *very* good man and it was a *very* bad rack," kept coming to my mind as I teetered on my twin knife-edges.

The water around the reef was very clear, and we wasted no time throwing ourselves into the comfortable embraces of the sea. As usual, Rodney had shot his first fish within a few minutes, and we waited hopefully for the sharks to arrive. But there was no sign of them; we swam around for half an hour, and finally decided that we were out of luck. Why they were so shy this time, when they had been all around us the week before, is just another of the many mysteries of shark behavior.

From well below the surface, the barnacled rocks which formed the highest part of the reef looked like a low hill whose summit was intermittently hidden by storm-tossed clouds. Those clouds were the breakers—the white water which even though the sea was calm was smashing over the nearly exposed rocks with considerable force. It was exciting to swim into it, and to become

lost in a dazzling white mist as the surge sucked one helplessly through the channels between the great boulders. With reasonable care, this amusement was perfectly safe; if you relaxed and let the water carry you, you automatically avoided the rocks and their frieze of razor-edged barnacles.

I spent some time diving under the surge around the reef, and looking up at the brilliant white fog of bubbles that formed and re-formed above me, sometimes hiding the reef, sometimes unveiling it as a mist may roll away from Highland hills. It is fascinating to watch breakers from below, for the foaming water gives an unforgettable impression of the sea's power and restlessness. And only a few hundred yards away, there was another and grimmer reminder of that power.

Rodney knew every boulder and almost every fish in this area, and presently led me away from the boat on a long circular tour. It was the first time I had ever been swimming far out at sea, half a mile away from the nearest object which could provide support. One of the reasons—apart from enjoyment—why everyone should learn to use mask and flippers is that they instill a sense of confidence and a realization that it is almost impossible to drown in salt water, at least when the sea is calm. I am a very bad swimmer, and doubt if I could cover two hundred yards without my flippers. But I am so accustomed to the fact that it takes five pounds of lead to make me sink effortlessly, and am so used to swimming for half a minute on one mouthful of air, that I am perfectly happy in the sea for indefinite periods even without mechanical aids. It required those aids, however, to build up that confidence, and to make me regard the sea as a supporting rather than an asphyxiating medium.

Below us was an endless vista of gray, cracked rocks, sparsely peopled with fish. And then, quite abruptly, we were swimming

over the ruins of man's handiwork (Plate 8). Set upright in the sea bed was the single vertical blade of a propeller that had been buried up to the hub; the remaining blades appeared to have been welded into the rock. This solitary metal tombstone, we later discovered, marked the resting place of the *Earl of Shaftesbury*, which ran onto the Akurala Reef in 1893.

A short distance away was the end of a boiler, lying on the sea bed like the lid of a gigantic saucepan. Near that was a huge crankshaft—huge, that is, by any but marine standards. And that was all that was left of the lost ship.

We swam around these pathetic relics for ten minutes, disturbing a large moray eel, which slithered through the rocks like a hideous black snake. The sight of the broken propeller blade, containing as it did many hundreds of dollars' worth of high-grade bronze, roused our cupidity, but we could think of no way in which we could salvage this small fortune. Perhaps one day we will be able to do something about the numerous propeller blades we have collected—or at any rate located. It represents quite as real a treasure as any sunken bullion, and could be turned into cash with fewer complications.

It was while swimming round this wreckage that I noticed, at unpredictable intervals, a strange groaning noise that seemed to fill the waters all about me. When I surfaced beside Rodney, I asked him if he could account for this sound. Like most mysteries, it had a simple enough explanation. I was hearing the huge boulders beneath me protesting audibly as the swell of the ocean shifted them on their foundations.

A few minutes later, I realized that the Akurala Reef, which seemed so calm and peaceful now, had claimed more victims than the lost *Earl of Shaftesbury*. We had swum out to deeper water, and the sea bed below us was now invisible. But lying on it, ap-

parently rolled over on its side, was the barnacle-encrusted hull of a fair-sized ship. The highest part of the wreck was about thirty feet below the surface, so I was able to skin dive down to it without much difficulty.

The 3,300-ton *Conch,* which was one of the Shell Company's first oil tankers, was dragged onto the rocks by a powerful current on the night of June 3, 1903, and quickly broke in two. On a later reconnaissance trip to Kalkuda, on the east coast, we were fortunate enough to come across what must be one of the few surviving eyewitnesses of the disaster. Mr. Hubert Paterson, now a well-known planter, had then been a young Lloyd's assessor at the port of Galle, about ten miles south of the Akurala Reef.

Early on the morning of June 4, news came that a ship had run aground further up the coast. Paterson and his colleagues at once hurried to Akurala village and bargained with the fishermen for their boats, just as we were to do more than half a century later. They had to pay no less than fifty rupees a boat—and in 1903 the rupee, like most other currencies, was worth at least ten times as much as it is now, so the fishermen drove a hard bargain. One cannot really blame them, for they were being asked to risk their lives and thus the welfare of their families.

Five boats set out through the narrow gap in the wall of coral fringing the shore, and the rowers fought their way against seas which were so high that both land and wreck were often invisible. After battling for half an hour, they reached the enormous patch of oil now spreading round the ship; it seemed, as far as they could tell, to have no calming effect on the water, and waves were breaking entirely over the ship.

After some dangerous and delicate maneuvering, the catamarans were brought up to the wreck and the whole crew were taken off—even the ship's cat being rescued! The sailors were in a pitiable

condition; because of the oil all around them, they had been unable to use any lights and had passed the night in complete darkness, with the knowledge that their ship was rapidly breaking up. (Even today, incidentally, the local fishermen claim that they can smell oil from the *Conch,* though this is a little hard to believe.)

When the work of rescue had been completed, the overloaded catamarans started the even more dangerous return journey. As they left the *Conch,* only her stern still remained above water, and the waves were breaking over that. Paterson was to remember all his life the pathetic sound of the ship's bell, still tolling in the deserted and disintegrating hulk.

This was the vessel which, fifty-three years later, was being visited by men again. It had only recently been rediscovered by Rodney, and in the next few weeks was to become one of our favorite wrecks, as well as the scene of some of our most successful, exasperating and sometimes hair-raising adventures.

On that first visit, Rodney and I merely made a few dives along the gently curving sides of the overturned hull. As we were not using Aqualungs, we could not enter the wreck, and it was very difficult to decide how large a vessel she had been. Not until some weeks later did Mike, rummaging through the records in Jo's office, discover her name and tonnage.

I was beginning to feel tired, and did not object when Rodney started to swim back to the catamaran. Once or twice, just to remind me that I had been in the water long enough, I felt a twinge of cramp. This is perhaps the most serious danger confronting the lone diver on an extended mission, especially if he overexerts himself. In Ceylonese waters the surface temperature hovers in the eighties and one can swim all day without feeling the cold. But even twenty feet down, it can sometimes feel quite chilly and attacks of cramp through cold and exhaustion have to be guarded

against. These twin enemies of the diver can creep up on him un-
awares, especially when the fascination of his surroundings has
made him forget the passage of time.

This had certainly happend to me. When I got back to the cata-
maran, I had been swimming continuously for three hours, often
at depths of over thirty feet. Even a Ceylonese fishing boat felt com-
fortable as I lowered my protesting muscles into it, and dozed
lazily away while the rowers took us back to land after a total time
of five hours at sea.

I continued lazing the next day, and was quite content to watch
my companions set out to the reef without me, while I took still
and movie shots of their somewhat hectic progress over the coral
bar. Then I started to explore the village of Akurala, and was im-
mediately surrounded by a dozen self-appointed guides ranging in
years from six to twelve. Although my command of Sinhalese ex-
tended no further than the words for "yes" and "no," we got along
famously, and I was taken on a circular tour through the coconut
groves, stopping to look at the attractive little temple set in its
clearing amid the palms. Various efforts were made to sell me
small, unhappy fish circling in jam jars, but I turned them down as
tactfully as I could, tempted though I was to release the captives.

The Ceylonese villagers and fisher folk live in picturesque
squalor in crude huts sheltering under the ubiquitous palm trees.
It is impossible to imagine Ceylon without palms; every beach is
lined so solidly with them that it is sometimes hard to see any signs
of human settlement. Wherever there is an open space, the palms
lean toward it, apparently in an effort to catch the extra light, so
that along the shore they are canted seaward at Pisa-esque angles.
Even along the highways the same thing happens, the palms on
either side of the road leaning inward so that one is often driving
beneath a complete and continuous archway.

Valuable and beautiful though they are, however—for they provide not only food but rope, matting and all manner of constructional materials—the palms can also be dangerous. A coconut coming straight down from sixty feet is a lethal projectile, and many who have rested in the shade of these lovely trees have never waked up again.

Despite their apparent poverty and the scantiness of their personal belongings, the villagers I met on my tour seemed cheerful and well-nourished. In the monsoon season, when it is impossible for the boats to put out, they have a difficult time and are sometimes near starvation. But this was the beginning of the year, when the sea was calm and they could safely stay out all night with their nets.

The children, besides being friendly and intelligent, are often strikingly beautiful; indeed, the Ceylonese must be one of the most handsome races in the world. Unfortunately, grinding toil and a tropical climate soon leave their mark, particularly on the women with the additional burden of childbearing. It sometimes saddened me to glance at the friendly, inquisitive crowds, and to look in vain for the beauty of the children in the faces of the adults.

Ceylon is a country of many races, and the simple word "Ceylonese" is almost as uninformative as the equally omnibus word "American." The Sinhalese are in the great majority; they are predominantly Buddhists (though there are many families that have been Christian for generations) and now that the British have gone are the leading power in the land. A talented, intelligent, high-spirited and extremely friendly people, they are not famous for reliability or devotion to hard work, and gaily admit this failing. (If it is a failing, which one begins to doubt after one has lived in Ceylon for a few months.) Judging from their past history and achievements, some of which were to fill us with awe when

we visited the ancient city of Anuradhapura, this may be the consequence of centuries of foreign occupation, and perhaps in the future we may see a revival of the old Sinhalese spirit. At the moment it would not be unfair to say that they combine many of the characteristics of the Irish and the Spanish.

The next largest group is the Tamils, who are mostly found in the northern part of the island and have close associations with India. They tend to be bigger and darker than the Sinhalese; we were often told that they were harder workers, though we never had a chance of putting this to the test. Their religion is Hinduism, and their grotesque and lavishly ornamented temples form a striking contrast to the classic simplicity of the best Buddhist dagobas— the gleaming white domes to which the coconut palms provide such a perfect setting.

Apart from numerous invasions from India over a period of about two thousand years, Ceylon was progressively occupied by the Portuguese, the Dutch, and the British. Only the British left under their own power, and each of these Western interlopers made a permanent mark on the country—the Portuguese their religion, the Dutch their architecture and law, the British their commerce and language. And since the early settlers were not particularly color conscious, they often intermarried with the local population so that today there is a small but important community known as the Burghers, who for many years have taken a disproportionately large share in the administrative, commercial and artistic life of the country.

In addition there are Indians, traders from the Arab countries, British, Chinese—almost any race one cares to mention, in fact, with the possible exception of Eskimos, and I would not care to take a bet on that. Luckily, English is spoken almost universally, and even in the remotest settlements one can usually find someone

who understands it. I can still remember my surprise when, in a tiny fishing village a hundred miles from Colombo, one of the small children in the crowd around me looked closely at my photographic equipment and then carefully read out, with scarcely a trace of accent: "Weston Master II Universal Exposure Meter." That gave me a considerable respect for the educational system of Ceylon; I only hope that the new spirit of nationalism that is now abroad, with its insistence on Sinhalese as the state language, will not undo the good work of the past and so cut Ceylon off from the culture of the West.

6

A CLEAR RUN TO THE SOUTH POLE

EXACTLY a hundred miles from Colombo, and almost on the extreme southern tip of Ceylon, is the little town of Matara. During the seventeenth century the Dutch made it one of their main bases, and built a small fort which stands almost unchanged to this day as a classic example of the military architecture of the times.

Rodney Jonklaas had chosen Matara as one of *our* main bases, though our intentions—except to the fish—were more pacific than those of the Dutch invaders. On second thoughts, that is hardly fair to the energetic and practical Hollanders. The Dutch were after trade, not empire or conversion, and were highly adept at avoiding bloodshed. When they realized that the time had come to bow gracefully from the scene they did so without any death-or-glory nonsense, as the unscathed state of their forts testifies.

The Matara Rest House was attractively situated overlooking the sea, and one of our first acts on arriving was to lay out all our equipment—Aqualungs, compressor, cameras, rubber dinghy, Landrover—on the lawn so that we could photograph it before it became too battered and bent to make a good picture. The final result (Plate II) looked as if a sports store and a camera shop had combined forces for the spring sales, and the local inhabitants were most impressed. So were we, especially when we remembered how

long it was going to take us to pay for all this.

It was too late to do any diving the day we arrived, and after dinner my three companions—Mike, Rodney Jonklaas and Rupert Giles—decided to have an early night. But it was too warm and peaceful for me to go to bed, and I wandered up onto the battlements with a pair of field glasses. I was only six degrees from the Equator, and the Pole Star was barely visible in the northern haze. Hanging in the sky before me now were the constellations of the antipodes, whose names I had never learned, even after a year in Australia. The richest star fields of the Milky Way, with their glowing outriders the Clouds of Magellan, arched across the heavens in a spectacle unmatched in the misty skies of England. South for a quarter of the world's circumference there was nothing but empty ocean between me and the icy walls of Antarctica.

It was lonely and mysterious up on the deserted battlements; as I peered through the firing slits out across the dim-lit sea, I could fancy myself in the company of old Dutch ghosts—perhaps poor soldiers who had to wander homeless because they could not afford to have their tombstones shipped out from Holland, as many of their wealthier countrymen had done. And, with a slight change of nationality, this would have been the perfect place to meet Hamlet's vengeful father.

Despite my midnight vigil, I was up with the others when we set off to the exact southern tip of Ceylon, Dondra Head, just five miles further along the coast. A fine, white-painted lighthouse stands proudly here in well-kept grounds, overlooking the rocky bay from which Rodney proposed we should start our swim.

We had parked our cars in the shadow of the lighthouse and were adjusting our equipment when suddenly there was a brief, muffled explosion. Rodney and Rupert looked at each other and simultaneously said the same word: "Dynamiters!" Without wast-

ing any more time, we grabbed our cameras and hurried to the water's edge.

The beautiful little bay was the scene of great activity. Half a dozen catamarans, full of small boys with an occasional adult to direct operations, were milling around in the center. More small Ceylonese were swimming in the water, diving to the bottom and returning with handfuls of fish, which they passed over to their companions in the boats. They were collecting their illegal harvest from the ocean.

There was quite a large audience watching the busy scene, and no one seemed to resent our arrival. The Sinhalese are so fond of having their photographs taken that they appear not to mind if the shutter closes when they are doing something illegal. The people on the shore moved politely aside to let us photograph their friends and relatives at work; even the man who was obviously in charge of the whole proceedings, and had probably supplied the dynamite, made no attempt to keep out of our way.

Mike was in the water almost at once, swimming out to the nearest canoe. I thought that this was a little rash; though no explosives would be dropped on top of him—for there were still plenty of other divers around collecting their fish—it seemed likely that he might get a knock on the head with an oar if he became too inquisitive. However, he soon made friends by helping to pick up the catch. This was probably compounding a felony, but since the fish had already been killed there was no point in leaving them to rot.

I followed a little later with one of the still cameras. The sea bed beneath the boats was sprinkled with silvery corpses, but the underwater visibility was so poor that it was impossible to get a good photograph. (Later, off Trincomalee [see Plate 25] we were able to record a similar scene.) We swam around for some time

47

until most of the catch had been picked up, then decided that there was nothing further to see here and it might be a good idea to get out of the way before more dynamite arrived. So we swam around the headland and out to sea, where the no-longer-land-locked water at once became rough and we were soon tossed about in the waves.

It was an uneventful dive, and there is no point in recording it. Rodney, as usual, shot some fine pompano which would help to reduce our bill at the Rest House. He also caught a small turtle and tried to get it to take him for a ride in front of the camera, but the intelligent beast bit him on the thumb and made its escape. And once we heard, but did not feel, a distant explosion which told us that the dynamiters had been in no way abashed by our presence but were up to their tricks again.

By a piquant and extraordinary coincidence (if it *was* a coincidence) it so happened that at this very moment the Director of Fisheries was holding a conference at the Matara Rest House, just five miles along the coast. We had spoken to him as we departed for Dondra, and had left him listening to the grievances of a deputation of local fishermen. Perhaps they thought it would be quite safe to go dynamiting while they held the director in earnest conversation. Perhaps they simply didn't care.

Rodney, who had waged a fruitless war on the dynamiters throughout his career as a government official, was very bitter about the whole incident. The trouble with dynamiting, of course, is that it kills fish of all sizes so that the immature ones have no chance to grow up and breed. Eventually the fish are either wiped out, or leave the area, so that by using this technique the fishermen were really robbing their own children for the sake of a quick return.

Since the water at Dondra was not as clear as we had hoped, and it did not appear to be a healthy place for skin divers, we decided

to head north. But we spent one more night at Matara, and once again I walked the battlements because it was too early to go to sleep. I did not stay up there for long, however, for to my great surprise a famous and familiar sound soon reached me on the evening breeze. Who on earth, at this time of night, would be playing Beethoven's Choral Symphony at the lonely southern end of Ceylon?

The last thing I expected to find in a remote Rest House, which is exactly what its name implies and where very few people stay for more than one or two nights on their way to somewhere else, was a hi-fi enthusiast with a small library of classical records. But there was one at Matara, and I spent some time lurking outside his door while Beethoven's last will and testament filled the night air around me.

Who my unknown benefactor was I never discovered; before I could introduce myself a crowd of his friends arrived and that was the end of Ludwig for the evening. I went to bed and to a rather disturbed sleep in which I was pursued by hostile Ceylonese, though I cannot remember if they were throwing sticks of dynamite at me.

The next morning we moved up the coast to the Rest House at Weligama Bay, one of the most famous beauty spots in Ceylon. The great curve of shoreline, two or three miles in length, embraces a group of lovely little islands, one of which—Taprobane— can be reached by wading from the mainland. The word "Taprobane" is the old European name for Ceylon; it had been applied to this little island by a romantic exile, the Count de Mauny, when he settled on it early in this century.

We were to visit this modern Taprobane later; for the moment we were busy securing our base at the Rest House and getting our

equipment once more in readiness so that we could operate any-where we chose up or down the coast.

It is probably true to say that no Rest House was ever the same after we had stayed there; Weligama certainly wasn't, as Mike nonchalantly demolished the front steps when we finally drove away. Landrover and rubber dinghy occupied the lawn; cameras and Aqualungs filled a couple of bedrooms; film-developing tanks and beer bottles full of processing chemicals overflowed into the bathroom. It was not altogether surprising that, despite all our efforts at tidying up, we always seemed to lose something at each stop we made, even if it was only a pair of tennis shoes.

The Rest House at Weligama looks out at the bay across a grass-covered courtyard, and in one corner of this courtyard stands a massive bo tree. During the daytime, the branches of this tree are festooned with a most peculiar fruit; it seems that hundreds of large, black pears are hanging from the twigs. I never gave them a second thought until I was told to look at them more carefully; when I did, I wondered if I had been suddenly transported to Castle Dracula. The "pears" were giant fruit bats, leathery monsters with two-foot wingspreads. During the daytime they hung upside-down making querulous noises, but at dusk they would take off in a cloud that momentarily darkened the sky, to ravage all the fruit plantations for miles around.

Since they had thoughtfully roosted in a tree which was sacred to the Buddhists, and indeed had a shrine at its base, they were perfectly safe from molestation. At least, they had always been in the past—but they were soon to learn that times were changing.

We had just finished organizing ourselves and disorganizing the Rest House when a large American car drove into the courtyard. Two men festooned with Leicas and Canons, and followed by a caddy with more cameras, started to take photographs of the

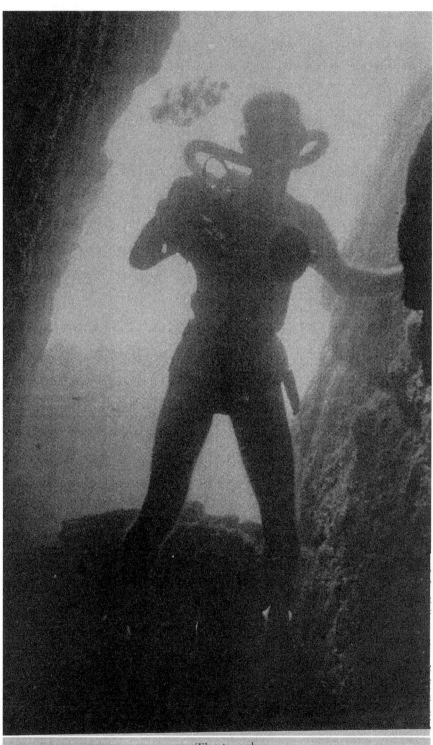
The intruder.

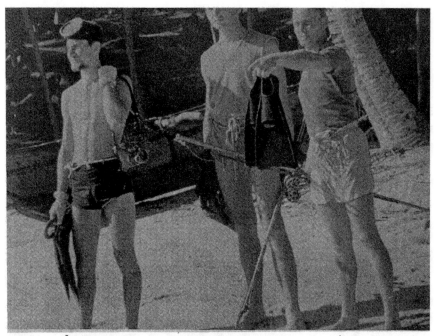

Rupert Giles points out a possible hunting ground to
Tony Buxton and Mike.

The air compressor always gathers a good crowd.

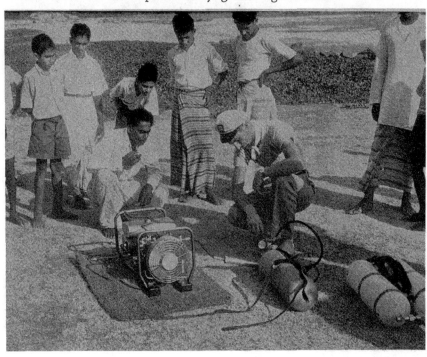

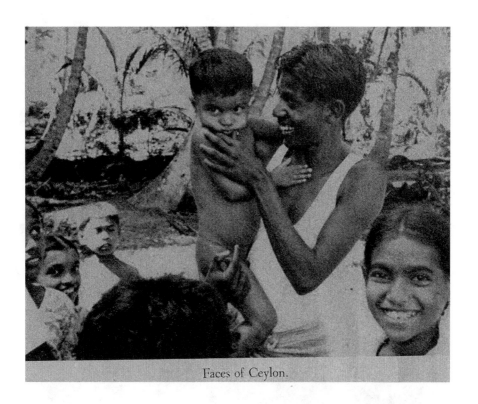

Faces of Ceylon.

One way of taking sharks
to market.

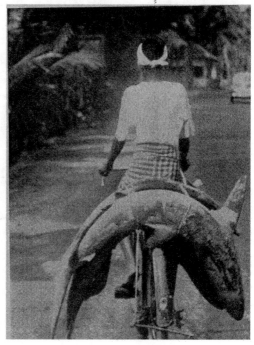

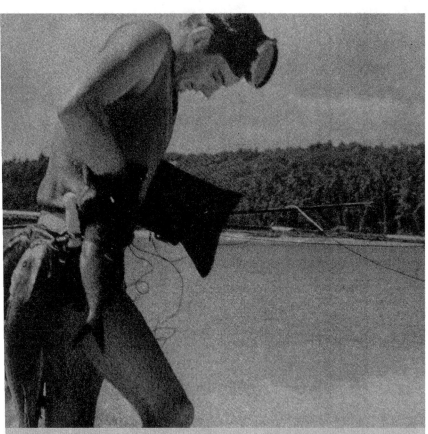

Tony Buxton comes ashore wearing a skirt of pompano.

The caranx, king of the fighting gamefish, is surprised by a flash bulb eighty feet down.

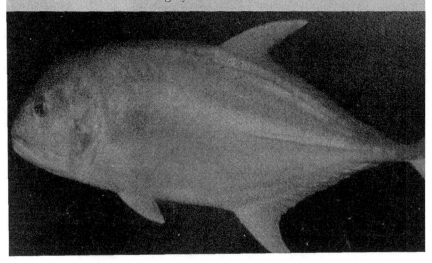

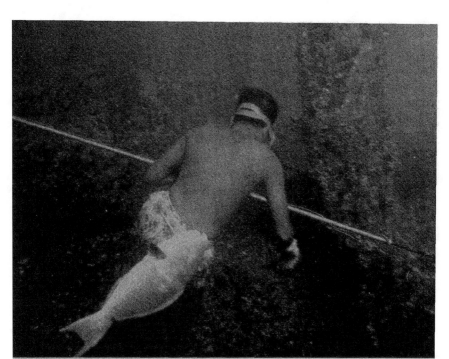

Rodney Jonklaas, with parrot fish in tow, hunts under the propeller of the sunken *Earl of Shaftesbury*.

Mike helps Rodney bring in a hundred-pound pig-faced parrot fish. Note the bent spear.

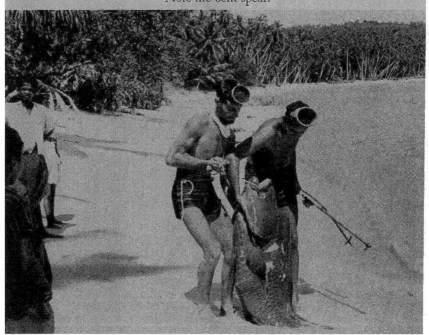

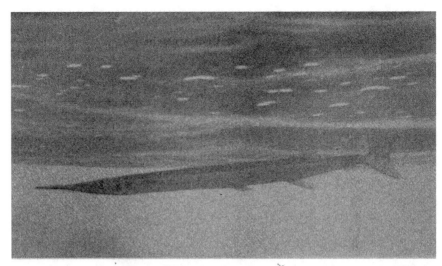

A needle-nosed garfish cruises below the surface.

Rodney, also just below the surface, on the lookout for game.

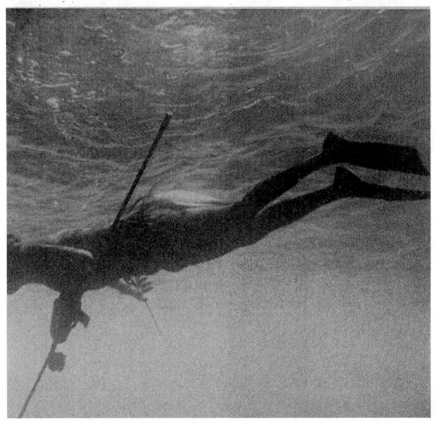

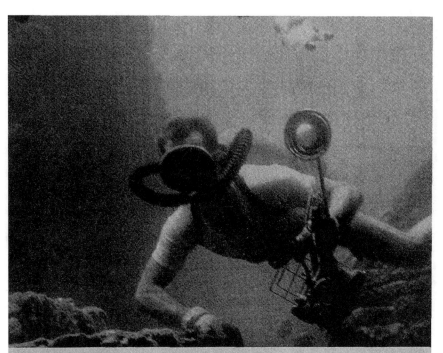

George Sandham explores an underwater cave.

A nine-foot white-tipped shark cruises past.

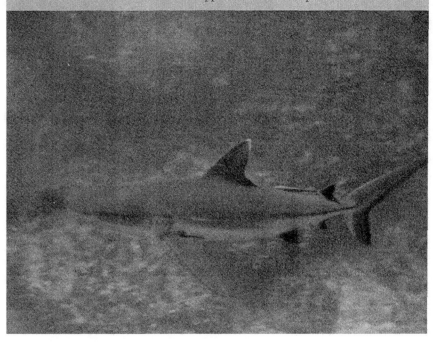

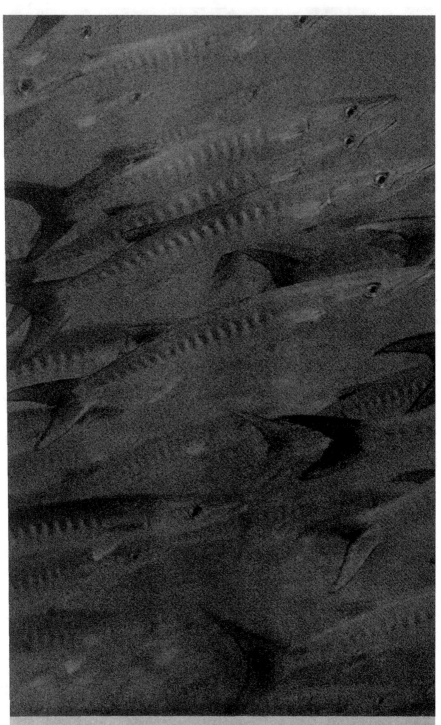
Wolf pack: the barracuda wonder if the photographer is edible.

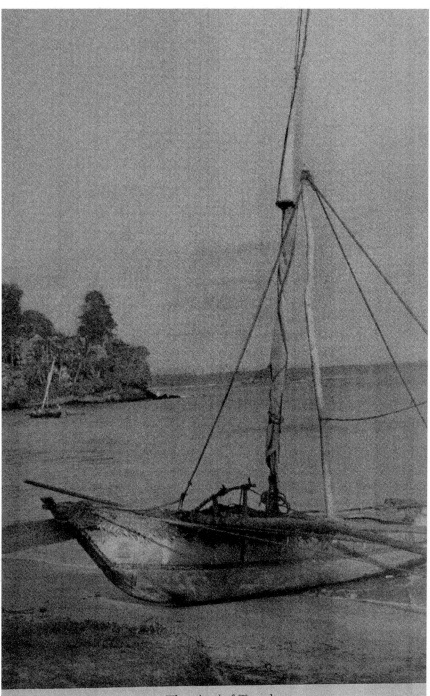

The island of Taprobane.

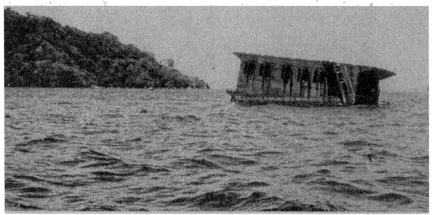

The rusty control cabin marks the grave of the giant floating dock.

After eleven years underwater, all the exposed metal has become completely incrusted with barnacles.

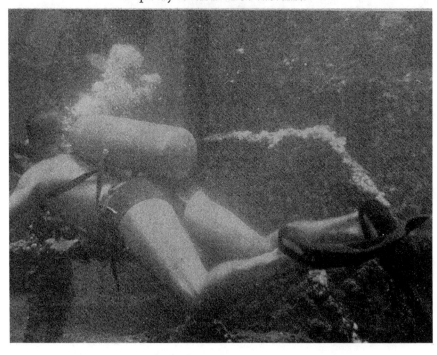

George swims over the dock through a screen of fish.

Hubert Paterson (right) tells the author how he rescued
the crew of the *Conch*.

The author cleans the barnacles from a submerged bas-relief.

A stone lintel in the shape of two elephant heads lies on the sea bed.

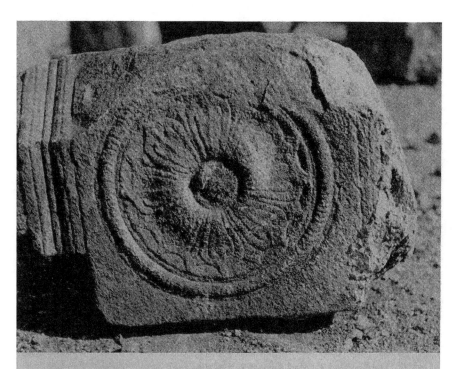

A characteristic lotus-blossom pattern on the columns of the ruined Hindu temple. Upper picture on land, lower picture on the sea bed twenty yards away.

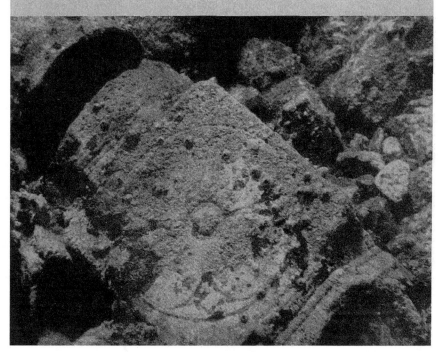

Dynamiters at work. Small boys dive to pick up the stunned fish.

The trail of the dynamiters.

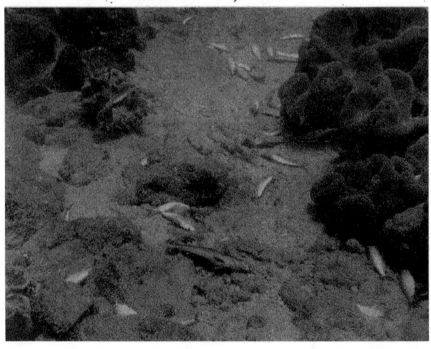

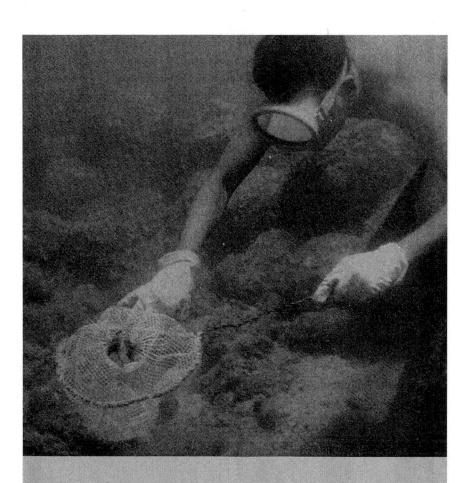

Rodney Jonklaas at work, netting a scorpion fish.

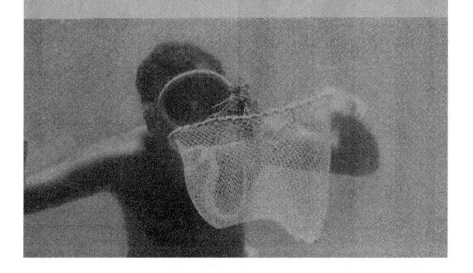

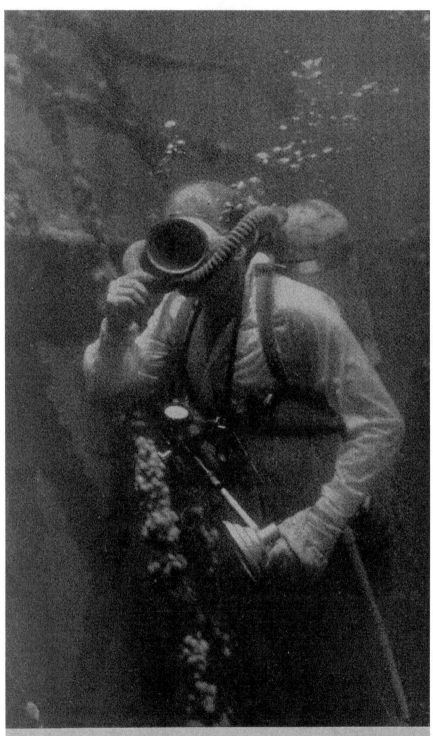

The author floats among twisted girders of the sunken dock.

fishing boats ranged along the beach. By a brilliant feat of deduction, we decided that this was a team from *Life* Magazine which we knew to be in the country, so we went over and introduced ourselves.

At first Mike was rather truculent, since by this time he had come to regard Ceylon as our own personal property, but I managed to convince him that Mr. Luce had really no need to ask our permission before he sent people here. After that, all was well, and we were able to co-operate in disturbing the siesta of the fruit bats.

The *Life* team had brought along some firecrackers, and just in time we stopped them from placing their explosives on the shrine under the bo tree. It was an easy enough social error to make, since the shrine was nothing more than a small, rectangular concrete box, completely devoid of ornament, but with a window in one side behind which were a few offerings and a constantly burning oil lamp. Probably the easygoing Buddhists would not have minded a small bomb on the altar, but in these matters it is always best to be on the safe side.

The firecrackers were placed on the grass, and we focused our lenses on the upper branches of the bo tree. There was a sharp report (we seemed to be meeting a lot of explosions on this trip, I could not help thinking) and within seconds the sky was full of squealing, protesting bats. They circled for a few minutes, giving us time to get some good action shots, then kindly landed again so that we could repeat the performance.

Jumping off from a new section of coast is always an adventure; it is a gamble whose outcome can never be foreseen, for even if one is familiar with a given area the underwater conditions are continually changing and so, to a large extent, is the underwater population. The spot Rodney had chosen for our next dive was

the tiny village of Gintota, five miles north of the port of Galle. It was another quite typical fishing village, with palm trees leaning along the beach and catamarans drawn up on the shore. We managed to hire two of these at the standard ten-rupee rate, but we decided to take the rubber dinghy with us as a second and more convenient base for the divers to work from.

Rodney and I each took a catamaran, but Mike and Rupert Giles decided to go out under their own steam. Into the dinghy, despite our warnings, they piled three Aqualungs and a couple of cameras, and started to paddle out to sea. They had not traveled more than thirty feet when a large and hostile wave picked up the dinghy and emptied its loose contents into the boiling surf. Fortunately, everything of value had been tied on, and only assorted flippers and face masks went overboard. There was a brief delay while crowds of volunteer searchers scrabbled in the sand for our lost property; amazingly enough, every item was recovered, both from the sea and from the searchers.

Nothing daunted, Mike and Rupert tried again. Paddling furiously, they switchbacked through the surf and this time managed to reach smooth water without mishap. Our oddly assorted little fleet of two catamarans and one rubber dinghy set bravely out to sea.

We had traveled only four hundred yards when we came to the resting place of the motor vessel *Elsia*, a Danish cargo-passenger ship which caught fire and had to be abandoned in 1939. She lay in about forty feet of water, but unfortunately visibility was so poor that we could see only about fifteen feet. The superstructure of the burnt-out ship was just visible from the surface as a dim shadow beneath the waves, and although any photography was out of the question we dived down to see what we could find.

It takes considerable determination to plunge down into a green

mist which may conceal anything, and in which you may even lose your way back to the surface because you can no longer distinguish between up and down. When the underwater horizon is only a few yards away, you become lonely and lost; you cannot see your companions, or the reassuring glint of the waves overhead. Anything may come swimming toward you out of the gloom, and even familiar objects are distorted and made mysterious by the haze.

I took a deep breath and plunged down toward the enigmatic blur lying beneath our boat. Before I had run short of air, I found myself *inside* a ship. The *Elsia* appeared to have split open, revealing all her internal machinery. A big electric generator, overgrown with weeds and barnacles, lay surrounded by large air cylinders, most of which had been completely eaten through by corrosion. Pipes and cables snaked everywhere, sometimes looking alarmingly like giant tentacles.

Because visibility was so limited, it was impossible to get any idea of the true size of the ship. She seemed enormous, for wherever we went we kept on discovering more of her. After working steadily across the deck in a series of brief exploratory dives, I finally went over the rail and all the way down to the sea bed. The entire side of the ship had been torn off, and lay on the sand forty feet down according to my depth gauge. I could just reach it before having to head back to the surface for air.

One of the dangers of diving around such a wreck, in conditions of poor visibility, is that it is altogether too easy to swim under an obstacle without being aware of it until you start to hurry back to the surface. There were also, almost certainly, some very large fish in the *Elsia*; the giant grouper was most unlikely to miss such a desirable residence. After half an hour of exploring, therefore, we decided to try our luck further out to sea.

One day, perhaps, we may go back to the *Elsia*; she is the most accessible wreck we know—or, rather, she was until the events recorded in Chapter 11. Unfortunately one cannot have it both ways; wrecks that are close to the shore are almost always in dirty water, and are therefore of no use to the photographer, however interesting they may be to the hunter or salvage collector.

When we tried to leave the *Elsia*, however, we found that she did not want us to go. The heavy stone used as an anchor had caught in the wreckage and could not be dislodged. Feeling heroic, I grabbed a knife and went down to see what could be done.

My earlier diving had left me a little tired, and it seemed a long time before I reached the trapped "anchor." It was clearly visible, wedged between two plates, and I tried to pull it clear. But I was thirty feet down, at the end of my operational range, and there is nothing more totally exhausting than hard work under water. When I finally gave up the struggle, I barely had enough air left to get back to the surface. A miserable lump of stone was hardly worth this effort, so Mike went down and cut the line. It was then that I discovered I'd made my descent without the five pounds of lead I normally use to neutralize my buoyancy, so it was not surprising that the bottom seemed a long way away. I could have got down easily with the lead; but would I have got up again after fighting with the anchor?

By this time I was ready to go back to land, but to my dismay my younger and more energetic companions felt that the day had only begun. Just visible out on the horizon—or so it seemed—was a patch of white breakers, marking the position of one of the most treacherous reefs in Ceylonese waters. They determined to head for that, and as the journey looked like being a long one I decided to move from the catamaran to the rubber dinghy, which would surely be more comfortable.

I have seldom made a bigger mistake. By this time the dinghy had lost a good deal of its air and was no longer rigid. It not only flexed with every movement of the waves; it amplified them and added a few modes of vibration of its own. By the time I had clambered out of the cramped, uncomfortable catamaran into the soft and rubbery embraces of the dinghy, it was too late to correct my error. I was stuck there, because I didn't have the strength to climb out again.

I consider myself a fairly good sailor, and have thoroughly enjoyed myself aboard small boats in quite rough seas. But that bucking bronco was too much for me: I passed the rest of the journey in an exhausted stupor, trying to imagine what it was like to be on dry land again.

After several weeks of subjective time, we arrived at the reef and I could hear the glad cries of my companions as they disported themselves in the water around me. They seemed to be having a splendid time; I wished that I could say the same. Suddenly the fishermen started shouting, "Mora, mora!" The Sinhalese for shark was one of the few words of the language I knew, but even this cry did nothing to rouse me from my apathy. A few seconds later, Mike surfaced and shouted to someone: "Get in the picture with him!" All sorts of exciting things were obviously happening, but the only thing that interested me at the moment was the lovely firm sand on the beach at Gintota, an endless mile away.

As it turned out, I was missing a great deal. Rodney had shot quite a large shark, which Mike was busily filming from all angles as it careened around in the water towing the spear and line. Eventually they released their unpaid, non-union actor, who swam thankfully away as quickly as he could. Landing a shark is such an exhausting business, and usually involves the corkscrewing of

so many spears, that it is not worth the trouble and the Reefcombers very seldom do it.

Rodney and Rupert then started on the less photogenic but more profitable business of spearing pompano. Every time they shot one of these fish, a shark, grouper or caranx would try to take it away from them. This happened to Rodney seven times in succession, and began to be a little monotonous. Rupert was equally badgered; once, when he was trying to chase away a persistent little shark, an eighty-pound caranx started to nuzzle his rump.

But I knew nothing of all this, and cared less as the aeons passed. Never again, I told myself, would anyone get me out to sea in one of these ridiculous conveyances. In fact, I then and there renounced the sea and all its works. When I got back to land, if I ever did, I would stick to it.

At last Mike took pity on me, detached one of the catamarans, and sent me home in it. I must somehow have conjured up enough energy to climb out of the dinghy; of course, I was much lighter by this time. As the shore approached, my spirits revived accordingly; when the catamaran finally grounded on the beach, no one could have guessed that I had not altogether enjoyed my trip.

I am not sure whether it is a greater proof of resilience or stupidity to record the fact that I was up at six the next morning to repeat the trip. When we reached Gintota, however, we found that we had a strike on our hands. The fishermen, who had previously agreed to take us out for ten rupees, now insisted on getting fifteen. Our departure was held up for half an hour while Rodney orated large quantities of Sinhalese which we would have given a good deal to understand. After that, we got the boats for ten rupees.

This time we had a sail and bounded out to the reef in fine style. We bypassed the ill-fated *Elsia*, and in half an hour were a couple

of miles out to sea. Now, for the first time, I could take some interest in the spot I had visited, without noticing it, the day before.

The Rala Gala Reef is also known as Wave Rock—a perfect description of the place. Even on a calm day, a great surge of water perhaps ten feet high may suddenly rear up out of the sea, giving the only indication—perhaps too late—of the danger lying beneath the surface. The fishermen anchored their boats at a respectful distance from the reef, and left us to find our way there under our own power.

The water was a revelation. It was the first time I had ever encountered visibility of over a hundred feet in the open sea, and there appeared to be absolutely nothing between me and the rocks fifty feet below. We swam slowly toward the reef, until Wave Rock loomed up ahead like a small undersea mountain.

Rodney, plunging like a hawk down the mountainside, had soon shot his first pompano, and Rupert quickly followed suit. Mike and I were carrying the cameras, in the hope that sharks would be attracted by the struggles of the captured fish, and very soon our expectations were fulfilled. The slim, blunt-nosed shapes began to appear from nowhere; sometimes we would glimpse them out of the corner of our eyes and they would be gone before we could photograph them, but sometimes we would spot them first as they hugged the rocks below us, and would dive-bomb them with our cameras. They would then usually put on speed and get out of range in a couple of seconds.

Most of these sharks were small and shy; we had been diving around the reef for about an hour when we met one that was neither. I was swimming with Rodney and Mike over a rather dull and uninteresting wilderness of rocks, and had been spending most of my time about twenty feet down, gliding down to this

depth with as little effort as I could and letting myself drift back to the surface whenever I felt like it. The whole secret of underwater sightseeing—and indeed of diving in general—is summed up in what is known in physics as the Principle of Least Action. Never exert yourself unnecessarily: the universe doesn't.

I was relaxing twenty feet down when I saw a large shark coming straight toward me, almost on a collision course. Such a confident and assured approach was most unusual, and I quickly whipped the camera up to my eye, praying that my air would hold out until the shark reached me. He was a beautiful beast, about nine feet long, with the inevitable sucker fish latched onto his back just behind his big, white-tipped dorsal fin. I could see his little beady eye and the vertical slats of his gills; he seemed to be moving utterly without effort as he grew larger and larger in my field of vision.

At the last minute he swerved to my left; I clicked the shutter and then realized that I was completely out of air. There was nothing to do but to race back to the surface as quickly as I could. When I emerged, spluttering, Mike popped up beside me. "Why didn't you wait until *I* could get into the picture as well?" he grumbled. I had to explain that I'd no idea he was anywhere near me; nothing else but the shark had existed in my field of consciousness.

Much to my disappointment, he did not return for another photograph, and thereafter we met only a few shy three- and four-footers skulking on the rocks beneath us. The only other fish of note we encountered was a wary seventy-pound grouper which gave Rupert a fine game of hide-and-seek. It dodged in and out of rocks, judging with great accuracy the moment when he had to return to the surface for air. As soon as Rupert started his ascent, the grouper would pop out into the open; as soon as he was back

in gun range, it would disappear under a boulder. This could probably have gone on all day, but Rupert got tired first.

He obtained ample compensation a few minutes later. A splendid thirty-pound caranx, the finest game fish in Ceylon waters (Plate 7) very rashly swam up to have a look at him. I heard the "spang" of Rupert's spear gun from fifty feet away and turned in time to see the frantic fluttering of the fish's mirrorlike body as it scintillated in the water. At once it plunged to the sea bed, taking Rupert's spear with it and dragging out the whole of his line. It lay on the sandy bottom, obviously mortally wounded but still with plenty of fight. Rupert dived down to give it the *coup de grâce* and to make sure it was too firmly impaled on his spear to get away, but as soon as he gripped the fish it gave one last kick with its powerful tail and escaped from both Rupert and spear. Weaving drunkenly over the sea bed it staggered into deeper water, and lay gasping out its life on a patch of sand sixty feet down. The water was so fantastically clear that even from the surface I could see every detail of the fight; merely by lying beneath the waves, I could get a grandstand view.

Rupert's spear had been bent into a neat bow during the struggle, so he was unable to reload his gun. Since there was still a possibility that the caranx might get away—and the Reef-combers, like all good spearmen, hate to let wounded fish get loose again—Rodney dived down almost to the full depth of sixty feet and shot it with his gun at point-blank range. From my high-altitude eyrie, I saw him dwindle until he was a doll-like figure on the sea bed beside the gleaming fish; then the spear flashed out, the caranx gave one last twitch, and the fight was over.

A place like Rala Gala was bound to have a wreck, but it was a couple of hours before we found it. Nothing was left of the *King Lud* but a huge propeller with ten-foot blades, and an old-

fashioned anchor surrounded by a few twisted lumps of iron. The sea had done its job so thoroughly that one could swim right over the debris without noticing it; even the jungle cannot match the ocean in the speed with which it disguises the works of man.

When we returned to Gintota after five hours at sea (and only one of them spent in the boat) we had a good haul of fish as well as of photographs. A brisk auction sale quickly developed, and in a few minutes we had raised seventeen rupees, leaving us only three rupees out of pocket for the entire trip. I am afraid there is something about life in the East that makes one prone to haggling and bargaining even if it is not really necessary; certainly we were rather proud of the fact that this excursion had been almost self-supporting.

As far as I was concerned, that was enough diving for one day. But Rupert, Rodney and Mike were gluttons for punishment; no sooner had we got back to Weligama than they paddled out into the bay in the dinghy, determined to get more fish for supper. I relaxed on the verandah, thinking of the Three Men of Gotham Who Went to Sea in a Bowl, and watching the small black dot dwindle in the distance. Though they must have been half a mile away when they finally anchored, I could hear the shouts and curses of the hunters coming quite clearly across the still waters as they emerged, successfully or unsuccessfully, from the depths. And from time to time I could distinctly make out the slogan of our expedition, which had been adopted a few days before and had since been brought out on every suitable and unsuitable occasion. It was the heart-felt cry which had been wrenched from a Scots Reefcomber when he had received the bill in a certain hotel: "Two rrrupees! It's rrrobberrry! I'll no pay two rrrupees for that *miserrrable* piece of chicken!" The phrase "Two rrrupees!" had developed into a running gag and everyone within earshot had

grown accustomed to it, even if they had no idea how it had originated.

Apart from this distant and intermittent distraction, the evening quiet had stolen over the entire panorama of land and sea. Miles away, the steeply slanting sunlight was illuminating the palm-clad shores on the other side of the bay; nearer at hand, Taprobane and its companion islands were also beginning to glow with the curious luminosity that seems to transfigure all objects in the moments before sunset. The catamarans lined up along the beach in front of the Rest House, though not particularly beautiful in themselves, provided a fitting lower border for the picture; the outstretched branches of the bo tree completed the frame. The scene was so peaceful and so completely relaxing that I was able to enjoy it without the feeling—from which professional writers are seldom free—that I really ought to be working on something, it didn't matter what. For an hour or so I had escaped from the tyranny of the typewriter, and that was an achievement well worth the journey to Ceylon.

7

CASTLE DRACULA

OUR stay at Weligama lasted several days longer than we had
intended, as the Landrover developed a leak in the radiator system
and started doing only about a mile to the gallon—of water. There
were very much worse places where one could be stranded, and I
did not in the least mind the delay.

We sometimes wondered what the other guests thought of our
activities; doubtless any suspicions they may have had concerning
the sanity of Englishmen were now fully confirmed. But if so, they
were too polite to say anything about it, and only once was there
any sign that our presence was unwelcome. That was one evening
when we were waiting for the overworked staff of two to prepare
our dinner, and a most unprepossessing little man who was also
staying at the Rest House came into the dining room and started
to harangue the waiter. When he had finished, Rodney glared at
him and said, "I resent that—I understand Sinhalese." I have
seldom seen anyone so completely flabbergasted; when the other
had slunk silent and shamefaced out of the room, we asked
Rodney what he had been grumbling about. It seemed that he
had charged the waiter with serving us first because we had lighter
skins.

We resented this all the more because we had been working
hard to get a good tan. Rodney, in particular, is so dark that he
is often taken for a Sinhalese—even by the Sinhalese themselves—
with results that are sometimes useful and sometimes embarrassing.

Ceylon provided a good example of a country where people of many different colors live and work together in harmony, but that does not mean that it is free from color discrimination. In social and business life, it is probably true to say that it makes no difference whether one is jet black, pure white, or any shade in between. But when marriage is being considered, color rears its ugly head, and light skins are at a premium. This is a prejudice which has nothing to do with race, since it can appear even inside the family. One very dark Sinhalese once complained to me, half-seriously, that he was called a nigger by his brothers and sisters. . . .

After being in Ceylon for a few months, I found myself developing a distinct color prejudice—or perhaps it would be truer to say color preference. I first became aware of it when, walking through Colombo one day, I came across a group of leprous-looking creatures from whom I recoiled in horror before I realized that they were English tourists. They looked like something that had crept out from underneath a stone—at least, as far as their complexions were concerned, though otherwise they were quite presentable. I hurried past them with averted eyes, swearing that I would never let myself relapse into that hideous pallor when I returned to England.

Context is, perhaps, all important in this matter; just as a pale face looks out of place in the tropical jungle, so the various shades of ebony, tan and chocolate found in Ceylon might seem inappropriate on a rainy day on Fifth Avenue or what passes for a sunny one in Glasgow. But in their natural background of blue seas and green palm fronds, the dark skins of the Ceylonese peasants and fisher folk can be extremely attractive, and it is just too bad that the girls are kept so carefully out of the way. . . .

It was while we were based on Weligama that Rodney made his biggest catch of the trip. With Mike and Rupert he had been

out in the rubber dinghy to hunt around a partly exposed reef half a mile from shore. I had waited on land, attracting the usual crowd of curious villagers, and when the dinghy finally started coming back to the beach it seemed to me that it was making very slow progress and traveling in a most roundabout manner. The mystery was solved when the hunters got back to the beach, after hitting the shore several hundred yards from their starting point and having to wade through the shallows until they reached the eagerly waiting crowd of spectators. The dinghy was entirely occupied by a hundredweight of punctured parrot fish (Plate 9); the poor beast was still wriggling feebly, so it could not have been a very comfortable ride back for anyone.

The three hunters had met the great fish off Bellows Reef, a dangerous spot which had only been visited once before. The catamaran which had towed them out refused to go within a hundred yards of it, for every few minutes there would be a great roaring and a huge wave would rear itself out of the sea. So the dinghy was anchored, not without some trepidation, on the outskirts of this foaming caldron, and the divers went over the side.

Mike was immediately involved in excitement. He was Aqualunging along the sea bed when a three-hundred-pound grouper charged at him out of nowhere, breaking its rush only a yard away. As he had no weapon but a camera, Mike was forced to retreat slowly to the surface, where he found that his helpful companions had been laughing their heads off at his discomfiture.

A moment later a shark put on exactly the same act, coming to within a few feet before Mike scared it away with a stream of bubbles—a technique which does not always work with sharks, and never works with groupers. It was quite obvious that Bellows Reef was a busy place, and that the local inhabitants had no fear of man.

It was probably this fact which enabled Rodney to shoot the parrot fish. Normally they are extremely wary creatures and it is impossible to get anywhere near them. But this one came up to within six feet of Rodney, and then turned broadside-on to swim away—a foolish and indeed fatal move. Rodney shot it amidships and it promptly dived to the bottom in a cloud of bubbles, its air bladder having been penetrated.

Because one harpoon was not enough to make sure of so large a catch, Rodney wasted no time in racing back to the surface, borrowing Rupert's gun, and placing another spear through the parrot fish's gills. In a moribund condition, it retreated into a small cave, and then followed a hectic fifteen minutes while the hunters tried to get it out.

The cave was open at both ends, and a strong surge was sweeping through it in sympathy with the waves breaking over the reef. A hundred pounds of fish, two harpoons, and a tangle of wire occupied the little tunnel, and it was quite dangerous extricating catch and weapons. After a quarter of an hour of exhausting work, the parrot fish was pulled out of its retreat, and the spears were found to have been bent into interesting curves. There was another battle to get the—luckily still quiescent—beast into the dinghy; then followed the long and tortuous row back to shore, which I had observed with curiosity from the beach.

It was an impressive bag, though this specimen was by no means an outstandingly large member of its species. We had seen parrot fish weighing perhaps four hundred pounds off the Akurala Reef, but always in deep water so that it was impossible to get near them. And in the Red Sea, Commander Cousteau's team has run into fifteen-foot specimens which must weigh something like a ton, and would be altogether too much for our rubber dinghy.

After no small tussle, we managed to hang up the parrot fish so

that it could be photographed and measured. We had no tape or foot rule with us, but by one of those coincidences which would never happen in a well-constructed novel, a survey party appeared on the beach at that very moment complete with theodolites, chains, rods, poles, perches and the other tools of their trade. We were thus able to ascertain that the fish was 4 feet 6 inches long and 5 feet 7 inches around the thickest part of the body.

Rupert now had to drive back to Colombo, so we pushed the parrot fish into the back of his battered Vauxhall. (It had been a new car a year before, but a single season had made it age badly. The combined effects of sand, salt water, and carelessly-parked spears had turned it into a typical skin diver's car.)

We had promised to give some of our catch to the garage where the Landrover was being repaired, and one of the memorable sights of this trip was the proprietor's face when Mike whipped open the back of Rupert's car and said, "There's your fish!" Inside the Vauxhall the parrot fish looked much bigger than it had on the open beach; in fact, it was hard to see how there was any room for Rupert. Nevertheless he got it all the way back to Colombo and sold it in the local market, though the dealers, unimpressed by the fact that it was by far the biggest fish of its kind ever shot in Ceylon waters, gave him only twenty rupees for it. Even after several hours out of the water, it still weighed 103 pounds.

The battle had damaged Rodney's spear points, and he asked the garage owner (who had been recompensed by a more reason-ably-sized fish) to make him some new ones. This innocent request resulted, I was rather sorry to hear, in the dismissal of one of the garage mechanics. A good Buddhist, he refused to manufacture a weapon which would be used for taking life. It seemed a little hard that he should have to suffer for the courage of his convictions,

which appeared to be unusually strong. Buddhism is a tolerant religion, and those who make a living by fishing and hunting normally have no trouble with their consciences. They will refrain from their work on holy days, and feel that is a sufficient proof of their obedience to the Buddhist precepts. This, it seemed to me, was rather akin to a Christian modifying the Sixth Commandment to read: "Thou shalt not kill (on Sunday)."

It was just before dusk one evening that we paid a visit to the little island of Taprobane, as it lay at anchor off the beach of Weligama Bay. (See Plate 15.) The island, which is about a hundred yards across, rises steeply out of the water and is crowned by the rather fantastic house which the Count de Mauny built in the 1920's. Not much of the house is visible from the shore, as it is almost entirely concealed by palm trees and other foliage. The entire island, indeed, is one huge garden, which must have taken years of loving labor to create.

We were not going to Taprobane merely as sightseers; Rodney was carrying a .22 rifle, which caused the housekeeper to look at us in some alarm when we knocked on the gate, after wading almost waist-deep out from the beach to the island's now-ruined jetty. Taprobane's present owner (the American author Paul Bowles) was not home, and at the moment the place was sublet to two of the Reefcombers, who used it as a base for weekend diving.

The house would have delighted the heart of Charles Addams. Built in vaguely Oriental style, it consisted of one very high polygonal room from which various subsidiary chambers radiated. Everywhere there were signs of the count's artistic talents; he had made the furniture and painted the murals around the walls, designed the house and landscaped the entire island. But with his death the loving care needed to keep such a place in good condition

had no longer been available; broken windows had been boarded up, plaster was flaking away, and though the place was still perfectly livable there was a general air of neglect. (I hope Paul Bowles does not sue me for this.) One felt that it needed some bats to complete the picture; we did not have long to wait before they arrived.

As soon as darkness fell, the fruit bats took off from the bo tree on their nightly raid. We could see them circling over the Rest House in the fading evening light; squadrons peeled off in all directions, heading for the banana groves which the high command had chosen as target for tonight. The bo tree was a quarter of a mile away, and it seemed too much to hope that any of the beasts would fly over us. But Rodney had studied their habits, and stationed himself in readiness with the rifle.

Before long, the giant bats began to flap along the narrow channel between Taprobane and the mainland. "Crack!" went the rifle, and "Smack!" went the bullet into one of the airborne mammals. It faltered but flew on; a few seconds later, exactly the same thing happened again. "Let *me* try," said Mike, obviously sure that he could do better. For the next five minutes, he and Rodney alternated as anti-aircraft gunners, while I did my best to fill the role of radar predictor. The bats would appear out of the gathering gloom and there would be not more than four seconds in which to take aim and fire at a small object flapping along perhaps fifty feet overhead. Despite this, Mike and Rodney between them missed only once in a dozen rounds—but those bats could absorb as much punishment as a 1939 Wellington bomber. The bullets hit them all right, but the body was so tiny compared to the wide, leathery wings that no damage was done.

The squadron had almost passed when a lucky shot brought one of the creatures spiraling down into the sea. We caught the hideous

little beast as the current swept it under the jetty; it had a wing-span of nearly three feet and such vicious teeth that a single glance at them was enough to give one a most uncomfortable feeling in the region of the jugular vein.

As we left Taprobane and waded back to the beach, the island became a dark pyramid silhouetted against the night sky, with the light of a solitary lamp appearing and disappearing as invisible palm fronds momentarily eclipsed its rays. As I looked back I wished that I could have seen Taprobane in its heyday, when it must have been the equal of San Michele or any of the fabled villas of wealthy Mediterranean exiles. The count had made himself a unique and beautiful home, but it was swiftly following him into oblivion. If one wanted to draw a moral, one could say that it proved the vanity of worldly possessions. But moralizing is not profitable in Ceylon, which is not the least of the country's attractions.

I shall always remember Weligama as the place where I learned to wear a sarong, a garment which up to that date I had chiefly associated with Dorothy Lamour and had certainly never regarded as an article of male attire.

The sarong consists of a simple tube of cloth about four feet long and seven feet in circumference. It is therefore not a very good fit around the waist for a normal human being; when you stand up inside it, you are a couple of feet away from it in every direction. To keep it in place it is pulled tight, the surplus length is folded across the front of the body, and the end is tucked in at the left side. This operation takes half a second to perform, but as a rigorous topological description of the process would require several pages, anyone who has not got the idea by now will simply have to take it for granted that a sarong can be fooled into holding itself up.

However, unless the original loop is drawn very tightly round

69

the waist, and the overlap is correctly arranged, disaster quickly strikes. You may take perhaps two or three paces, and then you will feel a sudden lessening of tension round your midriff. The end of the tuck creeps slyly out, and before you know what has happened a kind of sartorial chain reaction has taken place. Unless you are quick on the grab, you will be unveiled like a statue in the park when the mayor pulls the cord after his speech of dedication.

It is advisable, therefore, to practice wearing the sarong in private until you have mastered it. After a while you will discover how to anticipate and prevent its imminent collapse by a kind of quick shimmy and a few dextrous twists of the wrist. When you have reached this stage, it is safe to venture outdoors.

Because of its simplicity, its comfort and the speed with which it can be put on and taken off, the sarong is ideal for housewear in tropical climates; once I had discovered it I never wore anything else. But out of doors it has disadvantages, which in my case I concede may have included the aesthetic. You cannot hurry in it, for apart from its natural instability (unless you cheat by wearing a belt, as in fact everyone does) it prevents the lower limbs from taking a full stride. So when the Ceylonese peasant is in a hurry, he has to hold up the hem of his sarong with one hand—an action which often looks unpleasantly effeminate. And when he wants to get into a fight, he has to tuck up the whole affair around his waist to give himself complete freedom of action.

The upper-class Ceylonese, and anyone who is anything in the city, even if he is only a post-office clerk, wears ordinary European dress. Since trousers are a perfectly ridiculous lower garment for tropical climates, a vast amount of discomfort is caused by this form of snobbery. Having no reputations to maintain, Mike and I could always wear shorts when we traveled around; the European

clothes we had brought with us we never wore once during our entire stay.

I fear we are both going to be very uncomfortable when we get back to the lands of the pin stripe and the gray-flannel suit. . . .

8

THE DINOSAUR HUNT

PAST Dondra Head, the absolute southern tip of Ceylon, the coast road runs east for another sixty miles before it deserts the sea and turns north toward the interior. When we left Weligama, we drove along this road until we came to the little fishing village of Tangalle, where we took over the Rest House with a smooth precision born of long practice.

We were now about as far from Colombo as we could reasonably get; beyond us to the east were hundreds of square miles of virtually uninhabited jungle. Little underwater explorations had been done along this coast, and it was Rodney's hope that we might meet both with good conditions and with fish that had not yet learned to run for their lives at the sight of men.

The Tangalle Rest House is a two-century-old Dutch building situated, as is usually the case, on high ground immediately over-looking the sea. At night, far out across the Indian Ocean, we could see the flashing of the lonely lighthouse that marks the Great Basses Reef and warns all shipping to keep clear of the empty southern coast of Ceylon. At one time we had hoped that we might get out to that reef, which is utterly virgin territory, but we would have had to ask too much of the weather and had decided not to risk the gamble.

As soon as we had settled in at Tangalle, Mike started to wake the place up with a little hot music. He had brought along a power-ful record player and a stack of discs a yard high; soon the efforts

of Stan Kenton, Dizzy Gillespie, Dave Brubeck, Frank Sinatra, Oscar Peterson, Buddy de Franco, and Charlie Ventura began to astonish the local inhabitants, who gathered in droves outside the Rest House to see what on earth was going on. Occasionally Mike would vary the fare with a little Wagner, Sibelius or Stravinksy, mixed up with recordings of Dylan Thomas and the sound track from *Julius Caesar*. I am sure that Tangalle is yet another place that will never forget the Clarke-Wilson Expedition, no matter how hard it tries.

The next morning we contacted the local fishermen and hired one of their boats on the usual terms. As soon as we got to sea, however, it was quite obvious that photography was out of the question—the water was much too dirty. This was no discouragement to Mike and Rodney, who promptly seized their guns and jumped in. Since I had nothing to do and would be much more comfortable in the water than in the catamaran, I decided to caddy for Mike.

We were operating around an almost-submerged reef over which the waves were breaking with considerable violence, and with each surge visibility would be reduced nearly to zero. Mike was using an inflated inner tube from which he proposed to hang his hypo- thetical catch; the Reefcombers find these patched rubber dough- nuts very useful when they go on long swims far out to sea, and may accumulate fifty or more pounds of fish. They can hang the fish from the inner tube and thus retain their freedom of move- ment; the odd-looking black object floating in the water seems to frighten the sharks, as they never steal the catch while the hunter's back is turned.

Before long I was sharing the inner tube with a large caranx which still had a little life in it, and which was so scratchy when I got too near its fins that I decided that the Reefcombers must have

73

much tougher skin than mine if they could carry even moribund
fish tied round their waists. Then I remembered that this was
nothing compared to the pachydermous conduct of one under-
water hunter who is reputed to bring home crayfish tucked inside
his swim trunks.

I followed Mike and Rodney around in the boiling surge over
the reef, occasionally losing the rubber tire and its increasing load
of fish, but always managing to retrieve it again. Having no gun
of my own, and being reduced to the menial role of porter, I soon
became bored; unless one is hunting, diving in water with poor
visibility is no fun at all. Eventually I changed my mind about
prefering the sea to the boat, and climbed back into the catamaran.

We now had a number of other fishing boats gathered round
us to see what we were doing, and when Mike decided that he too
had had enough he tried to thumb a lift on a very small catamaran
rowed by two little boys. By this time we were so accustomed to
the stability of these craft that we had become careless about
getting into them, and as Mike climbed aboard the minute vessel
he had hailed his weight proved too much for it. I heard yells and
was just in time to see an outrigger float wheeling gracefully
through the air as the boat turned completely over, emptying its
small occupants into the sea.

Before we could reach them, they had, with incredible speed and
dexterity, righted the catamaran again—a feat which I should have
considered almost as difficult as overturning it in the first place. I
thought it very sporting of them to invite Mike aboard once more,
when they had finished bailing out the hull. This time he managed
to avoid capsizing the boat, though we all waited hopefully to see
if there would be an encore.

The next morning we tried our luck further east, at the tiny
village of Hungama. To the distress of the hunters, it turned out

to be a Buddhist holy day, and the villagers would take us out to
sea only on condition that we left our guns behind. As the water
was now really dirty, this ruled out any kind of operations, so we
decided to stay ashore and organize a photographic safari after the
big monitor lizards which flourished in a coconut plantation not
far away. These prehistoric survivals are six or more feet long,
and we thought that with a little luck we might get some really
"Lost World" movie sequences.

Well draped with cameras, we tramped through undergrowth
and waded unsteadily along the slippery bed of a shallow river. At
one moment we would be in jungle, at another in well-cultivated
coconut groves. The usual small escort of unofficial guides kept us
company, and soon we were glad to unload our surplus equipment
onto the more reliable-looking members of our entourage.

There was no trouble in finding the monitors, but they did not
appreciate the honor we intended to do them. The big lizards in-
sisted on lurking under bushes half submerged in the water, and
we had to organize a barrage of stones to get them out into the
open, being careful merely to frighten but not to hit the fearsome-
looking though perfectly harmless monsters.

The monitors are not only harmless, but also so useful that they
are protected by law. They eat carrion and the land crabs which
would otherwise riddle and ruin the bunds (dikes) of the paddy
fields, and they help to keep the crocodile population under con-
trol by their fondness for the reptiles' eggs. Poultry farmers, how-
ever, regard them with disfavor, as they are equally fond of hens'
eggs—not to mention chickens.

Eventually one of the dragons, hissing like a steam engine,
broke from shelter and galloped angrily in a kind of high-speed
waddle to the nearest river, where it was safe from its tormentors.

We shot all the pictures we could as the lizard broke from cover, then began our struggle back through jungle and swamp. We had got back to the road and were repacking our equipment in the car when one of our volunteer guides caught up with us, carrying a little item we had absentmindedly left behind. As he restored our best Leica to us, we decided that there were some honest people in this part of the world.

There were also some very friendly ones, so Rodney told us. He had made such a hit with the local squirearchy that he had been pressed to remain as a permanent resident, being offered a house with all the necessary home comforts (and I mean all). Presumably the villagers wanted to import a little culture and sophistication from the big city, but though Rodney was flattered he decided that life in a gilded cage would eventually pall.

We were also beginning to yearn for the city, for we had been on the move for ten days, and were getting very tired of an exclusive diet of Rest House meals. Since the underwater visibility appeared to rule out any serious work, we decided that we would hurry back to our Colombo flat, where at least we could do nothing in comfort.

The little villages along the coast road flashed past once more as we began our homeward journey. Every few miles there would be a vista of palms, sea and sky which once would have left us breathless, but which we now regarded as almost commonplace. We were more interested in such piquant cameos as a cyclist pedaling to market with a fair-sized shark slung behind him (Plate 5). It seemed an ignominious end for a tiger of the sea.

We stopped for lunch at the small town of Galle (pronounced "Gaul"), Ceylon's only natural harbor on the west coast. Galle is a lively little place that has been by-passed by history. Like Matara,

it is dominated by a fine Dutch fort, and for many centuries was one of the most important nodal points of the sea-borne traffic of the East. Indeed, there is good evidence that Galle was the Tarshish of the Old Testament, and may have provisioned Solomon's ships in their quest for gold and ivory. Through the little port of Galle, perhaps, the wealth of lost Ophir may once have flowed.

This is a thought which raises interesting speculations. Galle is a difficult harbor for ships to approach during certain conditions of wind, as it is guarded by dangerous coral reefs. During the port's thousands of years of maritime history, countless ships must have struck rocks and sunk almost within sight of Galle; we know of five within the last century. Perhaps much of Solomon's treasure still lies at comfortable lung-diving depth in these waters.

There is no doubt of the existence of one valuable wreck. On February 28, 1860, the steamer *Malabar* went down off Galle with $650,000 worth of bullion aboard. According to Lieutenant Harry Rieseberg, the well-known treasure hunter and octopus fancier, only $150,000 has been salvaged from her. Since Mike and I have a fondness for nice round numbers, one of these days we may have a look for the remaining half million.

There was one fantastic and awe-inspiring moment, at the end of the last century, when it would have been easy to locate the *Malabar* and all the other wrecks lying off Galle. It was a moment unique in recorded history, and one which will probably never come again. I would have given anything to have been present then with a camera, but would probably have been too terrified to use it.

One August day in 1883 the water suddenly started to drain out of Galle harbor. Within a few minutes, the sea bed was exposed for hundreds of feet from shore. Myriads of fish were flopping around in their death agonies, and many wrecks, from small fish-

ing boats to large iron steamers, were miraculously uncovered by the water that had concealed them for years.

But the inhabitants of Galle did not stop to stare and wonder. They knew what to expect, and rushed to high ground as quickly as they could. Fortunately for the town and its people, the sea did not return in the usual tidal wave; perhaps because Galle was on the far, sheltered side of the island, it came back smoothly and without violence, like a swiftly incoming tide.

It was many days before the people of Galle learned why the sea had so suddenly deserted their harbor, when they heard for the first time the doom-laden name of Krakatoa.

Galle ceased to be of major importance as a port when the far superior but purely artificial harbor of Colombo was built by the British during the last decades of the nineteenth century. Now the traffic of the east passes it by, and from the walls of the old Dutch fort the great liners and merchantmen of today can be seen far out on the horizon as they prepare to round the southern tip of Ceylon.

On the road back to Colombo, we slowed down once to observe an entertaining spectacle. The villagers around Galle have an unusual method of fishing in rough water; they erect poles in the surf and cling uncomfortably to these while they angle with rod and line and the waves break all around them. It looks a most precarious way of earning a living, but the sight of these lonely black figures clutching their frail supports amid foam and spray is an irresistible one to photographers. So our friends from *Life* had found; they had rounded up most of the local population, and the sea was practically hidden by the scores of stilt fishers pretending to practice their craft for the benefit of the cameras. It was probably the most profitable day's work they had done for a long time.

We were tempted to get a free ride on *Life*'s expense account by

photographing the spectacle, but decided that we did not care for such mass-production methods. It seemed more effective to take a picture of at most a couple of fishermen against the vast and lonely sea, and this is what we did later without its costing us a cent.

9

HOW NOT TO TAKE
UNDERWATER PHOTOGRAPHS

Our first visit to the wreck of the *Conch,* on Akurala Reef, has already been described in Chapter 5. Since we knew its location, and it was fairly accessible—as well as lying in reasonably clear water—we decided to concentrate on it until we had obtained some good photographs. In an hour's steady work, with all the cameras operating, we should be able to get everything we needed. So we calculated; but what happened was slightly different.

In the Giles fish hearse we left Colombo at the fantastic hour of 5 A.M., stopping on the way to collect George Sandham, another Reefcomber who was to figure prominently in our adventures and also in our photographs. (For an excellent likeness of George, see Plate VII.) When we reached Akurala it was still only eight o'clock and I was just beginning to wake up. Deciding to economize, we hired only one catamaran, Mike and Rupert paddling the rubber dinghy while we carried the heavy equipment in the boat.

Rubber dinghies are not built for speed, but Mike and Rupert got to the wreck first and dropped their anchor on it. The water was quite clear, but we were so early that the sun had not risen high enough to give the best illumination. Moreover, a fearsome new compressed-air gun had just been sent to us for test by the

Spanish manufacturers, and Mike's trigger finger was itching. So we made a regrettable decision; we would hunt for an hour or so, and do the photography later.

Leaving the dinghy anchored by the wreck, we moved farther out to sea to begin our operations, hoping—perhaps optimistically —that if we did our shooting somewhere else the fish around the *Conch* would continue to regard us as friends, or at any rate as harmless. Not having a gun, I followed the hunters with my Leica, but had to give up after half an hour for an unusual reason. My eyes were paining me badly; being one of those unfortunate people who cannot see without spectacles, I use contact lenses when diving, and this morning I must have scratched an eyeball while inserting one of them. There was no alternative but to surface and take the things out. (The lenses, not the eyeballs.)

I did not feel like doing this while perched unsteadily on the upended planks of the catamaran; it would be the easiest thing in the world to drop one of the fingernail-sized wafers of plastic overboard, a disaster which would terminate my effective diving career. I decided to swim back to the dinghy, where there was room to operate comfortably.

There I lay in a blurred mist for the next half hour, comfortably wrapped around a couple of Aqualungs, while the shouts of the hunters grew fainter and fainter into the distance until at last I could easily believe that I was utterly alone on the sea. The fact that my radius of clear vision was about two feet added to the illusion, and in these circumstances it was slightly disconcerting to hear the air from the rubber dinghy slowly whistling out through the valve a few inches from my ear. I knew that if I did something to it I could reinflate the dinghy with my mouth, but I was afraid that if I pulled the wrong plug the entire contraption might

81

collapse. So I did nothing, and fortunately we remained afloat.

This time, however, I was not in the least worried about seasickness. The water was calm, and the dinghy was anchored to the bottom, so there were no buckings and heavings to discommode me. I waited, perfectly content, until my eyes had returned to normal; then I reinserted my contact lenses and slipped over the side to do a private reconnaissance of the *Conch* and to study a few camera angles before the others returned.

It was not, perhaps, a very wise thing to do—diving over a large wreck, in the open sea, with nobody else within half a mile. And if I had known what was in that wreck, I should certainly not have gone cheerfully swimming around it by myself. However, this patch of sea bed, with the overturned hull lying on it, seemed friendly and familiar, and I had little hesitation in dropping down to have a look at it.

I at once discovered that there was an extremely powerful current that made it hard work even to stay still in the water, let alone go "upstream." The line securing the dinghy to the anchor was taut as a steel bar, and sloped up from the sea bed at something like forty-five degrees. Without my flippers, I should have been swept away in a moment; even with them I had to plan my dives with care unless I wanted to waste a lot of energy.

The highest part of the wreck—the barnacled hull—was just thirty feet below the surface, and when I allowed myself to sink past that I could catch a glimpse of the ship's interior, for she had split in two at the point where I was anchored. To conserve my breath and energy, I would go hand over hand down the taut anchor line, pausing when necessary to allow my eardrums to "click." Even so I could not stay at the wreck for more than a few seconds, and it was hard to do any systematic exploration be-

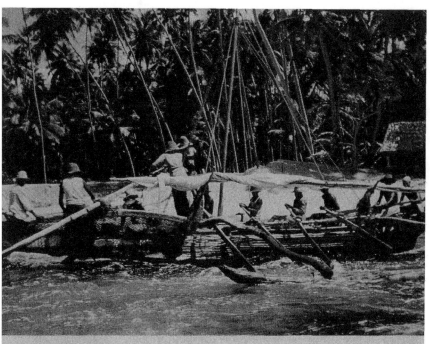

I. The fishermen bring their catamaran across the reef.

II. The expedition and its equipment at Matara. Left to right, the author, Mike Wilson, Rodney Jonklaas.

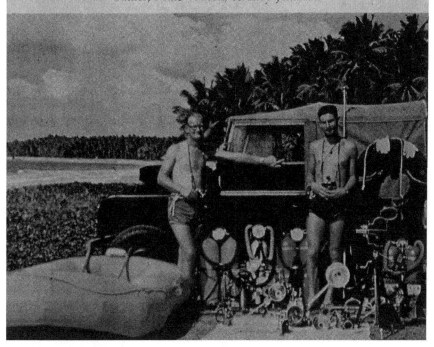

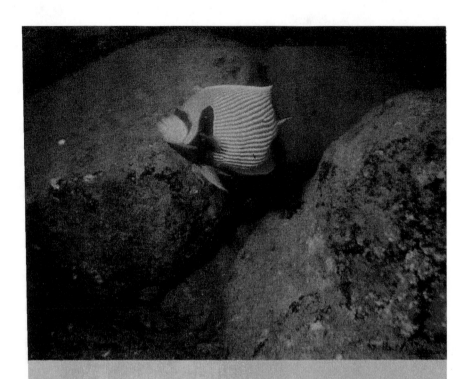

III. and IV. Imperial Angelfish (above) and Ringed Angelfish (below)
—perhaps the most beautiful creatures of the sea.

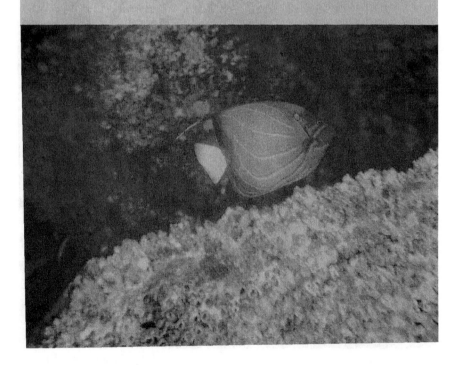

V. The inhabitants of a coral grotto are revealed by the flash bulb.

VI. Invitation to divers: the gaping hatches of the sunken dock.

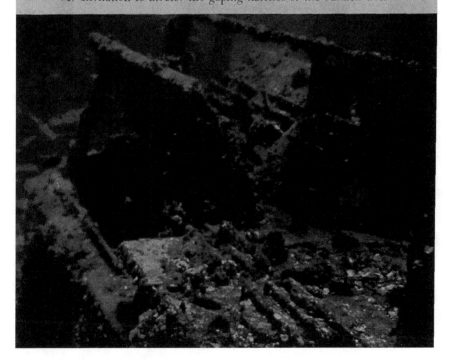

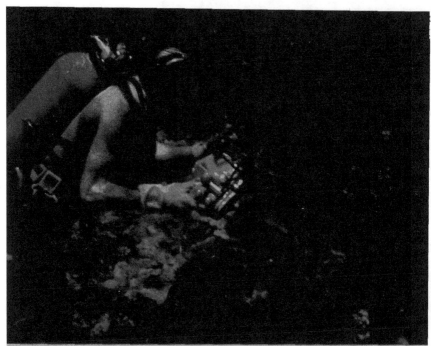

VII. George Sandham beside the overgrown wreckage of the *Conch*.

VIII. and IX. The camouflage expert. Left, a cuttlefish hanging motionless above a patch of sand. Right, the same cuttlefish a few moments later, poised over a clump of stagshorn coral.

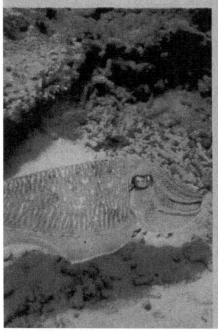

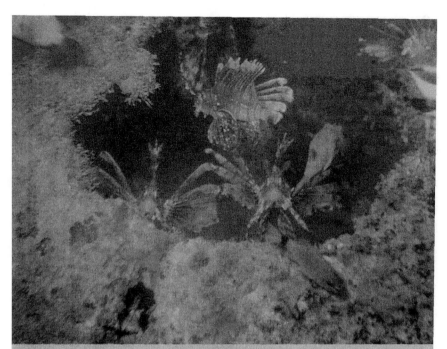

X. The inquisitive scorpion fish goggle at the photographer.

XI. Rupert Giles hunting for crayfish.

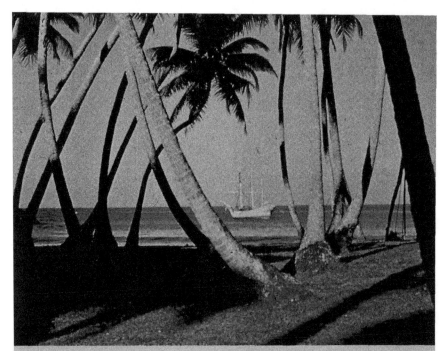

XII. A schooner from the Maldives rides offshore.

XIII. Mike explores the Silavatturai Reef.

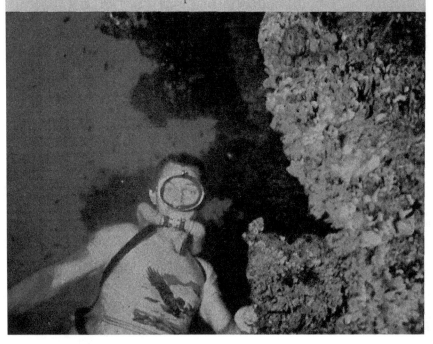

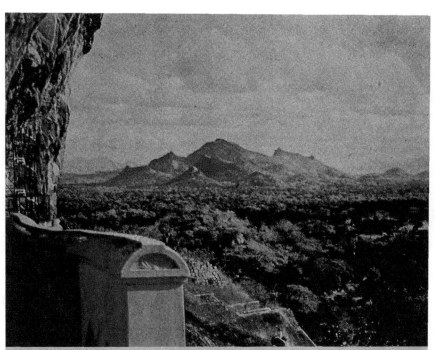

XIV. The gallery at Sigiriya, two hundred feet above the plain.
The spiral stairway leads to the frescoes.

XV. The ladies of Sigiriya.

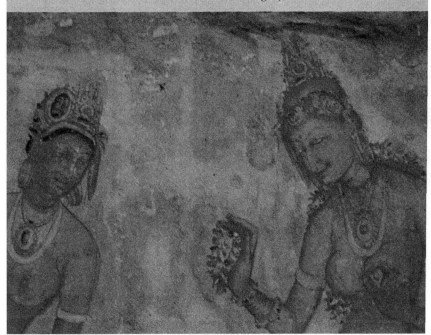

XVI. Worshipers gather on the summit of Swamy Rock, where one of the temple pillars still stands.

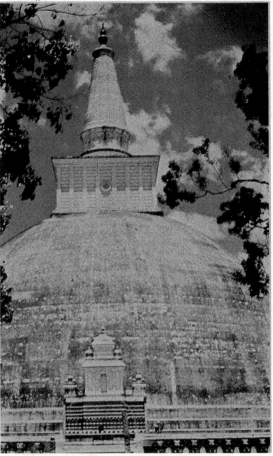

XVII. The two-thousand-year-old dagoba at Anuradhapura.

cause of the terrific current. Whichever way I set out, I would quickly find myself yards downstream and would have to battle to get back to the dinghy.

Eventually the distant hunters decided that they had had enough shooting for one day, and the catamaran started to row its leisurely way toward me. I abandoned the dinghy and swam to meet the boat, something which I had no hesitation in doing as it involved going across the current, not against it. I had no sooner reached the catamaran and climbed aboard when somebody shouted, "The dinghy's adrift!" and we saw to our consternation that it was heading rapidly away from us down the current. The strain must have parted the anchor line; it was only by the greatest good fortune that this had happened now and not an hour or so earlier. In that event, I and the equipment with me would have been speeding southward to some unknown destination along the coast—if we did not carry on past Dondra Head to Antarctica.

We had no difficulty in catching up with our wandering property—the current did most of the work for us. But by the time we had made the dinghy secure to the catamaran, we were hundreds of yards away from the wreck and were no longer certain of its position. We started paddling back upstream, without a great deal of help from the four rowers we had hired with the boat. They included an old man and a boy, and their combined output was hardly enough to overcome the current, let alone make headway against it.

George and I paddled furiously in the dinghy, but we seemed to be getting nowhere. Rupert and Mike swam along beside us, clinging to the float of the catamaran and occasionally diving down to see if they could get their bearings in the submarine territory above which we were so painfully crawling.

Then some exhausted optimist (no one would own up to it

afterward) said hopefully: "We're over the wreck now," and without bothering to see if this was true Mike grabbed a twin-tank Aqualung so that he could go down and locate the lost anchor. A twin-tank unit is heavy, and the best way of putting it on is to have it thrown in the water beside you, where it will weigh nothing and you can climb into the harness without assistance from anyone else. But this takes time (and sometimes acrobatics, for the floating straps can get themselves into tangles which one would have thought theoretically impossible). By the time that Mike had got his unit working, he was a hundred yards downstream and we had to go almost back to our starting point to rescue him. This was particularly exasperating to Rupert, who really had found the wreck but could do nothing about it since we had deserted him.

For the second time, we started off upstream. If our progress had been slow before, it was now imperceptible. The four fishermen seemed to have lost both interest and energy, assuming that they had ever possessed either, and as none of us spoke Sinhalese we found it impossible to make them speed up their leisurely strokes. The dinghy which we were paddling was half waterlogged, and its hydrodynamics were not improved by a couple of Aqualungs hanging below it like sea anchors.

Before long I found that each paddle stroke was requiring a concentrated effort of will. My arms were numb with fatigue; they were not merely aching—they were simply no longer under my control. Even now, as I recall my sensations, I find that my typing is going more and more slowly in sympathy and the keys appear to have acquired enormous inertia.

Rupert, who was still marking time over the wreck, kept shouting encouragement. We had got to within a bare thirty feet of him when I decided that even if my life depended on it I couldn't paddle another stroke. With my defection, George could no longer

make even our present minimal progress, and the rowers in the catamaran were only too happy to follow my example. We began to drift briskly downstream again. . . .

And so, on a bright sunny day, in clear water, with our cameras full of film and our Aqualungs full of air, and a most photogenic wreck only thirty feet away, we abandoned the project which we had driven fifty miles and got up at five in the morning to achieve. Perhaps it is just as well that we were too exhausted to lose our tempers; otherwise with all this underwater artillery around there is no knowing what might have happened.

When we were again on speaking terms with each other, Rupert recounted the Curious Incident of the Shark in the Surf. ("But the shark did nothing in the surf, Holmes." "*That* is the curious incident.") Rupert had been swimming through rough water, on the lookout for game fish, when a sudden and a quite inexplicable impulse made him glance back. Dogging his footsteps, and creeping slowly up on him second by second, was a handsome nine-foot shark. How long it had been there Rupert had no idea. *Why* he had looked back when he did was also a mystery. And what the shark might have done had Rupert remained unaware of its presence is an interesting subject for speculation. As soon as he made threatening gestures with his gun, it departed at high speed.

This trip to the *Conch,* totally unsuccessful though it was, only made us more determined to photograph the wreck at the next opportunity. So the following weekend we packed our equipment and started down the coast again. This time we did *not* leave Colombo at 5 A.M., and we had agreed in advance that no spear fishing would be allowed to interfere with the serious business of photography.

It seems to be a rule in the underwater business that missed opportunities never recur. Last time the water was crystal clear,

perhaps because it was moving so rapidly. This time, there was no current—but visibility was only twenty feet. Bitterly disappointed, we decided that we would at least go through the gestures of underwater photography in the hope that the water might slowly clear.

We transferred all our equipment to the rubber dinghy; this time we had brought a chain instead of a rope to anchor us, so that there was no danger of going adrift. Until now, all my diving in Ceylon had been without the aid of breathing gear, but as we now intended to make a thorough examination of the wreck, Aqualungs had to be worn. Treading water, I fastened up the harness, put the breathing tube in my mouth, and hung the camera round my neck. When no air came I quickly realized that, as usual, I had got the last two items on in the wrong order, so that the weight of the camera was constricting the rubber breathing tubes. Having sorted this out, I followed Mike and Rupert down to the wreck, which did not become visible until I was within twenty feet of it. On the previous trip, we had been able to see it from the surface.

We formed a little group near the anchor, which was lying close to the point where the *Conch* had been snapped in two. A cross-section of the ship reared up beside us, the corroded steel wall of a bulkhead preventing us from going into the hull at this point unless we wormed our way through a hole which hardly looked big enough to admit a man with an Aqualung on his back.

While Mike was getting into position to take some Rollei shots, I made a close examination of this intriguing cavity. Underwater caves and holes have an irresistible attraction; they almost always contain *something*. And this was a giant steel cave—practically a submerged house—into which I was peering.

At first I could see nothing at all. The only light that reached the interior had to leak through the hole which I was partly block-

ing, and I might have been staring into a cellar at midnight. But presently my eyes adapted themselves to the gloom, and I could catch a glimpse of weed-festooned girders suspended in space above me.

There was also something else, so inexplicable that I stared at it with rising curiosity for several seconds, quite unable to decide what it was. A pale white band appeared to be floating a couple of feet from my eyes, almost spanning the width of the hole through which I was peering.

I pushed my head in a little closer to have a better look and to shield my eyes from the external light. Then, in a sudden explosion of sheer disbelief, I realized that the enigmatic white band stretched only a yard from my eyes was nothing less than a tightly pursed pair of lips.

They did not remain pursed. The giant grouper—we should have guessed that such a wreck would contain one—gave a prodigious gulp and I could almost imagine myself being sucked through the broken bulkhead. Back-pedaling rapidly (quite an achievement with flippers, incidentally) I went to collect Mike and Rupert. They were busy photographing some inoffensive piece of coral and didn't want to be disturbed. Eventually they swam in a leisurely manner across the scrap-iron-littered sea bed to find out what all the fuss was about, and I had the great satisfaction of watching their reactions when they looked into the hole.

For the next five minutes we played peekaboo with the huge fish, sticking our cameras (but not our heads) through the yawning cavity in an attempt to get a good flash shot of the occupant. Though he continued to make unfriendly gestures—opening his mouth wide enough to swallow us up to the shoulders should he feel inclined—he did not seem particularly aggressive, and backed

87

away into the wreck when the flash bulbs started to go off. Unfortunately all this activity stirred up the sediment from the bottom, and before long visibility had been so reduced that photography was out of the question. Flash pictures are very sensitive to dirty water conditions, since each floating particle acts as a scattering center for the flash and the result is a dull, muddy blur often covered with inexplicable spots of light. I think I can claim a record for the number of flying saucers I have photographed underwater. . . .

We left the ogre in his cave, determined to visit him again when we had the opportunity—and perhaps to try to make friends with him by the time-honored technique of offering other fish as bribes. Whether we will come as peaceful photographers or deceitful hunters, we have not yet decided.

Since the *Conch* appeared to have snapped clean in two, the remainder of her could not be far away and we set out to locate the missing portion of the ship. Swimming slowly along the line of broken debris and twisted girders, we found ourselves descending over the edge of a small cliff, and in a short time the reading on our depth gauges had increased from forty to seventy feet. It was here, on a sandy bottom, that we found the rest of the *Conch*. She was a weird sight, for all her deck plating had been ripped away and only the massive metalwork of her engines remained, looming out of the mist like the strange yet hauntingly familiar shapes in a surrealist painting. Her screws were half buried in the sand (more valuable bronze if we could ever think of a way of getting it up . . .) and the coral-encrusted steps of a companionway led out of the sea bed up to nowhere in particular.

Mike took some shots of Rupert and me peering coyly through interesting metal frameworks, and he was in the process of com-

posing another *avant-garde* study when he suddenly left us and started to shoot straight up to the surface. He had obviously run out of air, and as he was carrying our most valuable camera we decided that we had better go after him to see that it was safe.

Though careful and experienced divers don't do this sort of thing (or refrain from talking about it if they do) running out of air seventy feet down is not as serious or shattering an experience as might be imagined. All you have to do is to start coming up, when the reduced pressure around you will allow more air to pass through the regulator so that you can get at least one more breath. And that is plenty, since you are full of compressed air yourself and will be more busy breathing *out* than in during the ascent—unless you are particularly anxious to burst your lungs.

Though the photographic results of the trip had been disappointing, we all felt that it had been an interesting and eventful dive, and were in high spirits by the time we got back to the beach and the inevitable crowd of onlookers, fish merchants, and youngsters wanting to try out their English. I was standing guard over our imposing mountain of equipment when I suddenly noticed something that gave me a far worse shock than the close-up of the giant grouper, perhaps because the impact was in the general region of my checkbook. One of the Leica cases was half full of water; the poor IIIa—the first camera I had ever owned, and still my favorite —had been completely drowned.

The case must have flooded during the deepest part of my dive, and as I had not used the camera I had never noticed the mishap. We had used these cases on hundreds of dives in Australia and Ceylon without the slightest trouble, and perhaps I had grown a little careless—a little too certain that no water would ever get past the seals even when there was a couple of atmospheres' pressure outside. Perhaps I had also neglected to tighten the four thumb-

screws sufficiently—though I am fairly certain that this was not the case.

Whatever the explanation, it was heartbreaking to see my pet Leica swishing around in a pint of salt water. I opened the case at once, unloaded the camera (color film looks very bedraggled after it has been soaked in the sea), removed the take-up spool and unscrewed the lens. That was all I could do without getting to work with a screwdriver; I then washed out the camera several times with fresh water, and finally left it completely submerged to reduce the chance of oxidation. As soon as we got back to Colombo, I added a wetting agent (probably any detergent would have done) to the water in which the camera was soaking.

The shutter, surprisingly enough, still seemed to be working perfectly—though I have since been told that I should not have tried to operate it. It was too late to get the camera in for repairs that night, so it remained in its bucket of water until the next morning; it was thus in sea water for about one hour, and in fresh water for almost twenty.

A week later it was back in operation, looking as good as new. It was true that the slow speeds were a little rheumatic and it had lost that lovely oiled-silk feeling, but I believe that when it has had enough exercise no one will be able to tell that it ever went for a swim.

I have described this incident in such detail not because I expect Messrs. Leitz to give me a new camera (though that is an excellent idea) but because by the laws of probability quite a number of people who read these words will, sooner or later, find themselves looking glumly at a very wet camera. So I would like them to realize that there is no need for despair, if they take the proper action. The main thing is not to let the camera remain in simultaneous contact with air and salt water—an absolutely fatal combination.

Once submerged in *fresh* water (distilled would be even better) little further damage can occur.

Of course, if it happens to be a rather old camera, and it is fully insured under a really comprehensive policy—well, that might be a good argument for letting nature take its course.

10

THE WRECK OF THE HARDINGHAM

By this time, our appetite for wrecks was insatiable. Mike spent many hours in the Shipping Master's office, going through the lists of vessels known to have come to grief in the waters round Ceylon. One of the most recent—and most promising—wrecks appeared to be that of the British armed merchantman *Hardingham,* which came to a spectacular end on April 5, 1945.

The *Hardingham* had been unloading ammunition in Colombo harbor when she caught fire, and all attempts to extinguish the blaze proved futile. Since if she blew up she would take most of the town with her, there was nothing to do but to tow her out to sea. This nervewracking task was successfully accomplished, and the ship was set adrift with her tiller lashed.

A few hours later she exploded in a mighty column of flame and debris, and sank swiftly a mile and a half out from the harbor. Her resting place is now marked by a green buoy, for though she lies in seventy feet of water her superstructure is a possible hazard to shipping.

Before we could do anything about the *Hardingham,* however, we had to steal or borrow a boat. "I'll fix that," said Jo Ebert, and took us round to see Mr. Chandrasoma, the Port Commissioner and Principal Collector of Customs. As Mr. Chandrasoma was yet another photographic enthusiast, in no time at all it had been arranged for the pilot-boat to take us out to the wreck.

Unfortunately, I was completely out of action with a poisoned

foot, having picked up an infection during a trip down the coast a few days earlier. I could not even walk, still less put on a pair of flippers, so I had to wave good-by to Mike and wait for his report when he got back.

The sea was a flat, oily calm when the pilot boat left the harbor, and there was only a trace of wind. On arriving at the buoy marking the position of the wreck, Mike and Rupert Giles found themselves confronted by several boatloads of unfriendly fishermen, who informed them that the water here was more than two hundred feet deep. It also looked very dirty; even if the wreck were not as far down as the fishermen were maintaining, it seemed that photography would be out of the question.

Mike took a sounding with a nylon line he had brought along, and discovered that the bottom was a reasonable seventy feet down. When the fishermen had been convinced that no dynamiting was intended, and that no one was going to scare away the fish, they became less hostile but still far from co-operative. Asked if they knew exactly where the wreck lay, they waved their arms vaguely around the horizon. Mike and Rupert decided that there was only one way to find out; they put on their fins and masks and dived overboard.

The water was filthy—but twenty feet down, to Mike's surprise and delight, it suddenly became clear. Dim outlines appeared in the gloom—a three-inch gun, winches, and all the tangled debris left by the explosion and a decade in tropical waters. The wreck was too deep to explore by skin diving, so once they had located its position accurately Rupert and Mike wasted no time in returning to the launch and putting on their Aqualungs.

Carrying still and movie cameras, they sank down through the gloom until they reached the slanting deck of the dead ship. Now they could take their time and examine it properly, without the

need to rush back to the surface for air almost as soon as they had arrived.

Fish were everywhere, in all shapes and sizes from small groupers to shoals of three-foot barracuda. A large caranx swam up to look at the interlopers, but they were too busy filming to bother about this fine game fish. Rupert manned the three-inch gun while Mike took movies of him; when they had grown tired of this amusement, they went to look at the bows of the ship, passing the gaping hold on the way. It was so black and forbidding that neither diver made any move to enter.

They had been exploring for a little while when they realized that what they had found was less than half the ship. The bows had broken clean off; the rest of the vessel must—as in the case of the *Conch*—lie somewhere further down, in still deeper and gloomier water. They looked at each other, each considering the same thought. Should they hunt for the remainder of the ship? Mike stared at Rupert, who tried to smile round his mouthpiece and then shook his head slowly from side to side. That settled it; in any event, there was plenty to see and explore on this fragment of the ship.

The rollers of the Indian Ocean had been moving for a thousand miles before reaching the relatively shallow water in which the *Hardingham* lay, and consequently there was a considerable surge across the wreck. Several times the divers were swept off the deck and over the taffrail, so that glancing down they could see the side of the ship disappearing in the gloom. There was one minor mystery which they came across: the anchor chain had been let down, though there had been no one on the ship to release it when she came to her final resting place. Presumably the explosion had accidentally performed this last rite.

Rupert was carrying a bag of flash bulbs which were doing their

best to balloon him up to the surface, and was having trouble staying down. To help him out of his difficulties, Mike stripped off his own weight belt and handed it over, then went on a short tour with the movie camera. He swam across the deck, over the rail; and down the side of the ship. Rounding the prow, he was somewhat disconcerted to find himself only five yards away from a ten-foot-long giant grouper, which was floating in a most peculiar attitude. It was literally standing on its tail, with its huge, bulldog head looking straight up. Mike followed the direction of its gaze—and nearly choked on his breathing tube.

Rupert, now considerably overweight and still trying to cope with lead belt and flash bulbs, had been swept off the deck by the surge and was sinking straight toward the gaping mouth below. Mike was so stunned by the sight that it was a moment before he could do anything. Then he emitted his best underwater yell, which fortunately Rupert was able to hear above the noise of his own Aqualung regulator. At Mike's frantic gestures he started to look around him—in every direction except the one that mattered. As Mike grew more and more desperate, Rupert became more and more puzzled; he was only five feet away from the huge mouth with the small parasites feeding among its teeth when he finally remembered that there was such a direction as "down."

Rupert's fins disappeared in a blur of motion; with a take-off that would have done credit to a rocket he shot up the side of the ship and over the rail, where Mike joined him. The grouper, probably scared by this merger of forces, gave a flick of its tail and vanished into the depths while Mike and Rupert breathed bubbly sighs of relief. They could not help thinking that the groupers seemed to be getting bigger with each successive wreck, and wondered what the next one would bring.

Rupert was now running out of air, and visibility was becoming

poor, so the explorers decided to call it a day. They floated slowly up to the launch, and stripped off their Aqualungs while still treading water. While they were doing this, there was a sudden commotion a few feet away, and a rather large shark slashed through the water to snap up one of the spent flash bulbs bobbing on the waves. The effect of this upon the reporters who had come out to describe the dive was considerable, and it was not surprising that Mike got most of the *Ceylon Observer's* middle page the next day.

Our period of operations around Colombo was now coming to an end. There were two reasons for this; the weather—which had been superb—could not be expected to hold much longer; and we were planning to go north in a few days to watch the pearl divers working in the Gulf of Manaar, the narrow channel between Ceylon and India. We would have no time to go looking at any more wrecks—unless some skipper was obliging enough to give us a brand-new one right on our doorstep.

Which was precisely what happened.

11

THE AENOS GOES AGROUND

ON THE night of March 5, 1956, the Greek freighter *Aenos*, with six thousand tons of manganese ore aboard, was proceeding along the coast north of Galle when she struck the Rala Gala Reef. The captain tried to beach her, but ran onto another reef four hundred yards from the shore where she stuck hard and fast. Though their own lifeboats were overturned, the crew were rescued without any casualties by the local fishermen—who as soon as they had carried out this errand of mercy, started gleefully looting the ship.

The *Aenos* was entirely submerged apart from the bridge and the boat deck, so the looters had a rather restricted field of operations. Nevertheless they did their best, and within a couple of days had removed every portable item from the wreck and were starting to work with hacksaws on any promising pieces of metal they thought they could carry away.

Five days after she had gone down, we mounted our own assault on the *Aenos*. I was still immobile with my poisoned foot, so the reconnaissance party consisted of Mike, Rodney Jonklaas, George Sandham, Rupert Giles and his wife Isabel. When they arrived aboard the wreck, they found that the clearance sale was still in progress, and were looked on with rather a jaundiced eye by the local fishermen, who (not inaccurately) regarded them as potential rivals.

The wreck was perfect from the diving point of view—except for two minor items. Since she lay near the mouth of the Gintota

River, the water was not very clear; more serious, the monsoon winds were daily getting stronger. The heavy swell sweeping across the deck made swimming very dangerous, and huge waves were already starting to break the ship up.

Despite this, the divers decided to risk it, and very soon the still-exposed boat beck was covered with flippers, weight belts and Aqua-lungs (Plate 38). Because of the danger (it was quite disconcerting, Mike reports, to hear rivets popping in all directions, but after a while one got used to it) it was decided not to use lungs at first but to carry out a survey by simple skin diving. A man with a lung on his back is at a grave disadvantage in rough water or confined surroundings, where an unhampered diver may be perfectly at ease.

After battling with the waves, the four explorers managed to arrive at the stern, after Rodney and Rupert had been swept right over the rail by the swell and had fought their way back to the submerged deck. The holds yawned dark and empty, and even above the roar of the surf the slamming of steel doors down inside the ship could be heard. Diving down through one of the hatches, Mike and Rodney came across a line of lavatories, and Mike was unable to resist a joke that might have been his last. He swam into one of these now very watery closets and ensconced himself on the seat, to Rodney's vast amusement. A second later there was a sudden painful increase in pressure—and the door slammed shut on him, leaving him trapped in complete darkness. It took some pushing and pulling on both sides of the door before Mike could be released, rather short of air and not feeling like any more jokes for a while.

After a brief conference on the boat deck, plans were then made for a dive with Aqualungs into the interior of the ship. Wearing a twin-tank unit, Mike climbed through the exposed engine-room

skylight and braced himself against the surge. There were two doors leading into the engine room, and they opened out into a passageway which in turn led straight to the sea. Every time a wave hit the ship, it would rush through this passage with irresistible force, bang the engine-room door, and sweep away any unwary Aqualunger it encountered.

Bracing himself against this surge, Mike fitted the breathing tube of the Aqualung into his mouth and began to haul himself down the iron companionway. Rodney joined him a minute later and together they began their tour of the completely submerged engine room.

The light filtering down through the cloudy green water threw into relief the prisonlike bars of the catwalks and companionways. It became steadily darker as Mike and Rodney descended, and the sediment which rose around them with every step made matters worse. When Mike looked up all he could see was Rodney's vague outline, not more than two or three feet away. He had to rely entirely on touch to find his way around.

His groping fingers met something large and slimy, and he automatically recoiled. A moray eel? No, this was one wreck—probably the *only* wreck—which fish had not yet had time to occupy. Besides, the object hadn't moved. A more ominous possibility flashed through Mike's mind; then he remembered with relief that all the crew had been rescued.

He reached out again and strained his eyes, but it was no use. It was impossible to see anything. Grabbing Rodney's arm he steered him back to the companionway and up the iron maze that led to the sun. Once back on the echoing catwalks, they had a hasty council of war. There was one item of equipment that no one had thought of bringing on a bright, sunny morning—an electric torch. Before anything else could be done, somebody would have

to paddle back to land and get one.

The faithful rubber dinghy was launched into the turbulent water, and Rupert, helped by George Sandham (who had been unable to do any diving because of a bad ear), paddled the four hundred yards back to the shore. Meanwhile Mike and Rodney, not intending to waste any time, continued investigating the upper levels of the engine room, where there was enough light to see.

After struggling in vain to retrieve two heavy wooden chests which they had found lashed to some of the piping which always runs wild in the bowels of any ship, they began to swim along the galleries running round the engine room, Rodney taking the upper one while Mike took the lower. As he made his way cautiously through the gloom, Mike came across a heavy door with the key still in the lock. He hooted for Rodney, who didn't hear him above the general din of pounding waves, popping rivets and slamming doors. Mike tried the key; it turned easily, but the door refused to budge. So he swam up to collect Rodney, and together they organized an assault, using a crowbar as a battering ram. After a couple of smart blows the door swung open to reveal a pitch-black cavity, but as the torch had now arrived darkness was no longer an obstacle. When Mike switched on the beam he found himself looking at an imposing collection of drills, screwdrivers, saws, vises, stocks and dies—in fact every kind of tool that a ship needs at sea.

This valuable collection of tools belonged, of course, to the owners of the *Aenos* (or possibly, by this time, to Lloyd's of London). To have removed any of it would have put us in the same category as the busy hacksaw merchants on the upper deck. Yet if left there all these tools would soon be ruined, for there was certainly no one else who would salvage them.

It was a difficult moral dilemma. What, dear reader, would *you* have done?

Yes; we did exactly the same.

Now that the torch had arrived, Mike and Rodney decided to have one more trip down into the murky depths of the engine room. They passed the slimy body which had disconcerted Mike; it turned out to be a well-known make of mattress. After winding their way down through a maze of catwalks and alleys, they reached the engineer's kingdom and the weak beams of their torches disclosed rows of now useless pressure gauges. Oil rags hung grotesquely from hooks on the bulkheads; steam pipes snaked away into the gloom. Mike shone his torch along a lathe, still in perfect condition, as he discovered when he spun the wheels.

The two divers swam carefully through the labyrinth, trying not to distrub the sediment that had settled on everything like a thick dust. But despite all their caution, clouds rose up to envelop them at every move. It was too dangerous, Mike decided, to stay down here much longer. One could easily get lost in this gloom, run out of air, and perish miserably a few feet from safety.

He rapped on the steps to attract Rodney, whose torch appeared like a will-o'-the-wisp in the darkness. Pausing to collect a cup which some engineer had left hanging on a steam valve, they cautiously felt their way up the steps, and the light slowly grew around them as they retraced their path to the open air. They had been the privileged spectators of a far-from-unique yet seldom-witnessed spectacle—the birth of a wreck.

During his exploration of the *Aenos*, Rodney had also received a few shocks. He had managed to get himself imprisoned in the engineer's room when the door closed on him, and had then opened a cabinet out of which a pot of green paint had floated. The lid promptly came off, and he was unable to escape from this novel underwater peril, with the result that he surfaced looking like the Creature from 100,000 Fathoms.

The retreat from the *Aenos* might have been turned into a rout
had it not been for Rodney's knowledge of Sinhalese. When the
little expedition got back to shore with its souvenirs, the local
looters decided that this was unfair competition. Rodney heard
them planning to throw sand in his eyes and grab what they could
—an amiable plot that fizzled out when he told the thugs what he
thought of them, in their own language.

There was no opportunity of revisiting the *Aenos*. She had hit
just before the arrival of the southwest monsoon, and within a few
days of our visit the sea was too rough to allow boats to go out to
her. Before long she will have broken up and the fragments will
have slipped off into deeper water; the fish will move in, and at
least one giant grouper will take up residence to startle skin divers
in the days to come. And in twenty years, she will be just the same
as the *Earl of Shaftesbury* and the other completely shattered
wrecks we had discovered. Only the massive screws will still be
recognizable for what they once were; all else will have been trans-
muted by the violence of the sea and the subtler but no less thor-
ough camouflaging of corals and weeds.

The effect of this sequence of wrecks upon us was, perhaps, a
little unhealthy. Every time we saw a fine ship entering or leaving
Colombo harbor we would look at each other with the same un-
spoken thought. We would try to decide the best places at which
to arrange a slight marine contretemps; the ideal location would
have to be far enough from the coast to have clear water, yet not
so far that it was inaccessible or too deep for comfortable working.
As for the wreck itself, a liner of about twenty-thousand tons would
be acceptable, and though we would not like anyone to be hurt, we
would prefer the purser to leave in such a hurry that he had no
time to empty his safe or even remove the keys from the lock.

The Aenos Goes Aground

There is no denying the fact that, beautiful and fantastic though the natural wonders of the ocean may be, the wreck of even a dirty old tramp steamer can match them in strangeness and glamour when the sea has had a chance of working its magic upon it. By the time we had explored the *Elsia*, the *Conch*, the *Earl of Shaftesbury*, the *Hardingham* and the *Aenos*, we felt that we had seen just about everything that Ceylon had to offer in the way of wrecks, and had no particular regrets that the southwest monsoon had driven us away from one coast. We were now moving on to what, according to our plans, would be the main objective of our expedition—the pearl beds of Mannar.

We never guessed that not one of our plans for the pearl beds would work out as expected—and that as far as wrecks were concerned, we were shortly going to run into something which would make even our wished-for 20,000-ton liner look a very modest piece of salvage indeed.

12

PEARLS AND PALACES

For three thousand years, until the beginning of the twentieth century, Ceylon had been one of the world's chief sources of pearls. Together with gems and spices, they helped to spread the fame of the island to Europe, long before any European had ever gone there. Even to the Eastern world, Ceylon was a somewhat fabulous country. It was there that Sinbad discovered the inaccessible valley whose floor was paved with jewels, some of which he was able to retrieve by enlisting the aid of the local eagles.

Mike and I both approached the Ceylonese pearling industry by way of the Australian one, as has been recounted in *The Coast of Coral*. In almost every respect, the two trades provide a complete contrast. The Australian pearl oysters are collected primarily for their shells, which are very large—up to a foot across. It is from this material that all the genuine pearl buttons and knife handles are made. If any pearls are discovered when the shells are opened, no one knows anything about it except the diver and his tender; the pearling master gets his income from the steady sale of shell, and cannot rely on occasional windfalls to balance his books.

In Ceylon, the shells are very small and almost worthless. They are of value only for what they may contain, but seldom do. Naked divers working over a rich patch may bring up forty or fifty shells in a single two-minute dive. In Australia, on the other hand, a helmet diver working sixty feet below the surface may bring up only a dozen shells after an hour's walk along the sea bed.

All Australian pearling is done by luggers equipped with diving apparatus; no shell is now left in depths which can be reached without artificial aids. In Ceylon, on the other hand, diving equipment has never been used; the pearl beds lie in thirty to fifty feet of water, within the operating range of the naked diver.

But perhaps the most important distinction between the two industries is that whereas the Australian one is still healthy, if not exactly flourishing, the Ceylon pearl fishery has been moribund for half a century. There has been no fishery, in fact, since 1925, and the last really successful one was as long ago as 1905. The pearl oyster, it seems, is an extremely temperamental creature, and is also preyed upon by many enemies in addition to man. Skates and sawfish destroy the oysters in myriads, and in addition storms and unfavorable currents can wipe out entire beds.

The very fact that pearl fishing is such a gamble has undoubtedly added to its glamour. There is nothing romantic about the work of the divers themselves; it is hard, unpleasant, dirty and not particularly dangerous. In the days of the great fisheries, hundreds of ships would arrive from all over Asia, and a temporary town would be built to accommodate the thousands of merchants, divers, seamen and hangers-on.

When the oysters were brought back to land, the real gambling would begin. The shells would be piled in heaps, and then auctioned to the Arab dealers. Fortunes would change hands for what might be worthless piles of shell; not until *after* he had bought his lot would the dealer know what he had purchased. With trusted guards to keep an eye on his property, he would have to wait with what patience he could until the oysters had dried and rotted; then the shells would be opened—a process better described than smelled.

When the invention of the Aqualung made it possible to carry out a careful and relatively inexpensive survey of the pearl beds, the Ceylon Department of Fisheries sent Rodney Jonklaas up to the Gulf of Mannar to make a report on their condition. With Rodney went Rupert Giles, nobly contributing his Aqualung to the cause, so in 1955 the Ceylonese pearl oysters had their first visit from men who could take their time on the bottom, could see what they were doing, and did not have to go scurrying back to the surface for air after only a few seconds.

Rodney and Rupert, with a team of the native divers to assist them, collected thousands of oysters, which were then examined and measured. A detailed report on the survey was eventually written and still, as far as we know, reposes in the deep, unfathomed caves of the Department of Fisheries. Meanwhile the divers wait hopefully for permission to go after pearls again, and the oysters repose undisturbed on the sea bed.

Making the arrangements for our trip to the pearl banks had required a certain amount of tactful lobbying. We had to get government permission to go there in the first place, but we wanted more than that. So one morning we walked into the office of the Minister of Commerce and Fisheries, and asked for an appointment. Having promptly obtained that, we wasted no further time in requesting (a) Rodney Jonklaas, (b) a team of native pearl-divers and (c) a government boat to take us out to the pearl beds.

We would like to pay tribute here to the Minister, Mr. Shirley Corea, who at once gave us everything we asked for. Though we do not wish to get involved in local politics, we felt rather sorry when he was swept from office, like everyone else in the Kotalawala government, in the landslide at the general election a couple of months later.

It was arranged that we should drive north to the tiny village of Arripu, which lies on the coast looking across to the southern tip of India. A launch would be sent up from Colombo to transport us and our equipment out to the pearl beds, and the divers were told to stand by.

We set off from Colombo under threatening skies, for a drought which had lasted many weeks was coming to an end. Our Land-rover, with CLARKE-WILSON EXPEDITIONS INC. stenciled across the doors, and an inflated rubber dinghy on the roof, created a mild sensation when we stopped to make some last-minute purchases in the Pettah—the crowded bazaar in the heart of the city.

The coast road running north out of Colombo is a first-class one, and turns inland after it has made about half the journey to the Gulf of Mannar. For eighty miles we skirted the sea, catching occasional glimpses of it two or three miles away on our left. Many of the regions through which we passed were obviously suffering badly from lack of rain; we saw burned and dried-up paddy fields, and great reservoirs that were down to a few inches of muddy water. But relief was on the way, and we did not mind driving through an occasional shower so long as the sun came out a few minutes later and dried us off. Much of the time the landscape and vegetation reminded us of Queensland, as we had seen it on our way north to the Great Barrier Reef. The main difference was that there were about a hundred times as many people around— and the sea lay on the left instead of on the right.

Then the road curved sharply back into the interior, and rather to our suprise we soon found ourselves driving through untouched jungle. Sometimes troops of monkeys would scamper across the road and leap to safety in the trees. It seemed strange that they were so shy, as they are never shot at or molested, but it was impossible to get near them.

There was no other traffic around, and it was very lonely when we stopped the car on the thin strip of road slicing through the jungle. Every kind of animal lurked in the forest around us—deer, peacocks, elephants, leopards, wild pigs—but apart from the occasional monkey and a few cautious birds there was no sign of life.

Rodney Jonklaas and Rupert Giles were accompanying us in the latter's car, but sometimes one party or the other would stop for a little shooting and much of the time we were proceeding independently. We combined forces, however, for the last lap of the journey, and despite a little trouble with a signpost which had its arrow pointing in the wrong direction we all arrived safely at Arripu, two hundred miles from our starting point, just after darkness fell.

Our residence here was to be the Circuit Bungalow, a large illkept building which appeared to have been standing for at least a hundred years, and had some still older Dutch ruins in its grounds. It was occupied by the local police force, five in all, with whom we were soon on excellent terms. The Circuit Bungalow was a kind of Rest House for any visiting government officials, and we took over a couple of the huge rooms. We had brought all our own food, and were lucky enough to hire a local man to do our cooking for us. He managed surprisingly well on a simple log fire, but was apparently too shy to come and tell us when the meals were ready. As a result, we twice breakfasted at the unearthly hour of 5:30 on *cold* fried eggs, which I would not recommend as a suitable start for a day's onerous diving.

Though there was ample room in the bungalow, there were not enough beds to go around. In fact, there were only two between the four of us. But Mike had anticipated this situation while we were still in New York, and quickly broke out the two tent hammocks which we had brought with us and which I had, not very

secretly, hoped we would never have to use.

Three palm trees growing in the bungalow grounds, about thirty feet apart, gave us ideal supports for the hammocks. We slung them so that they were just clear of the ground, hoping that when we occupied them the lowest part of our anatomy would be out of range of any poisonous snakes that might wander past during the night.

I had never been in a hammock before, and still less had I attempted to sleep in one, so I resigned myself to suffering from both insomnia and curvature of the spine. Much to my surprise, I discovered that it was quite easy to stay aboard once I had got my center of gravity properly arranged, and when the built-in tent which protected the hammock from rain was zipped shut, the little canvas cocoon was a delightful resting place. I slept well for three nights, rocking slightly from side to side between the palms.

Mike was not so lucky; one night his hammock was invaded by a large spider, and on another day the flap of the tent was left open and a sudden shower turned the hammock into a bird bath. He spent a somewhat sleepless night on the porch of the bungalow, curled up inside the leaking and half-deflated rubber dinghy, whose weird moans and gasps as Mike tossed fitfully about reduced the two police dogs to such howling hysterics that it was hours before anyone else could get to sleep.

There are not many times in my life when I have voluntarily got up at dawn, but we had no choice here if we wanted to catch our divers before they decided to go off for a day's fishing. The promised launch had not yet arrived, but that neither surprised nor worried us. For the first day, at least, we were quite prepared to get some local color by operating from the native boats.

After driving for about three miles from the bungalow over the worst roads we had so far encountered in Ceylon we came to the

tiny village of Silavatturai. The fisher folk in this part of the country use boats quite different from those in which we had suffered south of Colombo; their *vallams* are large, wide-beamed craft about forty feet long, shaped not unlike landing barges. It was a delightful change having all the space we needed to lay out our equipment—and even being able to sit down ourselves in comfort.

Unfortunately, there was one serious drawback. At this time in the morning there was practically no wind, and the single large sail hung limp and bedraggled from the mast. We moved out from the shore at a spanking one-half knot, and after thirty minutes had not traveled a quarter of a mile.

Presently the crew decided that they had better do something about this, and unshipped their oars. Our velocity promptly rose to a whole knot, and we began to make real headway. As they rowed, the diver crew chanted an impromptu song the tenor of which, as far as we could discover, was "Let's hurry up and get out there so that we can see if these guys are any good in the water."

The channel between Ceylon and India is very shallow, for it is not so long ago, in terms of geological time, that the two countries were joined together. A couple of miles out, the water was still only thirty feet deep, and after we had been on our way for almost two hours we came to the reef.

It was the Great Barrier Reef in miniature—a wall of coral growing right up to the surface, pierced at a few spots by channels through which a shallow-draught boat might make a cautious way. The water was wonderfully clear, so much so that Rupert nearly wept tears of frustration at not having brought his movie camera as the fantastically shaped and colored coral drifted slowly past beneath us. Once we came to a large lagoon, the still surface of which was cleft by half a dozen triangular fins which slid effortlessly away before we could get near them. And once a school of

porpoises undulated past; we would have given much could we have somehow persuaded them to remain and play with us.

Mike and Rodney plunged overboard to scout a way through the submerged barrier, and presently—without any of the grindings and scrapings I had anticipated—the vallam was through the reef and out in the still clearer water on the seaward side. Apart from a couple of old men who stayed aboard, she was then promptly deserted. Everybody got into the sea.

My poisoned foot was still very painful—it had been sliced open a few days before to let out the infection, and had not yet healed up —so I soon took off my left flipper and continued to function on one engine only. Surprisingly enough, I found that my swimming was hardly affected; it was only when I tried to dive to any depth that I discovered how much of my propulsive power I had lost. The sea bed seemed a long way down, and when I finally reached it the surface seemed even further up.

The pearl banks themselves were some miles farther out to sea, but as it would take us the rest of the day to reach them in the vallam we were content to remain here and make the most of this really beautiful reef. In its way it was perfect; the water was nowhere more than twenty feet deep, and it was often possible to stand with one's head and shoulders above the surface. The place was crowded with fish, though we saw no very large ones. They swam in legions through and above the branching, pastel-hued twigs of the stagshorn coral, and we were soon chasing them with the cameras. Occasionally there would be a clear path of sand, in the center of which a coral boulder would rear up like a mesa in the Arizona desert. The larger fish would be lurking under these boulders; they were also the hiding places of magnificent crayfish which were soon twitching on the floorboards of the vallam.

The Silavatturai Reef, if it had happened to be in some more

accessible part of the world, would be black from morning to night with goggling tourists coming from all parts of the globe. Fortunately it is in a very out-of-the-way corner of Ceylon, at the end of a shocking road and a tedious voyage, so with any luck it should be spared this fate.

The native divers who formed our escort were all surprisingly elderly men; I doubt if one of them was under thirty and most of them seemed at least forty. Presumably the younger men had gone into more rewarding trades, as there has been no pearl diving for over a generation. In view of this, it seemed rather remarkable that there were still any divers around at all. They had retained their skill, however, and earned a modest living by diving for shells known as chanks which are used for ornamentation and carvings.

Wherever we swam, these divers accompanied us. They wore no masks, so the element through which they traveled must have been a blue-green blur. No human eye can focus underwater to form a clear image on the retina, but with training it seems possible to interpret these hazy blurs and to know what it is you are seeing. Even so, the most skilled native diver cannot hope to match a man with a face mask in the ability to locate objects on the sea bed. One diver who had been given a mask by Rodney the year before had been able far to exceed the take of his colleagues, though he had found it impossible to go down so deep, presumably because he had not learned the trick of clearing his ears.

As swimmers, these men were marvelous. They could practically match our flipper-assisted velocity, and could stay underwater for a couple of minutes without trouble. They would follow us down to the bottom with powerful kicks, and remain there without benefit of the lead weights which most of us found essential. Sometimes they kept us company for long periods while we, using Aqualungs, directed them to carry out some maneuvers in front of the

cameras, and quite forgot that our actors did not have the advantage of a portable air supply. Yet they never seemed to mind, and not once did we have to interrupt our filming while they went up for air. However long the shot, they always managed to hold out until the end.

We spent two hours swimming down the picturesque little valleys and over the petrified forests of the Silvatturai Reef, and it was well past noon when we started thinking of the long journey back for lunch. Fortunately, a stiff breeze had now sprung up, and the homeward trip took only thirty minutes. But when we arrived back at our base, there was bad news for us. The promised launch had broken down somewhere on its way up the coast, and we would have to do without it.

This was a crippling blow. In the vallam it had taken us a couple of hours to get less than halfway out to the pearl banks. Without some kind of powered vessel to tow us, it would be impossible to operate. We should be all day going and coming, and would have no time left to take any pictures.

There was only one hope. A government survey ship was working along the coast, about five miles out at sea, erecting beacons on the reef. Every day she sent her own launch ashore for messages and provisions; if we could intercept that launch and use it to tow us out to the pearl beds each morning, we could rely on the afternoon breeze to get us back to land. Unfortunately we never knew when the launch would come ashore, or even where, so there seemed little hope of putting this plan into practice.

Meanwhile our first day at Arripu was drawing to a close, and there was no night life within a hundred miles or so—even by the modest standards of Ceylon. We would have to make our own entertainment—and we could not even read after dark with any comfort, as the only illumination came from guttering oil lamps.

The policemen had at once adopted us, being obviously delighted at this unusual break in their monotonous lives. The constables were Sinhalese, their sergeant Tamil—and very well educated, as he spoke five languages including, unexpectedly, German. For recreation in their off-duty hours they played a game known as "Carrom," which combined the features of shove-ha'-penny and snooker; flat counters were flipped over a square board until they had bounced off the edges or each other and dropped into the pockets. They also had a battery-powered radio which must have been a godsend; when we left they begged us to send them any spare magazines we had to help them while away the empty evenings.

On my first afternoon, two of the young constables suggested that I might like a walk over to the village on the beach half a mile away, and having nothing better to do I agreed readily enough. In mid-journey, however, it became obvious that the main goal of my guides was not the village but the village well, from which the local maidens had to obtain all the fresh water needed for drinking and washing. We hung around the well for a considerable time on various pretexts, and I began to realize why it was that there was sometimes such an outcry from the women when the authorities threatened to install plumbing. It would save them miles of walking every day—but if the village well was abolished, where could the matrons gather for a quiet chat or their daughters exchange unchaperoned conversations with their boy friends?

There was a perfectly good well, at which we always bathed, in the grounds of the bungalow, and I used to make fun of the young policemen who found it necessary to walk a quarter of a mile to use the village water supply. The Ceylonese, incidentally, are an extremely bath-conscious people; our friends used to empty twenty or thirty buckets of water over themselves every time they

went to the well, while we contented ourselves with two or three and then slunk shamefaced away.

Our second visit to the Silavatturai reef proved to be our last—for this year, at any event. After another pre-dawn awakening and another breakfast of cold fried eggs, it took the vallam no less than three hours to get us out to the reef. The vessel's progress was not only slow; it appeared to be unpredictable. When we were a mile or so out at sea we spotted the survey launch on the horizon, and tried to attract its attention. Rupert tied a shirt on a long pole, and began to semaphore vigorously in the hope that there was someone aboard the launch who could read Morse. He sent "s.o.s. —WE HAVE MESSAGE FOR YOU" and repeated it a couple of times before collapsing in the bottom of the boat. It is one thing to send Morse with a key, and quite another to send it with a heavy, ten-foot-long pole.

The launch took no notice; it was so far away, in any event, that no one could have read our signals unless they had been looking at us with field glasses. (Our own field glasses, incidentally, were on loan to the police, being permanently focused on the above-mentioned village well.)

After another hour of circuitous sailing, we eventually arrived at the launch, which had stranded itself on top of the reef in order to allow a working party to erect a beacon. Half a dozen men, apparently walking on water, were struggling to put up a flimsy bamboo derrick which would act as a survey point—until the first storm removed it with neatness and dispatch.

Rodney and I went aboard the launch and scribbled a message to the captain of the mother ship, whose presence we could detect by the plume of smoke visible over the edge of the horizon. We explained our predicament, and asked if the launch could be made available each morning to pull us out to sea. Then, feeling that we

had done all that could be done, we sailed on over the reef and began another day's diving.

For some mysterious reason, the water was not as clear as it had been twenty-four hours before, and our hopes of obtaining any really good photographs were dashed. However, Mike managed to obtain one amusing sequence showing Rodney chasing the bright-colored little fish who make their home in the tentacles of the giant sea anemone. All other fish are killed by the poisonous stings, but the anemone appears to ignore the lodgers who have taken up residence inside it. (Literally inside on occasion; when danger threatens, they will retreat into the anemone's stomach.)

Then disaster struck. Mike was diving with the movie camera when he noticed a thin stream of bubbles coming out of the lens. Surfacing at once, he found that the special correcting porthole which compensated for the refractive effect of the water had developed a flaw; the lens elements appeared to be intact, but the cement between them had begun to split away. No water had penetrated into the case, but that stream of bubbles was a warning that could not be ignored.

We began to feel that there was a curse on our expedition, and that it would be a good idea to get out before it was too late. It had been bad enough, not being able to reach the pearl banks because of the non-availability of the launch. But now that the most import-ant camera was unserviceable, we could do nothing even if we had transport.

As we started on the slow trip back to Silavatturai we made the only decision we could in the circumstances. We would cut our losses and head back to Colombo; the pearl banks would have to wait until next year. Although we had come three-quarters of the way around the world only to be defeated by a piece of glass, we were not particularly depressed. Ceylon had already given us any

amount of interesting and unexpected material, and we felt confident that there was plenty more to come.

The policemen were very upset when they found we were leaving so soon. On our last night, after we had done most of the packing, Mike, Rupert and Rodney took the sergeant and one of his constables out on a hunting trip in the Landrover. They were gone several hours, and were rather subdued and thoughtful when they came back. It seemed that they had driven up a jungle road in search of game, and had been waiting quietly for whatever might come along, when to their consternation they heard, altogether too close at hand, a sound as of trees being pulled up by their roots.

This, in fact, was exactly what they were hearing. A solitary elephant was prowling through the jungle—and lone elephants are usually rogues who have been ejected from the herd and are thus in a permanent bad temper. Mike's Luger pistol and Rodney's shotgun hardly seemed adequate to deal with the situation.

Luckily, the elephant did not detect the quaking hunters, who were able to get back to the Landrover and drive swiftly off into the night. Had it come to a showdown, there is no telling what might have happened.

There are estimated to be less than a thousand elephants still at large in Ceylon; they have been diminishing rapidly in recent years and at the present rate will be extinct in a decade. Although they are rigidly protected, occasionally they ravage crops and the irate peasants are then allowed to shoot them to protect their property. Since the elephant is unique, and the paddy field is not, there is now a move to arrange for government compensation when crops are destroyed, and to let the culprits go unmolested. If this proposal becomes law, someone is going to have a busy time going through

the hundreds of spurious claims that will promptly start coming in from the cultivators. The Sinhalese would never miss a chance like this.

As we drove out of Arripu early the next morning, the sergeant and his men lined up to salute us good-by. I am sure that the circuit bungalow has never been the same since, and the doings of the Clarke-Wilson Expedition must still be a favorite topic during the long evenings when the radio palls and it's too dark to see what is happening over at the well.

We had just started inland when we spotted the survey launch making straight for Silavatturai, and we guessed at once what had happened. Our plea for assistance had been acted upon; we could use the launch when it wasn't needed for its other duties. Feeling rather foolish, I had to write another letter expressing our deep gratitude, and explaining why we were no longer in a position to accept the help we had requested about eighteen hours previously.

We left the lonely coast behind, wondering when we would return and whether we would have better luck on our next visit. For the next sixty miles we drove through tiny villages and between endless acres of paddy fields, and along the narrow road sliced through the jungle. And then, quite suddenly, we were in the center of what had once been the greatest city in the world.

Until I came to Ceylon, I am ashamed to say, the name Anuradhapura meant nothing to me, as it probably means nothing to most of those who read these words. It was something of a revelation, therefore, to discover that the ancient capital where no less than ninety Sinhalese kings had reigned in continuous sequence had once housed three million people, and has probably never been exceeded in size until our own era. Founded almost two and a half millennia ago, the city in its heyday was at least

eight miles from side to side, and contained an intricate system of waterways and giant reservoirs which must have added much to its beauty. The life of the country depended (as to a large extent it still does) on irrigation, and the Sinhalese were superb hydraulic engineers, some of their great artificial lakes being thirty or forty *miles* in circumference.

For a thousand years Anuradhapura was the capital of Ceylon, until invaders from India forced its abandonment and the Sinhalese —who seem to have been better architects than fighters—built a second and scarcely less magnificent capital at Polonnaruwa, sixty miles away. The great city was abandoned to the jungle, which slowly overwhelmed the palaces and statues, the monasteries and courtyards, until today the twenty square miles of forest around Anuradhapura must cover the greatest archaeological treasure trove in the world.

Even the jungle, however, could not bury the enormous domes of the great dagobas or temples. The mightiest of these—the Abhayagirya—still stands like a hemispherical hill, crowned by a massive square building and a broken spire. Originally 450 feet high, the Abhayagirya was larger than St. Paul's Cathedral— larger, indeed, than all but one of the pyramids. When one stands at its base and stares up the now grass- and shrub-covered curve of the dome, it is almost impossible to believe that the structure is entirely artificial, being built of more than a million tons of bricks.

Impressive though the ruined Abhayagirya was because of its sheer size, the smaller Ruanveliseya Dagoba was more interesting, as it had been recently restored and so gave a good idea of what these temples must have been like in their prime. We approached the gleaming white dome under an archway set in a wall of elephants—hundreds upon hundreds of them, *life-sized*, completely enclosing a courtyard more than a quarter of a mile in

circumference. Originally each elephant had tusks of real ivory, so a fortune must have gone into the building of this wall alone.

The great courtyard was paved with huge stone slabs, uncomfortably hot to our bare feet, for of course we had removed our footgear at the entrance. It was hard to realize that we were walking in surroundings that had not changed appreciably since Caesar came to Britain. Though the rest of the great city had been overthrown by time and the jungle, here within the quiet courtyard of the Ruanveliseya pilgrims from any period in the last two thousand years would have felt completely at home.

One cannot walk more than a hundred feet in Anuradhapura without coming upon the foundations of enormous ruins, or encountering elaborate carvings half buried in the ground. Not even in the streets of Pompeii have I felt so strongly that I was in the presence of the past. It is doubtful if even the Romans could match the achievements of the ancient Sinhalese in architecture and civil engineering; it is certain that they could not approach them in the realm of art.

Early in the afternoon we left the small and tawdry town which is modern Anuradhapura and continued our journey to Colombo. We were lucky to get there, being involved in three near-crashes on the trip. The most serious of these was when a bus refused to let us overtake and deliberately crowded us off the road, so that the Landrover shot down an embankment and ended up in a ditch containing two feet of water. We backed furiously out of this predicament and advanced on the bus driver, who tried to hide under the seat when I stuck a Leica through the window of his cab to photograph him, just for the record. I did not realize until later that he probably thought I was going to use a gun, not a camera. We then made a great show of note taking, and though we never followed the matter up I am sure that bus driver was most unhappy for

several days, and may even have driven carefully for a whole week.

So, somewhat to our surprise, we arrived back in Colombo, only four days after we had departed, and without having seen a single pearl oyster. But I had seen Anuradhapura, and I was content.

13

THE BEAUTIFUL AND DEADLY

WE HAD visited the north, south and west coasts of Ceylon; now there remained the east, looking out across the Indian Ocean to distant Australia.

The backbone of mountains running down the center of the country gives Ceylon two climates, and though the weather on the Colombo side was now too uncertain to make diving worth while, on the east coast we were assured that it would still be fine. So Mike packed lungs, compressor and cameras and drove across country to have a look at this unfamiliar coast, while I stayed behind and battered despairingly at the typewriter.

Two days and several thousand words later, I received a telegram from Mike saying that conditions were perfect. So I gaily packed my toothbrush and spare sarong, thumbed my nose at the typewriter, and caught the night train to Trincomalee.

Trinco, as it is invariably called, has one of the finest and most beautiful harbors in the world—one large enough to accommodate the entire British navy in a completely land-locked anchorage. But despite its importance as a great naval base, the town is very small and seems isolated from the mainstream of the country's activities. It is entirely surrounded by jungle and all its life depends upon the sea.

The train journey across Ceylon left no impression whatsoever on me; I slept through it all and woke in Trinco with the dawn. Mike met me at the station with the Landrover and took me to the

Rest House, which the Reefcombers now had firmly under control. Counting Mike and myself (honorary Reefcombers) there were no less than seven members lodging at the Rest House, each with a small mountain of underwater equipment. I felt rather sorry for any other guests who were rash enough to stay here.

Mike has a useful knack of enlisting the aid (frequently voluntary) of people who can be of assistance to us. At Trinco he had established a secondary base at Nicholson Lodge, a British residential club overlooking the fine stretch of beach from which we were to start many of our swims. The managers of the Lodge, Mr. and Mrs. Roberts, were very good to us and allowed us to park the rubber dinghy and much of our other equipment in their grounds. In return, as will be described later, we introduced their ten-year-old son David to the delights of Aqualunging.

On my first morning at Trinco, Mike and I—with young Dave as passenger—paddled the rubber dinghy out to a buoy some two hundred yards from shore. We never discovered the purpose of this buoy, but someone must have considered it important because they had gone to the trouble of placing it there when its predecessor had sunk. It was this submerged buoy which was our objective, for it was the home of an entire colony of scorpion fish.

The scorpion fish, also known as the butterfly cod or lion fish (*Pterois volitans*) is one of the most dangerous of all marine animals. It is also one of the most beautiful—and, surprisingly enough, one of the friendliest. The danger and beauty both originate in the delicately colored spines, not unlike turkey feathers, which surround the fish in fluttering fans.

I had met *Pterois* before off the Great Barrier Reef, together with his equally venomous relative the stonefish, which the Australian aborigines call by the superbly apt name the warty ghoul. My fist encounter had been in a small coral cave some thirty feet below

123

the surface; I had crawled into it to pay a social call on a giant grouper, who happened to be out at the time. The little cave, a recess beneath an immense coral mushroom, had walls covered with a tapestry of reds and blues and golds, and I was examining this living picture when my eye was caught by a movement just overhead. A small bundle of feathers appeared to be orbiting in a leisurely fashion a few inches above me, and I realized at once that I was looking at the scorpion fish's venom-tipped spines.

Unless I accidentally knocked against the little creature, however, I knew that it would do me no harm, and for some minutes we quietly surveyed each other. Then I became ambitious and optimistically tried to capture the fish. The only tool I had with me that was of any use at all was the snorkel breathing tube which —like all good Aqualungers—I had tucked into my belt for use in case of emergency. Had there been any spectators, they would have been entertained to see a clumsy fencing match while I tried to hook the scorpion fish with my snorkel, and it neatly side-stepped me until it got tired of the game and disappeared into one of the cavern's smaller recesses.

The Ceylon encounter was quite different, both in locale and in the behavior of the parties concerned. Instead of on a crowded and busy coral reef, it took place on a sandy submarine desert where there was no other trace of life. And this time there was not one scorpion fish, but a couple of dozen.

We anchored the dinghy beside the still-operational buoy, threw the Aqualungs over the side, put them on while treading water, and dropped swiftly to the sea bed forty feet below. The water was extremely clear; even from the surface we had been able to make out most of the details of the major housing project we were going to investigate. It was an iron sphere about four feet in diameter, badly corroded and overgrown with weeds, and with its

upper portion completely rusted away so that the interior was wide open.

It appeared so packed with scorpion fish of all sizes that I wondered how they avoided stinging each other. They were swimming slowly around, fluttering their feathery spines like Edwardian ladies showing off their frills in an Easter parade, and as we approached they started to pour out of the buoy to have a good look at us.

A great many fish are inquisitive, but most of them are also shy and will retreat hastily if you come too close to them. These scorpion fish, however, showed no trace of shyness; they acted—probably rightly—as if they had no enemies in the world and could not imagine that anyone would want to harm them. Their sublime self-assurance seemed in the same class as that of Queen Victoria—who is said never to have looked to see if there was a chair when she sat down; she knew that somebody would have put one there.

They still showed no signs of alarm when flashbulbs started popping all around them; indeed, they began to ogle the cameras as persistently as the crowds round a mobile TV unit. It would have been hard to find more co-operative subjects, above or below water. Our only problem, as photographers, was to make sure that while we were busily focusing on one fish we were not getting into the poisonous proximity of another.

After a while we stopped shooting into the interior of the buoy and Mike lay on the sand about six feet away from it, so that he could compose some long shots in comfort. At once a small caravan of scorpion fish began to wend its way toward him, until almost a dozen of the creatures—from babies three inches long to grandfathers two feet across the spines—were ranged round Mike in a semicircle, all watching him to see what he would do next. They

reminded me irresistibly of puppies waiting to be taken for a walk (Plate 40).

By this time, of course, we had developed the friendliest of feelings toward the scorpion fish and were beginning to look upon them in a proprietary manner. With his gloved hands, Mike several times *almost* touched one of the smaller specimens, which would then ruffle its spines a little but show no great alarm, beyond retreating a few inches. The only thing that did seem to annoy them was a very small, brilliantly blue fish that acted as a gadfly, sometimes darting at them and biting their skin. In a spectacular feat of mistaken identity, one of these little bullies attacked me, and for a fish only an inch long it managed a nasty nip.

But that was nothing to what the amiable little scorpion fish could have done had I come into contact with them, as Rodney Jonklaas was able to assure me from personal experience. Rodney had netted dozens of these fish for aquaria, not always with immunity.

His technique, while swimming underwater, is exactly the same as a butterfly catcher's. Carrying a small net in his left hand, he uses his free right hand to scare his victims into captivity (Plates 26 and 27). One day he had just trapped a medium-sized scorpion fish in this manner when it suddenly backed out of the net and one —just one—of its poisoned spines barely penetrated the skin at the joint of Rodney's middle finger.

An excruciating pain at once spread over his hand, but he managed to recapture the fish and get ashore. For a moment the pain ebbed; then, in an even more intense form, it returned until his entire arm became numb. His fingers were swollen and stiff, and soon he was in such agony that he lost consciousness. When he recovered about ten minutes later the pain was still there, and it was half an hour before he could get treatment at the Colombo Zoo, of

which he was at the time Deputy Superintendent. The treatment consisted of drinking dilute ammonium chloride, and the pain then quickly departed. There were no after-effects.

A second occasion was very similar, but this time the pain was nothing like so intense and though it lasted for a couple of hours it was not incapacitating. And a third time the sting gave Rodney no trouble at all—though it would be rash to assume that he was building up an immunity, for in both these cases the stings were quite trivial.

It seems highly probable, therefore, that if one was unlucky enough to get a really good dose of the scorpion fish's poison, by being pierced by several of its spikes at once, the result would be fatal. Perhaps the remark made about the Australian stonefish also applies to *Pterois*: "It's not really poisonous, but the pain kills you." This could certainly apply to an Aqualunger who came into contact with one of these creatures at any depth; the shock might easily make him lose his mouthpiece and he could drown before reaching the surface.

The Ceylonese fishermen have a great dread of the scorpion fish and there have been fatalities reported through men stepping on specimens. However, as is usually the case, no one can give names, dates and places for these incidents, so the question of the fish's lethality is still unproven.

The poison-tipped spines are, incidentally, purely defensive. As Mike and I found, the little creatures are completely unaggressive. However, they are predators and eat only live fish, which they capture by a curious technique. The scorpion fish seems to mesmerize its prey by approaching and waving its fins in front of it, then suddenly opening its mouth and swallowing its victim whole. The family around the Trincomalee buoy may have thought that Mike and I were susceptible to this treatment, though some-

how I don't think so. Perhaps I am too trusting in these matters, but when I remember how they all filed out of their rusty home and gathered around our flippered feet I like to think that they simply wanted to make friends.

At last, quite reluctantly, Mike and I tore ourselves away from the scorpion fish and rejoined Dave in the boat. We were now about two hundred yards from a precipitous headland known as Swamy Rock—one of the most historic spots on the east coast of Ceylon. For at least three thousand years, with one brief interruption of a mere century or so, the rock has been the site of a Hindu temple. The interruption was caused by the arrival of the Portuguese, who looked with great disfavor on any religion except Roman Catholicism, and who were men of violent action where matters of faith were concerned.

Though we knew nothing of this at the time of our first visit to Swamy Rock, we soon became aware that there was something peculiar about the sea bed over which we were swimming. Huge blocks of stone were scattered in every direction, and though all were overgrown with weeds and barnacles many had a curiously artificial appearance. At first we decided that this must be an illusion; the action of the sea can sometimes carve rocks into surprisingly symmetrical patterns. But presently we had unmistakable evidence that beneath us was the work of man, not of nature.

The capital of a stone doorway, badly eroded but perfectly recognizable (Plate 21), lay in the jumbled chaos of rocks. Beside it was a broken column, its square ends bearing on each face a lotus-petal design not unlike the Tudor Rose (Plates 22 and 23). As our eyes grew more skilled in interpreting what we saw, other regularities began to make themselves apparent. The ruins of some great building had been scattered along the sea bed, where they lay in hopeless confusion. The water at the foot of the headland was

quite shallow; where we were diving it was nowhere more than fifteen feet deep, and most of the broken masonry lay only about five feet below the surface.

We continued our swim, often pausing to argue whether some curiously-shaped stone was natural or artificial. The fragments were distributed along some two hundred feet of the shoreline, and we had covered about half this distance when we came upon debris of a later civilization. A small ship had foundered here, and a massive Diesel engine lying on its side provided a piquant contrast to the stone pillars and shaped blocks around it. The broken propeller shaft, snapped off at the screw, jutted through the water like a gun barrel. It was quite disturbing to come upon it suddenly and to feel that it was pointed directly at you, loaded and ready to fire.

Some of the most beautiful fish we had ever seen were swimming around this wreck. Young emperor fish flaunted their brilliant blues against rusty gear wheels; iridescent angelfish (Plates III and IV) stared at us with expressions of permanent surprise. On a later visit, after Rodney Jonklaas had introduced me to the mysteries of the international trade in "tropicals," I often found it hard to look at these marine butterflies without attaching price tags to them. That glorious blue-and-white vision, I would remind myself, was worth twenty dollars any day in New York; and this not-particularly-beautiful little chap was good for a fiver in the right shop in London. All the treasure in the sea is not necessarily sunken bullion. . . .

It was around this wreck that Mike taught young David to use the Aqualung. Our units were man-sized ones and the fit left something to be desired; in fact, Dave dangled from the twin-tank lung rather as if he were hanging from a balloon, and we had to drape large quantities of lead around him to get him down (Plate 29).

But once submerged, he was quite happy underwater, and since then has taken up skin diving to such effect that all his parents ever see of him nowadays is a solitary snorkel far out in the bay.

I feel like making a digression here. As one who was born and bred beside the sea, I have always regretted the fact that the cheap and simple equipment which has opened up the shallow waters of the world to all who wish to explore them was not available in my youth. Face mask and flippers might have come into common use centuries ago—inevitably, they are described in the notebooks of Leonardo—yet it was not until after the Second World War that they led millions to the sea. I wonder if today's youngsters, finning happily among the fish, realize how lucky they are to have inherited a new element—and, indeed, a whole new world.

14

THE BIGGEST WRECK
IN THE WORLD

THE shattered masonry we had discovered off Swamy Rock presented a problem which we were determined to solve, but before we could do anything about it we were confronted by a far bigger challenge. Wherever man has dealings with the sea, he has to pay a never-ending toll. His treasures and the fruit of his labor slowly accumulate in the depths; indeed, it has been estimated that a quarter of the total wealth of mankind lies at the bottom of the oceans.

Trincomalee has been an important naval base for over three hundred years, and around such harbors, in times of war, man vies with nature in casting wealth into the sea. In one day during the Second World War eighteen ships—including an aircraft carrier—were sunk off this coast; but it was not any of these that attracted our curiosity and brought us the most awe-inspiring moments we have known underwater.

The inner harbor of Trinco is really a series of linked lakes, open to the sea through a narrow channel. Battleships could hide from each other in the same harbor, by sneaking into the many bays and coves. In one of these bays two curious objects protrude above the surface, even though the water around them is more than a hundred feet deep. At one spot a rusty iron deckhouse, tilted at a slight angle to the waves, appears to be just awash. So far away

from this that it seems impossible that they can have any con-
nection, the upper framework of a huge crane rears straight out of
the sea.

These two steel monuments are at least two hundred feet apart—
yet as we were to discover, they are separated merely by the *width*,
not the length, of the enormous piece of engineering whose rest-
ing place they mark. The wreck buoys warning ships away from
this area, and defining accurately the extent of the obstruction on
the harbor floor, are almost a quarter of a mile apart.

We had been told that during the war a floating dock had gone
down in Trinco harbor, but the information had failed to thrill us.
Wrecked ships were exciting; wrecked docks sounded dull, even
if unusual. It was not until Mike had made his one-man reconnais-
sance of Trinco and sent me a telegram with the brief message
"Dock fabulous" that I realized that there might be something
worth investigating here. Even so, I had no faintest conception of
the reality.

Since the dock was almost a mile from the nearest accessible
point on land, we were—as usual—faced with the problem of
getting our equipment out to it. It was solved by Dick Tame, the
officer in charge of the motor transport section of the dockyard.
Dick was as much at home on water as on wheels, and sailed us out
—towing the inevitable rubber dinghy—in one of the small boats
used for the naval staff's recreation. Sailing craft are too complicated
for me; I lay on the bottom, out of range of the treacherous boom,
while we jibbed and tacked and did other incomprehensible things.

We swept past a large buoy bearing the inscription "A.F.D. 23,"
and could not help thinking that the phrase "Admiralty Floating
Dock" was no longer very accurate. When we arrived at the steel
control cabin, we tied up the boat and unloaded all our gear on the
narrow catwalk, being careful to avoid the sharp-edged steel shut-

ters which had once protected the windows of the cabin. They now stuck out at all angles, frozen in position by rust, and nicely situated to stun anyone hurrying carelessly along the catwalk.

It was a fine, clear morning, still an hour before noon, so the sun was high and struck far down into the depths below us. We were gathered around the sides of a rusty steel building about the size of a small villa; looking in through the windows we could see a line of control panels, all the instruments and wiring long since ripped away so that only the corroded framework remained. There was nothing interesting here; the local fishermen would have seen to that.

This derelict metal room, once the scene of so much activity, sat slightly tilted upon the surface of the water, so that the catwalk surrounding it led gently down through the waves. As a nursery slope for embryo Aqualungers, Admiralty Floating (*sic*) Dock 23 could scarcely be bettered. A diver had only to walk downhill into the water until the sea took the weight of his equipment, and then he could sink gently onto the submerged deck twenty feet below.

It would have taken us many months of continuous diving to have explored the whole of this monstrous submarine ruin. From information we obtained later, we gathered that the dock was shaped like a huge box almost a thousand feet long and perhaps two hundred feet wide, open at both ends so that the biggest battleship afloat could be completely enclosed inside it. The whole dock floated on enormous buoyancy tanks—which formed, as it were, the bottom of the open-ended box. When these tanks were pumped full of air, the dock would rise out of the sea, lifting the ship it was holding until it was quite clear of the water.

But a floating dock is much more than this. It is also a complete shipyard with its own cranes, workshops, power stations, telephone exchanges, storerooms and—in wartime—anti-aircraft gun turrets.

These facts we did not discover all at once; they impressed themselves upon us slowly and unforgettably as we began our presumptuous exploration.

The water was so clear that even standing on the catwalk around the control house we could see a maze of girders dwindling beneath us into the depths. I hurried to put on face mask and flippers and was far too impatient to bother about the Aqualung. As soon as I got into the water, I let myself sink effortlessly down while I absorbed the astonishing sight around me.

An immense wall of steel extended as far as the eye could see in both directions. The control house from which we had started operations was perched high on the dock's starboard side, in much the same position as the bridge of an aircraft-carrier. From this steel cliff a spidery gangway, supported on massive girders, reached out toward the far wall, concealed from view by almost a hundred yards of water. This gangway must once have been a dizzy bridge high above the floor of the dock; it was apparently movable, so that it could be swung aside when a ship came in, and then replaced to span the man-made chasm below.

I was so fascinated by this tracery of steel that before I knew what had happened I was forty feet below the surface, and still sinking. The clarity of the water, and the vast scale of the constructions around me, made it quite hard to judge distances. I was almost out of air before I could reach the surface again, but despite this warning I kept making the same mistake. I would dive down the iron walls intending to sink no more than a modest twenty or thirty feet, only to find that the clearly visible surface was almost unattainably out of reach. Almost—but luckily never quite.

Everyone else had now got into the water, and the serious business of photography began. I swam back to the control house and put on my Aqualung, so that I could now make a more prolonged

inspection of the wreck and take my time composing pictures.

Immediately below the rusty iron control room, which was supported above it on steel pillars, was the upper deck, its wooden planking apparently as solid as on the day it was laid down. It slanted gently away into the haze, a silent vista of open hatches, storm-rigged doorways, and companionways leading down into mysterious darkness (Plate VI). Coils of wire rope and the links of huge chains lay everywhere, cemented together with encrustations of barnacles and coral. There were no large fish at this level— so near to the surface—but myriads of small ones, including not a few scorpion fish lurking in quiet corners.

Since my Aqualung was half empty, and I was not sure how much air I had left, I decided to remain in the upper levels of the wreck for this visit. Mike and George Sandham had no such inhibitions; their tanks were full, and though George had dived with an Aqualung only once before he had no hesitation in following Mike down the sloping deck into deeper water.

The litter and rubble increased around them as the needles on their depth gauges crept up the scales. Presently they came across a pile of huge ingots, looking exactly like a fortune in bullion. Mike hopefully scratched one with his knife; it was only pig iron and he continued his swim.

The small clumps of coral that grew everywhere in the sun-drenched shallower regions of the wreck had now been left behind. Sixty feet down it was a dull, gray world, peopled by nightmarish and unreal pieces of machinery. A series of lockers solidified out of the mist; with his diver's knife, Mike prized open one of the doors sufficiently to get a purchase with his gloved hands. It gave slightly; he placed his feet on the deck and the door flew open.

The contents were invisible because of the thick black silt stirred up by the sudden movement; when it had settled down,

Mike peered cautiously through the clearing haze. The locker was full of boxes, about two feet square. He hooted excitedly to George, who had been keeping watch in the background. One of the first rules of diving on wrecks is to be always on your guard; this is still more important in a wreck that is a fifth of a mile long and may attract proportionately large permanent inhabitants.

Carefully, they lifted one of the mysterious boxes onto the deck. For a moment security was forgotten as they both wrenched away at the steel lid. It came open, but inside was another barrier—a soldered tin box, pitted with corrosion. The knives made short work of this obstacle—and there, in rank upon rank like tin soldiers on parade, were Oerlikon shells, their brass cases greeny-blue in this filtered light.

With infinite care, the explorers replaced the box. Here was a hazard that had never occurred to them: had one of their knives struck a percussion cap while they were opening the case, the long-immersed and probably unstable explosive might have detonated.

Rather thoughtfully, they continued on their way, and presently Mike decided that they would leave the deck and go down the face of the steel cliff below them. Catwalks had been built on the outer wall to enable the workmen to move up and down between the various levels of the dock; being independent of gravity, Mike and George had no need for these aids, but nevertheless the flight of steps leading down the side of the dock was so familiar and reassuring that they decided to use it.

They angled down the companionway, grasping the corroded handrails with their gloved fingers so that they could use arms as well as legs to drive themselves into the depths. The endless steel cliff soared above them, so huge that it seemed hard to believe that mere men could have constructed it. They came to a small

platform thirty feet down, but did not pause here. As they swam
on down the second length of companionway, the wave-wrinkled
surface disappeared behind them and only the swiftly rising
streams of bubbles and the pearly light fading overhead indicated
the way back to sun and air.

At last the steel ladder came to an end; the depth gauges read
sixty-five feet, but they were still nowhere near the lowest part of
the dock. Below them the water appeared to be thickening into a
most unappetizing yellow soup; to their right a corridor opened,
and Mike swam into it. As George followed him through the open-
ing, Mike turned and photographed him, silhouetted against the
gray light.

A yawning oblong hole appeared in the floor above which they
were swimming, and peering into it they could see steps leading
down to a yet lower level. Very slowly and cautiously they eased
themselves into this gloomy cave, and followed the steps down to
the deck below. Twice they repeated this procedure, until they
were ninety feet beneath the surface and must at last be nearing
the immense floor of the dock—though they could only guess this,
as the light was now very dim and visibility correspondingly re-
duced.

Mike made one halfhearted attempt to go deeper, but quickly
turned back as the pea soup thickened around him. Besides, George
was using a single-tank lung, and would soon have to return to
the surface for air. It would not be wise to stay down here too
long in this mysterious and menacing gloom.

In their exploration, they had come to the end of the great
steel wall which was the starboard side of the dock. As they swam
back toward it, they had the choice of turning to right or left, and
ascending on the inner or outer face of the dock wall. Mike
hesitated, then pointed to the right; George nodded in agreement,

and together they rounded the corner of the metal cliff.

Who was more surprised it would be hard to say. Coming from the other direction, and only a few feet below them, was the largest fish that Mike had ever seen from such close quarters. It was the inevitable giant grouper—and this time he *was* a giant, all of fifteen feet long. He was so massively built that though he was actually moving he appeared at first to be motionless, like a submarine poised in mid-ocean. His body was about four feet thick, and he could obviously swallow either of the divers at a gulp should he feel so inclined.

They decided not to put this to the test. Suddenly remembering a prior engagement, Mike turned round and headed back the way he had come; there was no need to see if George was following him. They breathed a little more easily when they had risen up to the sixty-foot level, where the fish were once more of a reasonable size, and Mike paused on the way to collect an interesting souvenir. A large copper lamp—the dock's starboard warning light—was fastened to the hull by clamps which soon yielded to Mike's knife. Despite a covering of weeds and barnacles, it appeared to be in good condition, and between them Mike and George brought it to the surface (Plate 33). With the help of a little hydrochloric acid, it was later cleaned up so that today, as it stands in the corner of our living room, no one could ever have guessed that it had spent twelve years at the bottom of the sea. Even the oil lamp inside it is in perfect working order, with the original wick intact.

I met Mike and George in the upper levels of the dock as they brought their souvenir back to the surface; they could hardly wait to remove their mouthpieces before telling me of the grouper lurking in the depths below, and I felt very sorry that I had not gone down with them. But we had used up all our air and had stayed underwater as long as was wise in a single day's diving, so we

reloaded our equipment onto the borrowed boat and sailed back to land.

We now had two interesting problems to solve. Apart from the sheer fascination of exploring this enormous wreck—quite possibly the largest submerged man-made object in the world—we wanted to know how it had got here and what its history had been. The only facts we knew about it was that it had gone down during the war—and that there had been a battleship with her full complement of men inside at the time. As for the details of the disaster, everyone we questioned produced a different story, and it was more than a month before we were finally able to arrive at the truth (Chapter 16).

Our second problem concerned the ruins off Swamy Rock. They were the relics of a civilization at least two thousand years older than the one that built the floating dock, so it seemed a little unlikely that we could find out much about them. Ceylon, however, has the longest recorded history of any country in the world; when the Druids held sway in an England now lost beyond hope of rediscoverey, the priests of Ceylon were keeping written chronicles which, though entangled with legends, give the country's essential history back to the year 534 B.C.

While preparing for our next assault on the sunken dock, we decided that we would try our hand at a little archaeology, and have a look at Swamy Rock from the landward side.

15

THE TEMPLE OF A
THOUSAND COLUMNS

THE great headland of Swamy Rock has a complex history which
reflects, in its comings and goings of many races, the story of
Ceylon itself. Even before Buddhism came to Ceylon around 300
B.C., the rock was sacred to the Hindus, who built at least three
temples on or around it. The largest of these was a colossal edifice
known as the Temple of a Thousand Columns; it stood until 1624,
when it was destroyed by the fanatically religious Portuguese,
during their bloodstained occupation of the country.

During the early 1600's the Dutch also appeared on the scene,
and built a fort at Trincomalee which the Portuguese captured
before it could be garrisoned, after an epic march across the
country. Eventually both Dutch and Portuguese were ousted by
the English; and as I write this the English have also been politely
requested to leave. Today Swamy Rock is approached through an
archway in the walls of Fort Frederick, the bastions of which must
have made the rock almost impregnable to the weapons of earlier
centuries.

Inside the fort, the road leads past well-kept military buildings
among which, surprisingly enough, wander dozens of lovely, dap-
pled deer. Farther up the hill a gate blocks the approach for
wheeled vehicles; our Landrover simply by-passed it into the
bush and continued on up the road.

Just below the highest point of the headland stands a new Hindu temple—so new, in fact, that it has a sacred neon sign on which you are liable to bang your head when you enter. Inside the temple, ranged against the far wall, is a display of five bronze gods—including Siva, his consort, and the elephant god Ganesa.

On the very highest tip of Swamy Rock there stands a single column, said to be one of the pillars of the original temple. The view from this point, four hundred feet above the sea, is both magnificent and vertiginous. One can look for miles along the coast, and see far down into the water washing at the foot of the rock. On one visit, when there was half a gale blowing, Mike insisted on setting up the movie camera on this wind-swept eyrie, and filming the priest making his obeisances on the ledge below. I reminded him that though he had once been a paratrooper he no longer had the essential tool of his trade with him, but it made no difference. To this day I am not certain whether I was more scared for the safety of Mike or the Paillard-Bolex, and I had to avert my eyes until the sequence had been shot.

From this same rock, three hundred years ago, a young Dutch girl named Francina van Reede watched the ship of her faithless lover sail away, and then cast herself into the sea. This tragedy—such a recent incident in the long history of Swamy Rock—has added one more ghost to the legions which haunt this sacred spot.

As soon as we had located a temple attendant who spoke good English, Mike and I described our underwater discoveries and tried to obtain some information about the origin of the ruins. It was not until then that we had any idea of the antiquity of the place; there is evidence that a temple has stood on Swamy Rock for thirty-five hundred years, so it must be one of the oldest sites of continuous worship in the world.

The priests were extremely interested in our submarine explora-

tions, and asked us if we would make a search for some of the temple's missing relics. In particular they were anxious to locate the Lingam—the phallic symbol which is the emblem of Siva worship—which one might reasonably suppose to have been one of the first things the Portuguese iconoclasts threw into the sea. We were perfectly willing to assist in the restoration of this missing item from the Hindu pantheon, slightly embarrassing though it was even to post-Freudian Westerners. However, the immense jumble of stone—natural and artificial—covering so many thousands of square feet of the sea bed made any systematic search hopeless. The best we could do was to photograph the most clearly defined pieces of architecture so that those concerned would know just what was lying in the sea at the foot of the rock.

We even persuaded one of the Hindu priests to try his luck with a face mask, but without much success. He splashed unhappily around in the water, unable to reconcile himself to breathing through his mouth instead of his nose, and eventually gave it up as a bad job.

By the time that Mike had finished operations with the Rolleimarin, the battered stonework at the foot of Swamy Rock was probably the most-photographed underwater ruin in the world. It was not particularly glamorous in its present state, whatever it might have been in the past—but with all due deference to Commander Cousteau and his colleagues, we felt that it made a welcome change from Greek amphorae.

One of Mike's studies is shown on Plate 20. And if you think that it looks like an advertisement for underwater watches, you are perfectly correct. Messrs. Rollex had just sent us a "Submariner" for test, and we thought the least we could do was to let them have some photographs in return for their watch.

It was not until some weeks later, when we were back in

Colombo, that we learned the history of Swamy Rock from Dr. W. Balendra, who has been largely responsible for the erection of the modern temple and has made the place a subject of special study.

The destruction of the temple began on the Hindu New Year's Day, 1624, when Portuguese soldiers disguised as priests mingled with the worshipers and so entered the sacred precincts. They waited until the temple was deserted by the New Year's Day crowds, who followed a procession down the hill and left only a few priests on Swamy Rock. Then the plundering started; probably all those left in the temple were killed, and in a few hours the accumulated treasure of almost two thousand years was looted. The Konesar Temple—to give it its proper name—was one of the richest in Asia. It must have contained a fortune in gold, pearls and precious stones, and though the Portuguese must have captured most of this wealth, they did not get it all—as was demonstrated three hundred years later.

In 1950 some workmen were digging a well in Trincomalee when they came across metal about a yard below the surface. Further excavation revealed the statues of three Hindu gods, which were handed over to the authorities—not, one imagines, without some reluctance, for they comprised more than a hundred pounds' weight of gold and copper alloy.

Further inquiries revealed that two other statues had been unearthed some months previously without the Archaeological Commission or the local authorities being any the wiser. All that Dr. Balendra's brochure "Trinocomalee Bronzes" says on this subject is that "Persistent search was made for these finds . . . and they were ultimately handed over to the Chairman of the Committee appointed to restore the temple." This discreet statement, one cannot help thinking, leaves a great deal unsaid.

The five statues which now stand in the new temple are among

the finest examples of Hindu bronze sculpture known to exist. In particular, the seated figure of Siva, which dates from about the tenth century A.D., is regarded as a masterpiece.

It is easy to guess how these statues escaped the attentions of the Portuguese. During the looting of the temple, the priests must have seized the most sacred images and buried them where they hoped they would not be discovered. They were found, in fact, about five hundred yards from the temple, and one cannot help thinking that it would be most interesting to go over the rest of Swamy Rock with a metal detector. . . .

After the looting of the temple, the building was destroyed and the masonry either thrown into the sea or used to construct the fort which still guards the foot of the hill. Some of the temple's original stonework can still be identified in the European building, and by the entrance of the fort is a stone slab containing a curious inscription, which has been translated as follows:

> O King! The Franks shall later break down the holy edifice built by Kulakkodan in ancient times; and it shall not be rebuilt nor will future kings think of doing so.

The word "Franks" was applied to all Europeans, but the prophecy is certainly remarkable as it was apparently carved centuries before the Portuguese appeared on the scene. Their commander, Constantine de Sá, himself records the existence of the prophecy and was sufficiently impressed by it to send a translation to Lisbon. Perhaps he even felt obliged to make it come true —though the treasure of the Konesar Temple would have provided sufficient incentive.

In any event, the men who looted the temple did not long enjoy their gains. Six years later de Sá and his army of three thousand men were enticed into the jungle in the hope of finally conquering

the reigning Sinhalese monarch. With the Portuguese were troops of local militia, who had learned a lesson from the fifth column tactics the Europeans had used to enter and overthrow the temple. The Ceylonese recruits turned on the interlopers and slaughtered them to the last man.

Siva, the god of destruction, had worked his revenge. Today, more than three hundred years later, he is still worshiped on Swamy Rock, while the men who smashed his temple are forgotten and their empire destroyed.

16

A VERY EXPENSIVE NIGHT

ON OUR return visit to the sunken dock we had a definite but
perhaps ill-advised objective in view. George Sandham, Mike and
I all had fully-charged Aqualungs and cameras that had been
freshly loaded with film, and the plan was to pay a call on the giant
grouper. We felt fairly confident that he would not be aggressive
if he met all three of us at once, and hoped that he might stay to
have his picture taken. It is a wonder, when one comes to think
of it, that any fish remain in the vicinity of an Aqualunger, as he
undulates through the water ejecting intermittent clouds of bub-
bles. To the denizens of the deep, we must look quite as strange
as any Things from outer space will ever do to us.

Once again using the dock's control house as our base, we as-
sembled our equipment, put on our lungs, and sank slowly down
the steel wall below us. Sometimes when one goes back to a spot
that has made a considerable impression on the first visit, one feels
a sense of disappointment. That was definitely not true here; if
anything, the gargantuan wreckage all around us was even more
awe-inspiring than before. A huge chain, strong enough to secure
a battleship, swooped down through the water beside us, possibly
going to an anchor on the bottom more than a hundred feet below.
As we followed it down to the sixty-foot level the light grew dim-
mer around us, and for my part I felt a sense of indescribable op-
pression. Perhaps the knowledge that at least one giant fish was
lurking in the water near at hand had something to do with it,

The flooded bows point on a voyage to nowhere.

The Greek steamer *Aenos* the day after she grounded.

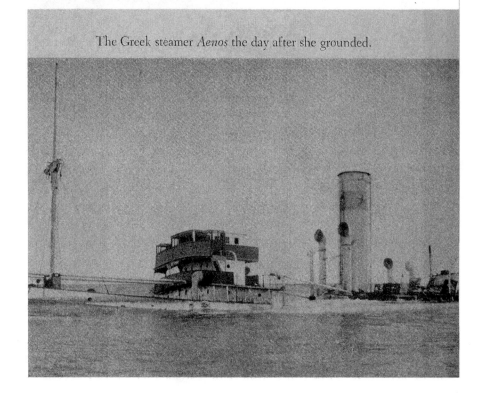

The monsoon seas begin breaking up the *Aenos*.

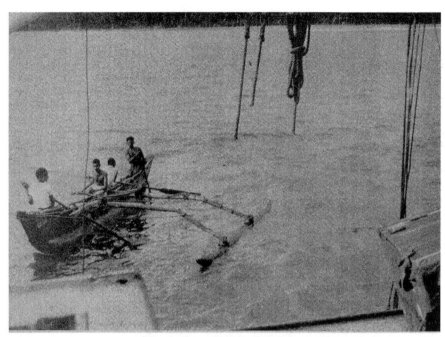

The looters arrive at the *Aenos*.

Some souvenirs of the *Aenos*. Left to right, Rupert and Isabel Giles, Rodney Jonklaas, George Sandham.

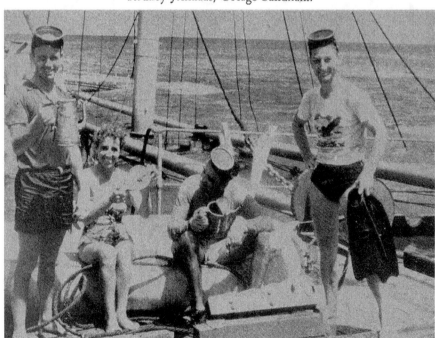

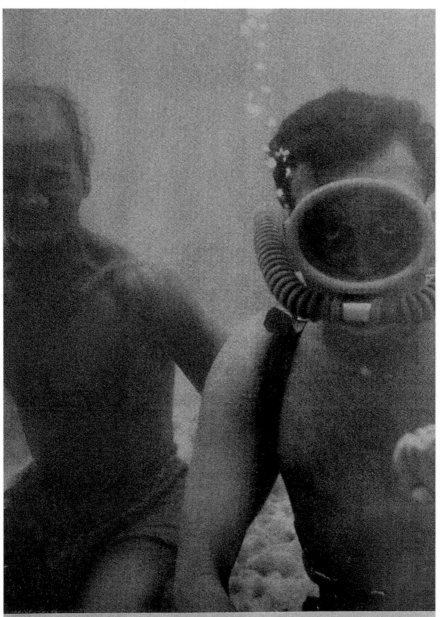

Old and new meet on the sea bed, as a pearl diver watches
Rodney at work.

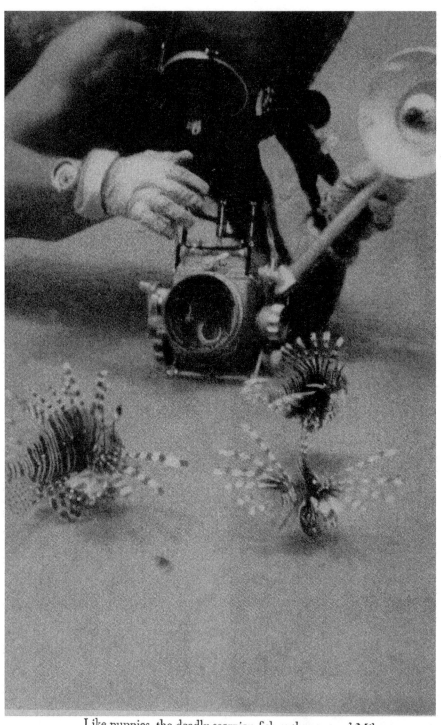

Like puppies, the deadly scorpion fish gather around Mike.

but I do not think that was the only reason. I was not only affected by the deepening gloom and the pressure of the chill, stagnant water, but also felt dwarfed and insignificant against the mountain of steel looming above me. There is a kind of nightmare in which a man imagines he has shrunk to a fraction of his normal size, so that he moves among the objects of the normal world like Gulliver in Brobdingnag. I have never experienced it—but now I know what it must be like.

It was already too dark, and the water was too turbid, for any useful photography, though we had not yet descended as far as Mike and George had done on their earlier dive. They had gone at least thirty feet below the gallery which we were now cautiously skirting, trying to make up our minds whether to go any deeper.

The decision was made for us when a massive, dimly seen shape cruised in out of the gloom, made a quick reconnaissance of us, and disappeared before we could get our cameras into action. It was another grouper—just a little one, about six feet long. I think that at this moment we all decided that he had gone to fetch his big brother, and that we might as well start heading for the surface. We would have stood our ground had the water been clear and had there been a hope of getting good photographs, but it was foolish to run unprofitable risks.

Mike turned back toward one of the great galleries which ran along the lower levels of the dock wall, and I started to follow him. Visibility was now extremely poor and seemed to be getting worse; it was like a London fog on a gloomy November evening. I glanced back to see if George was following me, and was disconcerted to find no sign of him. Since this was a place where unity was essential—and it was also only the third time George had been down with a lung—it was most important that we all kept together.

While I was trying to locate George in the fog, and wondering how many groupers were closing in on me, I lost Mike. For a moment I vacillated; then I decided that Mike was quite capable of looking after himself, and concentrated on finding George.

There was something very ominous about the way in which the fog had suddenly thickened. Surely we could not have stirred up so much sediment during our brief tour; the only thing I could imagine that might have caused such a commotion was a fight between George and the grouper. At once my imagination, heightened by my weird and depressing environment, filled in all the horrid details and their possible consequences. Was there any hope of recovering the Aqualung George had been wearing? It was a new one and it seemed a pity to lose it. And who would break the news to Mrs. Sandham?

I decided that the only thing to do was to head straight back to the surface and await Mike's arrival; when we had combined forces again we could descend once more to find what had happened to George, assuming that anything was left of him.

As I returned to the brighter, clearer water in the upper levels of the dock, my spirits revived somewhat and my more imaginative flights of fancy no longer seemed very convincing. Nevertheless I was almost as surprised as relieved to find George waiting for me just below the control house. "Where the devil have *you* been?" he asked.

Presently Mike arrived in a cloud of bubbles, and the three musketeers were reunited once more. After a brief council of war, we decided to forget about groupers for today, and to make our first visit to the far wall of the dock, where the great crane reared above the water in splendid isolation.

Though we were only swimming from one side of the dock to the other, and not along its length, the distance seemed enormous.

We followed the catwalk which spanned the width of the dock like a flimsy bridge, and at last reached the other side of the great thousand-foot-long box. The first thing we encountered, as we dived down to the upper deck, was a gun turret which at one time had probably mounted a Bofors or similar weapon. The gun was gone, but a pile of unused shells lay on the deck below the turret.

We continued our swim along the deck, and suddenly found ourselves passing over a group of huge smokestacks like the funnels of a destroyer. The trelliswork of the great crane—designed to lift the engines of battleships—loomed above us, reaching all the way to the surface and continuing fifty feet on into the air. The smokestacks, we assumed, marked the site of the dock's power station, which was probably big enough to supply the requirements of a medium-sized town.

We swam down toward the base of the crane, and its control cabin, itself the size of a small house, rose up to meet us. Cautiously we approached the gaping windows and looked through the cabin, over the great winches still wound tightly with steel cable, and out through the softly illuminated doorway on the other side, twenty feet away.

In a flash of silver, seven great caranxes cruised majestically past, framed for a moment against the pearly-blue iridescence. They were a beautiful sight—the first game fish we had met on the dock. The smallest was over fifty pounds, and for a moment at least two of us regretted that we had brought cameras instead of guns.

We swam around the cabin of the crane until we came to the door, and slipped through the entrance, being careful to avoid the razor-sharp barnacles. The operator's seat was a broken metal cup lying on the silt that covered the control panel; how it had managed to get there we could not imagine. A solitary light bulb, *sans* shade,

still hung from the sponge-covered ceiling. The water was cold and stagnant, and the sediment stirred up by the beat of our fins hung in the dim-lit cabin, making it seem ever more mysteriously gloomy than before.

I took a few flash shots of Mike, and then we swam out of the crane and dropped onto the deck below it. Beside us now were the huge bogies upon which the crane had once been able to run the length of the dock, and here we found a piece of machinery so familiar, yet so out of its normal context, that it was some seconds before we realized what it was. Standing on the deck in all its proletarian glory was a common or Main Street air compressor, and we could hardly help looking round for the pneumatic drills.

At this moment I started to have a little trouble with my Aqualung; there was a leak somewhere, and with every breath I swallowed half a mouthful of water. After a while I got fed up with this, and decided to return to the surface. Waving good-by to Mike and George, I spiraled up the scaffolding of the great crane, threading a path in and out of the girders until the wave-chopped surface appeared overhead. After waiting for a few minutes at a depth of about ten feet, to give myself time to decompress, I bobbed up to the surface and removed the breathing tube from my mouth. Luckily, I was carrying my snorkel (a rule I never break on extended dives) so I had no trouble in making my way back to our base on the other side of the dock. Breathing through the snorkel I could continue to swim with my face below water, so that I could see everything beneath me. Indeed, I had no choice but to swim this way, since the heavy lung on my back kept me submerged. Though an Aqualung is weightless underwater, it is a very different matter when you try to swim with it on the surface, and a diver with empty tanks and no snorkel breathing tube can quickly get into real trouble.

A Very Expensive Night

I had not realized how cold it was sixty feet down; the water seemed deliciously warm as I made my leisurely way back to the control house and the boat anchored beside it. When I arrived there, I cleared my Aqualung of water and decided to make another dive. The reason that prompted this was rather trivial; I had one flash bulb still with me and felt it was a pity to have brought it all this way without using it.

Looking back on my behavior, one would almost think I was suffering from nitrogen narcosis—the so-called rapture of the depths which destroys one's judgment. For with practically no hesitation, I decided to swim down to the bottom of the dock in the hope that I might run into the giant grouper and get his photograph. My reasoning (if it can be called that) seemed to be on these lines: the water down there might be clearer now, and the poor little fellow wouldn't be as scared by one diver as he might be by three.

I let myself drift slowly down one of the enormous anchor chains; being somewhat overweighted, it needed no effort on my part to sink down into the depths. Once again the light began to fade around me, and I felt very remote and isolated from the familiar world. Mike and George, I knew, were a couple of hundred feet away on the other side of the dock, where I had left them at the crane.

Very slowly, the huge metal walls flowed upward past me as I let my two or three pounds of excess weight carry me down to the depths which we had barely touched and had never explored. I was completely relaxed, making no movement at all as the pressure increased and the light became greener and fainter. Now I was about fifty feet down, and at any moment would be entering grouper territory.

And at that instant I was firmly and vigorously grabbed from behind.

Did my past life flash before me? Frankly, no. I am still a little puzzled by my reaction; in theory I should have been scared clean out of my Aqualung harness, but in fact I never felt a trace of that icy terror I have once or twice known underwater for reasons which turned out to be false alarms. I remember thinking, in the very instant of contact, "It *can't* be a shark or grouper—if it were I'd have been bitten in two by now." The thought was so immediate that it blocked the instinctive fright I should have felt, and by the time I had completed it I had already turned round—and was facing Mike.

He and George, unknown to me, had swum back across the wreck and had seen me falling, motionless and apparently unconscious, down into the abyss. *They* were the ones who had been given the fright, and Mike had dived after me to see if I was O.K.

By this time we had all run out of air, but not out of energy. We amused ourselves for another hour by skin diving round the upper levels of the wreck, and Mike started the rather hair-raising stunt of swimming into a hatch on the main deck, twenty feet down, passing along the corridor inside, and emerging from another hatch several yards away. Eventually I built up enough courage to follow him; there was no real danger involved as long as one kept one's head and didn't get tangled up in any obstacles inside the wreck. A surprising amount of light leaked down through the open hatches, and once inside the dock my eyes quickly accustomed themselves to the interior illumination, so there was no risk of losing my way.

Oddly enough, I had avoided going down into these hatches when wearing an Aqualung—I hated the idea of getting the breathing tubes caught in any of the pipes and fittings I knew must

abound inside the dock. I felt much happier, when I had got used to the feeling, swimming round inside these upper corridors of the dock without any breathing gear at all. By this time I seemed to have got my second wind, and on the last dive I made before calling it a day I scared my colleagues by staying inside the wreck for over a minute.

As we sailed back to land, having spent four hours exploring perhaps one-hundredth of the immense structure lying on the harbor floor, we continued our discussion of its origin and history. Dick Tame, our pilot, told us that the only person who could give us the true facts was the Senior British Naval Officer at Trincomalee—he had been on the dock the day it went down. We did not like to bother the S.B.N.O., however, as we knew that he was preparing for a visit from the First Sea Lord in the very near future. A few days later Lord Mountbatten turned up at Trinco—and wasted no time getting into the water with his spear gun. We could have shown Lord Louis a fish or two to use as target practice.

It was more than a month later that we managed to catch the Senior British Naval Officer, Captain C. C. Suther, R.N., at a spare moment between visiting admirals, and to learn the little-known facts about one of the major strategic disasters of the Far Eastern war—a disaster in which the human casualties came to one bruised thumb.

Admiralty Floating Dock 23 had been built in Bombay, and towed down to Trincomalee by tugs. Two smaller vessels had been lifted in the dock before its next—and, as it turned out, final—assignment, the 30,000-ton battleship *Valiant*. Late one August night in 1944 Captain Suther—then gunnery officer of the ship —was quietly playing bridge with his skipper and two other officers on the quarter-deck. The *Valiant* was sitting sedately in the dock,

and had been raised almost clear of the water. Another couple of feet, and she would be completely dry. Above her towered the four great cranes of which we had explored the sole survivor.

The dock—and the ship it supported—floated on three enormous buoyancy tanks, a large central one providing most of the lift and two smaller ones at either end controlling trim. The main tank alone was not enough to raise the *Valiant* clear out of the water, and the subsidiary tanks were now also being emptied as the dock's compressors pumped air into them. Inch by inch, dock and battleship—a combined weight of perhaps a hundred thousand tons—were being lifted out of the water.

With a sudden, rending roar the stern buoyancy tank tore loose and ripped upward with an impact of thousands of tons. It crashed into the *Valiant*, wrecking two of her screws and one rudder. More serious still, it holed the dock's main buoyancy tank, so that the entire structure started to sink—with the battleship inside it. To add to the confusion, the power supply failed and all the lights went out until the *Valiant* could get her own generators going.

The water round the dock was boiling as millions of cubic feet of air gushed out of the holed tanks. Huge balks of wood were shot high into the air—and then, as the dock tilted ever more steeply, the great cranes started to move along their tracks. Captain Suther was trying to calculate how much shelter his fifteen-inch guns would give him when one of the hundred-foot-high cranes went stampeding the length of the dock, mowing down the chimneys of the power plant like skittles.

The *Valiant*, wedged in the sinking dock, was now tilted upward at such a steep angle that it was hard to walk on her decks; her stern was almost underwater when suddenly—and fortunately —her own buoyancy made her tear loose, shooting everyone aboard her a couple of feet into the air. Though she was still tethered to

the dock she was no longer part of it and could remain afloat as the great structure sank around her.

The cause of the accident remains to this day buried in Admiralty files. Perhaps there had been faulty construction somewhere; perhaps the *Valiant* had been incorrectly positioned, so that the forces on the dock were not properly balanced. Whatever the explanation, it was a most expensive mistake, and one which must have given some headaches to the Far East command. A brand-new floating dock, costing millions of pounds, had been sunk with all its equipment and fittings. And a 30,000-ton battleship had been put out of commission.

There was at least one person on the *Valiant* that hectic night who had kept his head. When the members of the captain's bridge party had leaped to their battle stations, they had left one player behind—a Dutch officer attached to the ship who had no specific duties to perform in an emergency such as this. As the night filled with shouting and tumult around him, thousand-ton cranes started galloping back and forth, and geysers of escaping air gushed out of the boiling sea, he carefully collected the four abandoned hands and put each set of cards in a separate pocket. Then he retired to his cabin and spent the rest of the night in meditation.

The next morning he presented himself to the *Valiant*'s exhausted and disconsolate captain, saluted smartly, produced the set of cards and said: "Sir, if you had followed with the six of clubs you would have won that hand—so."

I can think of no better proof of the difference in temperament between the phlegmatic and steady-going Dutch and the mercurial, excitable British.

There was nothing that could be done with the *Valiant* but to patch her up so that she could make her way back to England for repair. With two screws and one rudder she could manage twelve

knots, though her steering left much to be desired—as the pilot at Suez discovered when he tried to take her into the canal. She rammed the bank and blocked the entire canal for several hours, before emerging backward at full speed and wiping out a whole line of buoys. After that, not even the most lavish entertainment which the *Valiant's* mess and bar could provide would induce the authorities to let her make another assault on their expensive canal. She had to go home round Africa, and took four months to make the journey from Trinco to Plymouth.

It cost a million pounds to repair and refit her; she was ready for action again when the war inconsiderately ended, and she was promptly scrapped.

Adding everything up, the unique diving Mike and I were able to enjoy in Trinco harbor cost the British taxpayer a pretty penny. At a rough estimate, our underwater entertainment has so far worked out at approximately a million pounds an hour. But, of course, we hope to go back again—and that will bring the average down to a more reasonable figure.

17

TROUBLE WITH DYNAMITE

WE ARE rather proud of the fact that our visit to Trincomalee was to strike a blow for justice and to put fear into the hearts of wrong-doers. Perhaps that sounds a somewhat self-important statement; let the facts speak for themselves.

One afternoon, as Mike and I were swimming out to Swamy Rock, we felt a sudden, sharp blow—not painful in any way, since luckily we were too far away from its source. We had felt that underwater impact before, at Dondra Head, as described in Chapter 6. Surfacing swiftly, we looked at each other. "Dyna-miters," we said simultaneously, and looked around for the culprits.

There in the shadow of Swamy Rock were half a dozen cata-marans, and we paddled toward them as fast as our rubber dinghy could skim over the water, i.e., at a good 2½ knots. The grinning fishermen watched our approach with complete equanimity, but their smiles faded when we produced our cameras and started to record the carnage on the sea bed. For scores of yards in every direction, the sand was littered with shining silver bodies. The charges had detonated in a school of sardines, and had wiped them out in thousands.

Luckily, it did not occur to the fishermen to destroy the evidence we were collecting by dropping dynamite on *us*. We got our picture (Plate 25) and in due course handed it over to Rodney Jonklaas to use as ammunition in his anti-dynamiting campaign, which had been in progress for some years with negligible results.

Rodney, who wields a trenchant typewriter, at once wrote a scathing article describing the techniques and activities of the dynamiters, the way they were organized into gangs with bosses who paid their fines on the rare occasions when they were caught, and the general ineffectiveness of the fisheries inspectors in bringing the criminals to book. He could now write with freedom, having left the Department of Fisheries a few weeks before, and some of his remarks must have made his ex-colleagues squirm.

The article duly appeared in a leading Ceylon daily paper, with our photographs of the dead fish on the sea bed and the dynamiters' minions diving to collect them. The editor had toned it down slightly so that it was no longer libelous, but it still packed a punch and it was obvious that Rodney would be well advised not to make any lone trips in future to the areas frequented by the maritime thugs he was attacking. They were likely to react violently to opposition; one man who had tried to report their activities had been mysteriously shot.

The newspaper—the *Ceylon Observer*—followed the article up with an editorial, and for a few days there was an indignant correspondence from readers who felt as Rodney did. One of them made a suggestion which, though superficially attractive, hardly bore serious inspection. He pointed out that the Veddas, the aboriginal inhabitants of Ceylon, a few tribes of whom still exist in the jungles, capture fish by means of a powerful narcotic, which they prepare by crushing various herbs. When dropped into the water, this drug paralyzes the fish, who are either caught when they float to the surface, or else revive and escape unharmed. Couldn't this drug, the writer suggested, be used instead of dynamite?

Unfortunately, he failed to realize that a technique which would work in a small pool, where the chemical could remain concentrated, would be utterly useless in the open sea.

Rodney was not optimistic enough to hope that his article, even with the help of the photographs, would do anything more than make the dynamiters mad at him. He'd written similar articles before, and officialdom had failed to be stirred from its apathy. A month later, however, we were able to strike another blow in the propaganda campaign.

One of the things I like about the Rest Houses of Ceylon is the interesting people one meets there. Indeed, since they are the only form of public accommodation available outside the half-dozen towns, if one took up permanent residence at one of the better Rest Houses one would eventually meet everyone in Ceylon whose duties caused him to travel around the country.

Thus it was at the Trincomalee Rest House that we met a young Crown Counsel—roughly the equivalent of a public prosecutor or D.A.—who was on circuit trying to obtain convictions against the current crop of murderers. Ceylon averages one and a half murders a day, which is an impressive performance for a country whose population is about equal to that of London. But we will return to the fascinating subject of homicide later.

As a relaxation from stringing up Ceylonese who had hacked their girl friends to pieces (or, as was more frequently the case, their girl friends' boy friends), the D.A. had brought along an inflatable surf ski. It was a war-surplus item, designed for the use of frogmen making assaults on enemy objectives, and one afternoon about two hours before sunset I suggested that we should head out to Swamy Rock on it. The D.A. was delighted with the idea; Mike had gone off on a trip of his own, and so we borrowed his face mask and flippers.

The ski was buoyant enough to carry us both, and we made good speed out to the headland—the D.A. paddling with his arms in front, and I kicking with flippers in the rear. Once I dropped over

the side to check the underwater visibility, and was promptly sur-
rounded by a school of barracuda (Plate 14) who looked me over
with that coldly calculating expression which is so unsettling, how-
ever often you have met it. I could not help remembering that,
when I was last in New York, Jonathan Leonard, the amiable,
erudite Scienceditor of *Time* Magazine, had told me that he had
seen a photograph of a man after a pack of 'cuda had dealt with
him. There were still a few pieces of flesh left on the skeleton.

Perhaps these Ceylonese barracuda were good Buddhists, or
else they decided I was poor eating, for they made one swift circuit
of me and shot off into the haze. We got to Swamy Rock with no
other incident, and I spent half an hour taking my companion on
a guided tour of the ruins and the wreck at its base. Although the
light was failing, and the water was dirty, he had never seen any-
thing like it in his life and was completely fascinated by the sub-
merged carvings and the georgeous-colored fish swimming among
them.

The sun was now very near the horizon, and I decided that it
was high time to head for home. I did not at all like the idea of
swimming after dark with barracuda and sharks around; it was
true that we could take refuge on the surf ski, but a choppy sea
had now come up and it was much easier to stay in the water,
towing the ski behind us. We paddled slowly homeward in the
teeth of the rising wind, while the light on the sea bed below us
gradually faded. The boulders and clumps of coral above which
we were passing became dim, mysterious blurs; sometimes I would
see a shape on the sea bed that baffled me completely and would
have to dive down to within a few feet of it before I could recog-
nize it as a large sponge or an unusual example of soft coral.

We were halfway back to shore when the sun disappeared com-
pletely. I would have expected the sea bed to become dark at once,

but instead it remained aglow with a faint, shadowless light, quite strong enough for us to make out a surprising amount of detail. But this light might vanish at any minute, and I decided that we would waste no more time diving down to the sea floor to look at the intriguing shapes that appeared and disappeared beneath me.

We were still a hundred yards out when I broke that sensible resolution. A diver gets to know the area in which he works, and though I had been this way only two or three times before—and then under very different lighting conditions—I suddenly realized that the sea floor beneath me was not at all as it had been on my earlier visits. Letting go of the surf ski, I dived down to the bottom—and was aghast at the destruction I saw there. The last time I had come this way, there had been a magnificent coral mushroom at this spot, the home of a dozen splendid fish of twenty or thirty pounds' weight.

Now the great coral boulder lay scattered in fragments over the sea bed, destroyed as completely as the Temple of a Thousand Columns had been by the Portuguese. All life had fled from this desolate spot; the fish living here had been killed, and there was no hope that others would return—the food and shelter that might have sustained them was gone.

I surfaced at once and dragged my companion down into the glimmering darkness so that he could see the havoc with his own eyes. If he was a little unhappy at swimming down into swiftly gathering night beneath the sea he gallantly hid his feelings. There was just enough light to see the damage that the dynamiters had wrought; the illumination was about the same as beneath heavy clouds on a moon-lit night, and our eyes barely had time to adapt themselves before we had to swim back to the surface for air.

Two quick dives were all we dared to risk; the sun had set ten minutes ago, and heaven alone knew what was swimming thought-

fully around us trying to make up its mind. When we finally hit the beach, it was completely dark.

Back at the Rest House, I made sure that my learnèd friend appreciated the significance of what he had seen, on the principle that there was no hope of stopping the dynamiters until we had educated the law to take them seriously. A few days later, by a fortunate coincidence, one of the local explosives experts was brought up for trial, with results that were probably a shock to his colleagues. Instead of getting off with a fine, or a month in prison, the magistrate gave him the maximum sentence—six months at hard labor. And in passing sentence he went out of his way to say that all future offenders would be punished accordingly, adding that he himself had not been aware how serious this matter was until he had seen Rodney's article.

We all felt very pleased with ourselves when we read this report. At the same time, we had certain qualms. There might be a lot of unused dynamite accumulating on the east coast, and perhaps it would be as well if both Rodney Jonklaas and the Clarke-Wilson Expedition kept away from Trincomalee for some time to come.

18

FLIGHT FROM TRINCO

It was while returning from Trincomalee to Colombo that I was introduced to the pleasures of flight. That may seem a strange remark from someone who has flown the Pacific once and the Atlantic five times, and has clocked up countless miles on internal airlines in three continents. All that flying, however, had been done inside Constellations, D.C.6's, Stratocruisers and similar impressive pieces of machinery which more or less insulate the passenger from the element through which he is traveling. When I came back from Trinco by Air Ceylon I also felt that I had gone back in time, and was separated from the Wright brothers by only thirty years instead of more than fifty.

The plane (I nearly wrote planes, but that may be incorrect) used on the Colombo-Trincomalee service is the little prewar De Havilland "Rapide," a twin-engined biplane with fixed undercarriage, canvas-covered wings and wooden-bladed propellers without pitch control—in fact, containing no technical features which would have caused surprise to a World War I aviation mechanic. Despite its age, the Rapide is one of the safest and most efficient airplanes ever built. And since almost the entire upper half of the eight-seater cabin is transparent, the passengers have a view which no one who is used to the keyhole vision available in modern planes can easily imagine. A flight in a Rapide combines all the best features of aviation and Cinerama, and I hope that Air Ceylon refuses to be bullied into retiring its faithful warhorse(s).

The economics of this cross-Ceylon service baffled me. There was just one other passenger besides myself on the day I flew back to Colombo, and I understand that this is quite usual. But the fare for the 150-mile flight (which allowing for one stop took two hours) was twenty rupees—say four dollars. And the five-mile bus rides at either end were free. . . .

I never solved this mystery, but if Air Ceylon was a charitable organization I was not too proud to accept its largess. The little biplane leaped gaily into the air at the end of Trinco runway and, as a change from seeing Ceylon from underneath, I had my first glimpse of it from above.

My first impression was the way in which Trincomalee was completely isolated from the rest of the country by the barrier of jungle. There was no hinterland of clearings or farms; the town was concerned only with the sea and had turned its back upon the land. After a while, however, isolated settlements began to appear—lonely little villages lost in the ocean of the forest. Two thousand years ago, England might have looked much the same as this if seen from the air.

But this was not an ancient, primeval forest over which I was flying. When my country was mostly jungle, this land had been a fertile paradise of farms and gardens, irrigated by a system of reservoirs and waterways the like of which the world has never seen again. At the height of its glory, before war and disease destroyed the patient toil of centuries, Ceylon had a population of perhaps fifty million, instead of the eight million of today. Much of the land beneath me had been intensively cultivated; when the Roman legions were pacifying the natives in savage Britain, the forest here had been in full retreat before fire and axe.

It had bided its time; when the invaders from India and finally Europe had done their worst, it was the jungle that had recaptured

the land which the Sinhalese no longer had the power to hold.

Several times on the flight we passed above the artificial lakes which are now the chief remaining monuments of the ancient irrigation system. Some of these are so huge that even the word "lake" is inappropriate, and their modern name of "tank" is simply ridiculous. In their heyday, some were as much as forty miles in circumference, and were virtually inland seas. Together with the immense domes of the dagobas, they form the most impressive monument to the genius of the Sinhalese.

Near the mid-point of the flight, we came upon a monument of a different kind—a reminder that the history of this beautiful land is as bloodstained as that of any in the world. The 165 kings who had ruled Ceylon in continuous though frequently disputed sequence for 2,300 years had included many great men, but also monsters who make John or Richard the Third appear paragons of virtue.

Rearing out of the jungle was an enormous and curiously shaped rock—a single giant boulder four hundred feet in height. Its upper portion overhung the base, so it was hard to see how it could be climbed. Yet the flat summit was completely covered with the walls of ruined buildings, some of which must have been of great size.

We were flying above the fortress of Sigiriya (Lion Rock) built toward the end of the fifth century A.D. by one of the most hated of Ceylonese kings in a vain attempt to escape the retribution he had earned.

Kasyapa I had murdered his father Dhatu Sen to attain the throne, but this fact would not in itself have roused much opposition as the old king was a tyrant whose cruelty had alienated his people. It was the manner of the murder that turned the nation against the parricide; in a fit of rage because he refused to reveal the

hiding place of the palace treasure, Kasyapa had entombed his father alive.

Though the luxury of a relatively painless death by suffocation was not often enjoyed by the enemies of the Sinhalese monarchs, this crime aroused such horror that Kasyapa was virtually ostracized by his subjects. His younger brother—whose assassination he had carelessly bungled—fled to India and raised an army against the king.

Eventually, prompted by both fear and remorse, Kasyapa left the capital of Anuradhapura and built a fortress on the impregnable rock of Sigiriya. The cliffs rise vertically for two hundred feet, and overhang for the remaining distance, so the citadel could be defended by a handful of men against an army. Kasyapa protected himself against starvation by enclosing the fertile ground at the foot of the rock by a series of immense walls and moats behind which crops could be raised in safety.

Here the king lived in exile, ruling the country that hated him while over in India his brother prepared his revenge. It was not an uncomfortable exile; the palaces, courtyards and baths built with unimaginable labor on the bare plateau four hundred feet above the plain were spacious enough. And in one of the galleries high on the face of the rock is a remarkable series of frescoes, almost perfectly preserved, showing the ladies of the king's court, who presumably accompanied him to Sigiriya. (See Plate XV.) At first sight they appear to be wearing nothing above the waist, but on more careful examination it can be seen that the artist, with extraordinary skill, has shown them wearing completely transparent upper garments. I was surprised to learn that such materials existed fifteen hundred years before the invention of Cellophane; in any event, it is very obvious that the king was well provided with entertainment in his windswept fortress eyrie.

It took eighteen years for Kasyapa's doom to overtake him. At long last his young brother returned from India at the head of a mighty army, and laid seige to the fortress. He could not even breach the wall surrounding it at ground level, and Kasyapa would have been safe indefinitely if, unable to endure repeated taunts of cowardice, he had not left his stronghold and challenged his brother on the open plain.

In the resultant battle Kasyapa was either killed or committed suicide when he realized that he was defeated; according to one version, his own elephant trampled him into a bog. He left to the future an infamous name—though he was by no means the worst of the Sinhalese kings—and the fortress rock which still dominates the surrounding landscape one and a half thousand years later.

Beyond Sigiriya the land rises slowly toward the central spine of mountains which gives Ceylon its two climates. The Rapide began to climb until presently it was quite chilly in the cabin, but the interest of the view took my mind away from the slight discomfort. On my left—to the south—I could see the mountains rising in rank upon rank toward the hidden hill capital of Kandy, where the last of the Sinhalese kings held sway until deposed by the British in 1815. We were passing from the eastern dry zone to the southwestern wet zone, and the land beneath was becoming more fully developed and cultivated. There were still plenty of wooded areas, but now the hillsides were terraced and planted with the millions of bushes of the great tea estates.

I had scarcely time to realize the change of scenery below me— from the undeveloped east to the crowded, populous west—when we were coming down out of the hills and the sea was ahead. There lay Colombo with its huge four-thousand-foot-long breakwater, and the great ships lying at anchor in the harbor. The plane wheeled over the city, then flew along the coast so that I could look down into

the suburbs ranged along the main railway line following the edge
of the sea. Our own tawdry Bambalapitiya—meaning "Plain of the
Bamboo Forest"—was obviously misnamed today, with its hun-
dreds of single-storied buildings, rows of busy little shops, and
occasional cinemas looming above the monotony of the whole. But
if the bamboos were gone, there were still plenty of coconut palms.
Much of Colombo may appear shabby and run-down (tropical sun
and monsoon rains are very hard on the work of the house painter)
but it is a city where there are still many open spaces and men have
not yet crowded all the trees out of existence.

When I landed two hours after leaving Trincomalee, I felt I
had seen a cross-section of the country not only in space but also in
time. And the flight left a question in my mind which only the
future can answer.

Will the new rulers of Ceylon, I wondered, ever match the
achievements of their ancestors, and use the techniques of modern
science to reconquer the virtually uninhabited three-quarters of
their land? And—more important—will they at the same time be
able to give all their people the freedom *and* security they never
possessed under the British, the Dutch, the Portuguese, or any of
their own long line of kings?

19

EKTACHROME AND DECAPODS

WHEN I returned to Colombo, I left Mike behind at Trincomalee to continue taking photographs, since I had been reluctantly compelled to admit that he was much better at it than I was—and, in any event, I had to catch up with several weeks' arrears of writing. By this time the expedition had a temporary-acting-unpaid additional member, a young British sailor whom Mike had encountered in the Shipping Master's office during one of the regular visits he paid to see if there were likely to be any good wrecks in the near future.

Fred Bloomfield had been rather careless; he had lost his ship. He had gone ashore with another friend in the crew, and when some considerable number of hours later he arrived back at the dock he discovered to his horror that his ship, with all his belongings, was well on its way to Australia. He swore that he had been perfectly sober and had been given the wrong sailing time; *we* believed him even if no one else did.

As Fred was stranded in Colombo until another ship with a vacant berth could be found to carry him home, he was able to join forces with Mike on a number of trips down the coast and one across country to Trincomalee. It was useful having someone who could help us with all our equipment and who was perfectly willing to go underwater himself after a little instruction. But though we may have helped Fred to pass the weeks of waiting in Ceylon, I am sure he will be very careful to check sailing times whenever he

goes ashore in future. It is extremely difficult to make one shirt and one pair of pants last a month in the tropics.

When Mike rejoined me in Colombo, he brought back half a dozen rolls of Ektachrome film he had shot off in the Rollei and said mysteriously: "There's something here that will shake you—can we start developing it?" I agreed with some reluctance, for I had made my own plans for the evening and knew that there was no hope of doing any other work once we started processing color film. However, I was as anxious as Mike to see the results and before long the apartment was being organized for an evening's intensive photographic work.

We have processed color film in some odd places, and never under what might be called ideal conditions. On the Great Barrier Reef, there was sometimes not even running water available for the washing, and we had to collect all that we needed in buckets. At least once (though quite accidentally) we have used sea water instead of fresh water, and managed to get away with it. Though we have skirted disaster narrowly on many occasions, we have never had a completely ruined film, which proves that Ektachrome is remarkably good-natured.

In our Bambalapitiya flat, however, we were as well organized as we had ever been. The main problem was temperature control; during its ten-minute stay in the first developer, the film must be kept within half a degree of seventy-five degrees. This is no mean feat when the surrounding temperature is at least ten degrees higher. What is more, the other processing chemicals and the large quantity of washing water needed all have to be kept very close to the critical seventy-five degrees.

So when we tackled a batch of color film, the first thing we had to do was to send Carolis out to buy a block of ice weighing almost as much as himself. We would then fill the bath with water, and

dunk pieces of ice into it until we had reached the magic figure of 75° F.

It is no harder to process color film than black-and-white; it merely takes a little longer, since seven stages are required using six different chemicals. We had all these lined up in beer bottles, which sometimes made people look at us most suspiciously when we mentioned that we didn't drink. These bottles would be popped in and out of ice until they too had reached the required temperature, and then we would be 'off.

Since the bathroom was only about twice as big as the bath, and also contained the usual accessories, it became a little crowded when the floor was occupied by a large block of ice, six beer bottles, a couple of developing tanks, as well as the entire staff of the Clarke-Wilson Expedition. Even if one of us enthroned himself, it left very little room for the other, and I was sometimes reminded of that famous scene in the Marx brother's film *A Night at the Opera* when about twenty people try to work in one small cabin.

It became particularly hectic when we were processing three films at once, and had to remember how far down the production line each of them was. There would sometimes be struggles for simultaneous possession of thermometers, and panics when the first developer was discovered to be creeping surreptitiously up to eighty degrees because we had turned our backs on it. Occasionally there would be head-on collisions when we both wanted the same chemical at once; then one of us had to mark time in the washing stage while the other used the disputed solution. And every so often one of us would accidentally sit on the block of ice, against which a sarong was very inadequate protection indeed.

These processing sessions, when we came back from a particularly successful trip, would sometimes last until two or three in the morning, and one night when we staggered punch-drunk to bed

at 3:30 A.M. there were no less than seven rolls of Ektachrome hanging to dry in the living room. It was very difficult to find time to eat on such occasions, and when Carolis tried in vain to get us to come to dinner his expression was apt to agree with the description "Morose" which had been unkindly written on his Servant's Pocket Register twenty years ago.

Tonight was not quite such a marathon, and we were still in full possession of our faculties when the bathroom was allowed to revert to its normal uses. As we hung up the films to dry, I saw that Mike had indeed captured an unusual subject and had made a complete photographic record of the sea's supreme camouflage expert, the cuttlefish, putting on one of his best performances.

He had met the creature while swimming in Coral Cove, a small bay in the Trincomalee dock area. The water was fantastically clear, with visibility of well over a hundred feet. Large sandy streaks broke up the coral reef into isolated patches, crowded with the usual myriads of tropical fish. A shark came into view, sixty or seventy feet away, and approached rapidly to have a look at the intruder. It is rare to see a shark coming—they are usually already there before you spot them—but the clarity of the water allowed Mike to obtain a real long-shot of the animal's swift, smooth approach.

He dived down toward it, hoping to get close enough with the camera to get a good photograph. In an instant, the shark snapped away on a new course with an almost audible flick, and vanished faster than Mike had ever seen a fish move before. He would have to look for another subject to pose for him.

He was in luck. A few minutes later he came across a large cuttlefish, hanging quite motionless four feet above a patch of sand. Its back was mottled with the most beautiful pastel shades, and Mike had no trouble at all in photographing it from almost point-

blank range. The big, staring eyes, astonishingly like a sheep's, gazed at him with alertness but not alarm; the ten short tentacles were clamped firmly together like the fingers of a praying hand.

Presently the creature began to move slowly over the coral, using its jet-propulsion equipment at low power. It seemed able to move backward or forward with equal ease, and as it changed its surroundings the markings on its body altered, *both in color and in pattern*, to conform with its background. Mike was able to catch it (Plate IX) poised over a clump of stagshorn coral with the brilliant lilac spots on the tips of the coral perfectly reproduced upon its body.

After a while it grew tired of his company, put on speed and disappeared into the distance. Altogether during his swim Mike came across three of the mollusks, the largest about a yard long.

The cuttlefish—the source of sepia and of the porous white bone found in the cages of well-kept canaries—is a close relative of the squid and the octopus, and a slightly more distant one of the common slugs and snails against which all gardeners wage unceasing war. All these mollusks are normally regarded as hideous and repulsive, the marine ones most of all because of their great strength and ferocity.

Yet no one who has actually met a squid or a cuttlefish in its own element and has had a chance of getting a good look at the creature would feel repelled by it—unless it was a little too big for comfort. The beauty of the coloring, which is not realized by those who have seen only black-and-white illustrations of the creatures, goes far to redeem their *outré* appearance.

Even the much-maligned octopus is a good deal more handsome than might be imagined. I met only one in Ceylonese waters, though they are not particularly uncommon. He was lurking among the ruins of the Hindu temple at the foot of Swamy Rock, heavily

disguised as a lump of coral. When he realized that I had seen through his camouflage, he turned a lovely brick red, presumably through embarrassment, and began to slither across the sea bed in a continuous flowing motion which, like the steady advance of a snake, was much swifter than it appeared to be. He retreated until he was literally with his back to the wall, and even in such un-promising surroundings his camouflage was still so good that he would never have been seen at a casual glance, but would have been taken for a bulge in the rock.

Mike speared a small fish and dangled it in front of him; at first he mistrusted our motives and turned almost white with anger or alarm. But eventually he accepted the offering, though I can-not say that it made him any friendlier. As he kept his tentacles closely wrapped to his body, it was hard to judge his size; he was probably about four feet in span. Even an octopus of this size could give one quite a tussle, and would be perfectly capable of drown-ing a swimmer if he felt like it. However, I have never seen an octopus that was anything but excessively shy, nor have I ever heard of a case of one attacking an underwater explorer who had not molested it.

But animals are as temperamental as human beings and all the octopi I have met have been a good deal smaller than I. If I ever run into a really big one, I am pretty sure which of the two parties is going to be shy.

20

THIS WAY TO BABEL

By LUCK rather than judgment, Mike and I had come to Ceylon during one of the most memorable years in the country's history. In the early part of our stay, we were caught up in the excitement of a general election which, to the great astonishment of all parties concerned, completely annihilated the conservative, Western-oriented Kotalawala government and replaced it by a left-wing and highly nationalistic government under Mr. S. W. R. D. Banda-ranaike. One of the main planks on which the election was fought was the question of the state language, the new government (and for that matter the outgoing one, which had tried to climb onto the same bandwagon) promising to replace English with Sinhalese at the earliest possible moment.

Until the present Ceylon has been a trilingual country, English being the language of law, government, commerce and what is usually called "society." This had gone so far that many Sinhalese were virtually unable to speak their own language or read their own literature; they had become completely Westernized.

When we left the country in mid-1956, the language contro-versy was in full swing. The government, with its huge majority, was insisting on the change to Sinhalese, but the large Tamil group (about a sixth of the population) was refusing to go along with it. The situation had arisen when one official would write to another in Sinhalese and receive a brief reply (which he would have to get translated) informing him in Tamil that the recipient didn't

read Sinhalese. Both, of course, would be perfectly fluent in English, and this is perhaps typical of the chaos which seems likely to spread over the country if the language policy is enforced on a reluctant minority.

While all this was going on, an event of much greater national importance was taking place—the 2,500th anniversary of the death of Buddha. Though Buddhism originated in India, it is now in total eclipse in its native country and Ceylon is today its most important stronghold, though even here it has been heavily influenced (some would say corrupted) by Hinduism.

The government had made great plans for the celebration of this anniversary and had voted large sums of money for rebuilding Buddhist temples, putting up decorations and making the necessary arrangements to accommodate legions of pilgrims in the holy places. There had been some protests at all this expenditure from Christian and Moslem quarters, and the story goes that the government had replied: "We're quite impartial; we'll let you have the same amount of money when it's *your* 2,500th anniversary."

By a remarkable coincidence, it was also exactly 2,500 years since the history of Ceylon began with the landing of its first king, Vijaya, in 534 B.C. (We will ignore those spoilsports who pointed out that since there was no year o all the celebrations were a year too early.) So the country had two causes for rejoicing, and made the most of them.

One of the commandments of the Buddhist, as of the Christian, faith is the simple phrase: "Thou shalt not kill," and in both religions the interpretation of this edict has caused endless controversy. Just as the Sixth Commandment has not stopped bishops from blessing tanks and fighter planes, so the words of Buddha have not stopped his followers from killing anything, animal or human, if they felt the need to do so.

They had, perhaps, more excuse than the Christians, since the gentle and moderate creed laid down twenty-five centuries ago does not *compel* anyone to do anything. It would be truer, in the Buddhist faith, to replace "Thou shalt not kill" by "Thou should not kill." However, the new government, in a quite un-Buddha-like excess of religious zeal, decided to do its best to enforce the precept by banning the slaughtering of all animals for a week throughout Ceylon, with the result that the butchers had to close down and the fishermen were (in theory at least) out of work. Knowing the Sinhalese genius for profitable compromise, I think it very unlikely that this ban caused any more real hardship than it generated purity of spirit; the main sufferers were the lions at the Colombo Zoo, who did not take kindly to a diet of frozen meat.

This ban on killing produced many sarcastic remarks from Buddhists and non-Buddhists alike, who did not fail to point out that the slaughter of the most important (in the absence of contradiction) animal still proceeded at the same rate. It is a curious paradox that all through history the easygoing, good-natured Sinhalese, despite their religion, have been prone to sudden spasms of violence at the least provocation. If proof is needed, here is one short item tucked away fairly inconspicuously in the *Times of Ceylon* for May 21, 1956:

> A 65-year-old scrap iron merchant of Kotahena—Othuman Lebbe Marrikar—was found dead in his shop yesterday with a gash in his neck, his mouth gagged and his hands and feet tied.
>
> At Kollupitiya, R. K. John, an employee of the Galle Face Hotel, is alleged to have been stabbed to death by W. D. Charles. The suspect is in police custody.
>
> At Ragala, Palingu Menika (23) is alleged to have been murdered by her 27-year-old husband, B. M. Kiri Banda who is now in police custody.

At Bibile, B. M. Kiri Banda is alleged to have been murdered by A. Siriwardane.

At Kurunegala, G. M. Punchi Banda is alleged to have been hacked to death with an axe by his younger brother, J. M. Mudalahamy, over a land dispute. The suspect has been taken into custody.

At Ja-Ela, five persons including a 67-year-old man and two children—one three-year-old—were shot at on Sunday night . . . four suspects are said to be absconding.

We will ignore the surprising adventures of B. M. Kiri Banda, who appears to have escaped from police custody at Ragala only to be murdered at Bibile; I suspect them to be the creation of a *Times of Ceylon* sub-editor or linotyper—though it would be perfectly possible in Ceylon for two people of the same name to be featured in murders on the same day. The unfortunate fact is that the above news item is not particularly remarkable, and I do not know whether racial make-up or environment is more responsible for this state of affairs.

Though earnest appeals were made begging members of the public to postpone their murders until after the religious celebrations, the statistics barely fluctuated. Indeed, one ingenious assassin used the special circumstances to carry out what he hoped would be the perfect crime. The ceremonies were linked with the full moon, and this year there happened to be an almost total eclipse. The murderer waited until the moon had dwindled to a barely visible crescent, threw a bomb at his victim, and escaped in the darkness.

Most murders in Ceylon are not as premeditated as this; they occur on the spur of the moment, and everyone is very sorry immediately afterward. A perfect example is given by a case we encountered in Trincomalee while we were there; the *venue* of the

crime was not far from the Rest House, and I will call the participants Mr. Perera and Mr. Fernando, despite the high probability that their real names, which I do not happen to know, may be exactly that.

Mr. Perera had spent an exhausting morning with rod and line, but had been rewarded by catching a single magnificent fish. He rushed home with it, set to work preparing it for lunch, and sat down at the table with a ravening appetite to enjoy the best meal he had had for months. Suddenly he realized that one thing was missing to make the feast perfect; it would only take a moment, so he hurried around the corner to get a bottle of beer.

Short though his absence had been, it was long enough. When he got back, there was no fish. Instead, looking extremely satisfied, was a cat which he recognized as belonging to his neighbor Mr. Fernando.

Any fisherman, and indeed most non-fishermen, can imagine Mr. Perera's feelings. The entire neighborhood was at once alerted when he picked up the cat by its tail and carried it, squealing and spitting, into the presence of its owner.

In a few well-chosen words he told Mr. Fernando what he thought of (a) his cat and (b) him. Then he shouted: "Do you know what I do to cats that steal my dinner?"—and demonstrated by dashing the animal's brains out against the wall.

Distraught with grief, Mr. Fernando cried: "A man who can do that to a poor, harmless pussy isn't fit to live! I'm going to have a look at your liver."

And he did.

There is no reason at all why even the most nervous visitor to Ceylon should be scared by these remarks, any more than he would be discouraged from going to certain Latin countries where knives

are also a popular method of settling differences. To put matters in their true perspective, I do not suppose that the murder rate in Ceylon is any higher than it was in Chicago during the spacious days of Prohibition. It merely seems odd that a people who are justifiably proud of belonging to a religion that has produced no martyrs, no crusades, no inquisitions and no "holy wars" should not be a little more tolerant of each other's point of view.

21

SOME UNDERWATER
ENCOUNTERS

THE truthfulness of rod-and-line fishermen is famous throughout the world, and I am not sure if underwater hunters and explorers have yet achieved the same reputation for probity. During our stay in Ceylon, Mike and I took special pains to note any unusual, amusing or hair-raising stories that the Reefcombers had to tell us about their experiences, and some of the more interesting of these are recorded in this chapter. Because stories of straightforward catches tend to be boring in repetition (unless it is the spearman who is caught) I have omitted all the usual "There was I at fifteen fathoms . . ." narratives, of which more than enough will be found in the standard books on underwater hunting.

One of the Reefcombers, who shall be nameless, though not initialless, claims that his life was once saved by a pack of barracuda—admittedly in an accidental and somewhat roundabout fashion. The other Reefcombers view this story with scepticism, but it seems too good to waste and it might, after all, be perfectly true. . . .

Our hero, A. B., was swimming near Colombo when he came across a school of these ferocious predators, and without any further thought shot one fair and square. At once the wounded fish dived for the bottom, towing the hunter after it. A. B. was using only a short line, and since even a medium-sized fish can exert much

more tractive force in the water than can the best swimmer, before long he was far below the surface and running out of air. There was nothing to stop his dropping the gun and making for safety, but his fingers had "frozen" on the handle and he was quite unable to let go. It was an understandable reaction; a spear gun is an expensive piece of equipment which one jettisons only as a last resort, and probably more than one hunter's judgment has failed at that moment.

Whatever the explanation, A. B. found everything going dark around him as he was towed down into the depths. Then, suddenly, there was a flashing of silvery bodies, and a great jerking on the line attached to his gun. Almost at once, the fatal tug vanished; he was able to break his dive, and at his last gasp managed to struggle back to the surface.

There were just a few pieces of flesh still attached to his spear. The rest of the pack had eaten the wounded barracuda—and so saved A.B. from being towed down to what would have almost certainly been his death.

Rupert Giles, the secretary of the Reefcombers, is probably the European with the longest experience of swimming in Ceylon waters, having been at it continuously—except when work or wife drags him ashore—since 1951. His adventures with us have already been described, but before we arrived on the scene he had some others which we were glad not to have shared. The most unpleasant of these involved a microscopic menace which can be as deadly as any of the larger perils of the sea, and has probably been responsible for many otherwise unaccountable fatalities.

One day late in July, 1951, Rupert was hunting off Trincomalee with the well-known professional spearman Gerd von Dincklage when he noticed a large patch of scum approaching, borne on the strong southwesterly breeze. It was moving swiftly and formed a

solid wall in the clear water, extending from the surface down to a depth of about fifteen feet. Being many yards across, it was impossible to avoid; within seconds, it was upon the hunters and they realized to their horror that it was an immense wall of jellyfish.

Almost at once they had been stung from head to foot by hundreds of these organisms, each with a sting as deadly and as painful as a wasp's. With howls of agony they raced for the shore—four hundred yards away. Before they got there, they had to run the gauntlet of thousands more of the stinging horrors, which had appeared as if by magic.

As he drew near to the shore Rupert's strength was beginning to ebb; the shock of the hundreds of stings was telling on him. He could think of nothing but the pain and when he finally stumbled into the calm, clear shallows of Coral Cove he was completely oblivious to a huge stingray basking in only a foot of water. The beast must have sensed his foot descending upon its back, for with a sudden swirl of sand the great, flat body shot away under his feet. As it passed the tail whipped over and slightly lacerated Rupert's left shin; the barb must have missed his leg by only a fraction of an inch.

That was the last straw; Rupert sat down on the sand and wept. It took him some hours to recover completely—and it was some days before he had quite regained his zest for spear fishing. . . .

Rupert and von Dincklage had an almost equally unpleasant experience fifteen miles north of Trincomalee when they set out at noon to swim to a nearby island. At least, they thought it was nearby, but it turned out to be more than two miles away. By the time they had reached it—after running into a manta ray some fifteen feet across on the way—it was four o'clock and the sun was far down the sky. They realized that they would have no time

for hunting, and allowed themselves only half an hour's rest before starting the long swim back to land.

Von Dincklage (who is a superb swimmer, with or without fins, and holds several long-distance records) soon left Rupert a hundred yards behind. The sun set while they were only halfway back to shore, and very quickly the light began to fade around them. Suddenly, in the gathering dusk, Rupert saw a huge animal bearing down upon him from the rear, and was quite sure that his last moment had arrived. The nearer the creature came, the more frightened he was—and at the same time the more baffled, since he had never seen anything like it before. It was not until it had come right up to him that he realized that it was an enormous turtle, five or six feet long, its shell completely covered with barnacles.

The creature had obviously never seen a human being before, and was so inquisitive that it started nuzzling Rupert with its head. It was not in the least hostile, but a quarter of a ton of turtle is an embarrassing companion in the water since it can hardly be expected to know its own strength, and its parrotlike beak could remove a hand or foot with no trouble at all if it decided to take a friendly nibble. In the end Rupert was forced to start kicking at the great beast until he had hurt its feelings and it swam sadly away.

There was no moon, and it was now completely dark. The only way in which Rupert and von Dincklage could tell the way to the shore was by the red lights on the masts of a radio station; they kept their eyes fixed steadily on these and continued to swim through the night, trying not to think of all the sharks and other predators that were undoubtedly following their passage with curiosity. Altogether they were swimming in darkness for almost two hours, and as they approached the shore they could see a line

of electric torches moving back and forth along the beach.

When they staggered onto dry land, after eight hours in the water, they found the search party looking for their bodies. It was a reasonable enough assumption, since their deserted car was still standing on the beach two hours after sunset with their clothes in it.

Rupert has never been attacked by sharks, but has twice had fish stolen by them. On one occasion, when swimming with another member of the club in virgin water, he met a ten-foot shark which became quite excited by the two hunters' presence and tried to stalk them, though they were carrying no fish. Eventually they took turns firing their guns at the shark—one hunter diving on it while the other reloaded. Even these mock attacks made little difference until a spear actually hit the beast and it finally became scared.

This shark must have been unusually hungry or inquisitive; I have never met one that hung around in front of my camera as long as this one did in front of Rupert's gun, but I am still hoping.

Most authorities agree on the unpredictability of sharks, and Rupert can give a perfect example of this. He was preparing to hunt in a small bay at Dikwella, near the southern tip of Ceylon, and as soon as he got into the water he found himself confronted by three six-foot sharks. Emerging rather thoughtfully, he told his companion what he had seen. His partner was one of those people who won't believe anything until they have checked it themselves, so he at once entered the water to see if Rupert's information was correct.

It wasn't; there were now *six* sharks there, so the two hunters decided to try their luck elsewhere.

However, that was not the end of the story. The next day they came back with Vane Ivanovic (author of one of the best books on spear fishing), determined to reduce the population of the place

they had now christened "Shark Bay." There was not a single shark to be seen. . . .

The casual way in which Rodney Jonklaas treats sharks has already been mentioned. He has had his catch stolen by them at least a dozen times, and regards this as one of the inevitable hazards of spear fishing. In his opinion a much worse menace—or nuisance —than the shark is the grouper. These massive beasts are often quite fearless and it sometimes requires brute force to get rid of them.

As an example, Rodney was once diving with Langston Perera, another enthusiastic Reefcomber, when his partner speared a twenty-pound caranx. The fish escaped from Langston's spear so Rodney, who had watched the whole scene from underwater, went down and secured it with his own gun. The effort completely exhausted his reserves of air, and Langston had to help him back to the surface, where he floated in a daze for several minutes.

In a blur, he saw a shark and then a sixty-pound grouper come charging up to steal the speared fish. The shark was not aggressive, but the grouper refused to give up without a fight. It came so close that it was impossible to hit it with the end of the spear gun: Langston had to raise his gun out of the water and bang the fish repeatedly on the head with the butt before it reluctantly went away.

A still more uncomfortable experience occurred to Rodney when he had shot a pompano and was surfacing to breathe. He had thrust his head above water (Rodney hates snorkel tubes and refuses to have anything to do with them) when he felt something grip his hand. When he looked down, he saw that a hundred-pound grouper was trying to swallow pompano, spear and most of his arm. Luckily Rodney was wearing long gloves so the fish's tiny teeth did not penetrate his skin, and the bite did not hurt him in the least.

Groupers are swallowing, not tearing, animals, and so far no Reef-comber has met a grouper that was both big enough and hungry enough to swallow him. I have a feeling that it is only a matter of time.

Rodney's most painful and alarming underwater encounter—with the possible exception of his mishap with the scorpion fish described in Chapter 13—occurred when he was hunting for crayfish in shallow water, and neglected an important rule. He saw the long antennae of a crayfish waving from a hole in the rock, and without thinking reached into the cave to grab it.

At once the middle finger of his right hand was seized with a vicelike grip. Rodney had assumed that the little cave had no other occupant except the prickly but harmless crayfish; in fact, it was also the home of a large moray eel. These hideous, serpentine creatures undoubtedly have the most diabolical expressions of anything in the sea, and their habit of incessantly opening and closing their jaws to reveal needlelike teeth does not add to their attractiveness. However, they are quite inoffensive unless molested; it was unfortunate for Rodney that this specimen was unable to distinguish between a deliberate attack and an accidental interference.

Moray eels are extremely strong, and it is practically impossible to drag them out of their holes while they are still alive. The only way Rodney could escape was by literally tearing his finger out of the creature's mouth, scraping the flesh down to the bone. He was in a mere ten feet of water, but could easily have been drowned had he been unable to get away from the animal's grip.

Fortunately, and despite statements to the contrary, the bite of a moray eel is not poisonous, though like all injuries inflicted by the teeth or spines of fish it can easily turn septic. As Rodney swam back to shore, he encountered a very large ray lying on the sandy bottom, and is ashamed to admit that he speared it in his rage and

pain. The only result was that he lost his spear, which he considers served him right.

The doctor who saw the injured finger almost fainted with horror and insisted that Rodney should go to the hospital at once. This was an ordeal he could not face, as he knew that someone would sew up the mess without giving him an anesthetic. So he patched up the finger with sticking plaster, and miraculously, after several painful days, the badly torn skin fused and healed, though Rodney will bear the scar for the rest of his life. He dived for weeks after this with his finger encased in a rubber balloon and covered with a glove.

The moral of this cautionary tale, of course, is that one should not put one's hand into mysterious holes without a careful census of their occupants. Naturally, this is not always possible, but Rodney has discovered a foolproof method of causing a mass evacuation of caves and crevices so that he can secure the fish lurking inside. All he does is to spear an octopus and push one of its tentacles into the hole, whereupon the residents emerge in panic flight.

Of all Rodney's underwater encounters, however, the most memorable occurred some ten years ago, while he was still at college. At least, he *should* have been at college, but it was a lovely sunny day and the sea was perfectly calm. This combination proved too much; spurning the pleasures of practical zoology as presented in the lab, Rodney decided to transfer his researches to the ocean.

If he had any hesitations about skipping his class work (which I doubt) they were dispelled when he saw, about a quarter of a mile out at sea, a solitary spout of vapor rising above the still waters. In a few minutes not only Rodney, but most of his friends, were setting out from shore on assorted surf skis and anything else that would stay more or less above water.

A humpbacked whale was swimming slowly along with a calf

tucked protectively under one fin, and it showed no signs of annoyance or alarm at the group of spectators gathered around it. Its forty-foot-long body was covered with barnacles, and when one of the boys got too close to it he received most of the fall-out from its spout. He was not precisely radioactive as a result, but no one would go near him for days.

The water was so clear that when the whale dived most of its body could be seen at once as it coursed along the shallow sea bed. Rodney believes that it had come in close to land to guard its calf against sharks, not realizing that it ran the risk of meeting a far more dangerous enemy if the local fishermen decided to do anything about it. For a while the two little groups of mammals—the ones that had returned to the sea, and the ones that had abandoned it but were now having second thoughts—swam slowly along in each other's company. Then mother and child outdistanced the spectators, as the call of the rich Antarctic pastures drew them to the south.

22

A DIVE IN THE JUNGLE

Soon after we had arrived in Ceylon, Rodney Jonklaas, finding the life of a government servant incompatible with wealth, liberty and the pursuit of happiness, threw up his job in the Department of Fisheries and went into a business peculiarly suited to his talents. He became head of the tropical fish department of one of the largest commercial organizations in the East, the Vavasseur Trading Company, and thus found himself exchanging the spear gun for the hand net.

The capturing and transporting by air of tropical fish to all quarters of the globe is a fascinating and somewhat exotic business of which I knew nothing until I saw Rodney at work (Plates 26, 27). Although the most beautiful fish are undoubtedly the marine ones, the problem of obtaining genuine or acceptably synthetic sea water makes it hard to keep them in captivity, and the most popular aquarium fish are the fresh-water varieties. So when Rodney invited me to accompany him on a trip inland to collect specimens, I was glad to do so—even though it seemed a little odd to pack face masks and then to turn our backs on the sea.

We drove south of Colombo in the company's Volkswagen van, its interior crowded with the tools of Rodney's new trade—aluminum milk cans, glass jars, nets, and pumps to ensure a good air supply to the captured fish. With us traveled Rodney's assistant Simon, a tough little man whom we had hired for one of our own trips, and who has overcome the usual Sinhalese objection to the

sea to such good effect that he now goes skin diving for crayfish by night.

Thirty miles south of Colombo we swung inland away from the busy main highway and soon lost ourselves on winding dirt roads which, though bumpy in places, gave the Volkswagen no trouble. We passed tiny villages set in the lush green of paddy fields, and finally came to a halt beside a bridge over a small, crystal stream. Looming above us was a group of steep hills, completely smothered in the forest which had submerged them like a great wave.

Carrying nets, cans, and collecting bottles we left the van by the roadside and began to walk along the low earth dikes which divided the paddy fields into squares which could be flooded or left dry at will. Zigzagging along the grid of embankments, and occasionally squelching through mud, we finally came to the river again at a point where it disappeared into a wide, leafy tunnel. I was about to step into the water when I noticed what appeared to be a small piece of liquorice attached to my ankle. It did not remain there, but started to walk up my leg like an inchworm or looper caterpillar.

I had heard about the Ceylon leeches, but this was the first one with which I had come into contact, and I wasted no time at all in knocking it off before it could go into the blood-transfusion business. Though only about an inch long, it was such a revolting object that I had no desire to meet one of its really big relatives, the three-inch variety which infest certain jungle areas. The favorite story told about these creatures concerns a hunter who broke his leg in the forest and tried to crawl to safety. He would have made it if the leeches had not reached him first; when his friends found him, he was a drained husk.

Trying to forget this cheerful tale, I stepped into the refreshingly cold water of the river and followed Rodney upstream. He was wearing face mask and swimming trunks, and carried a large

butterfly net. Simon, similarly equipped, followed a few yards
behind, and a couple of volunteer helpers brought up the rear with
the small metal churns in which the captured fish would be carried.
The stream was nowhere more than three feet deep, so even though
I was carrying a couple of cameras I had no difficulty in wading
after the intrepid hunters.

From time to time Rodney would plunge his head into the water,
and holding the net in his left hand use his right one to scare fish
into it. The technique never failed; fresh-water fish, it seems, are
much more stupid than marine ones. Sometimes when Rodney
pulled the net out of the water, it would be full of scores or even
hundreds of tiny red and silver shapes, few of them as much as an
inch long, destined to travel thousands of miles to grace aquaria in
distant lands. There were times when a single dip of a net would
bring up a hundred rupees'—say twenty dollars'—worth of fish,
and I began to wonder if I was in the right business.

The little river meandered along under the trees which formed
an almost complete archway overhead, shading us from the sun
and incidentally making it practically impossible to photograph the
operations. It was as fresh and mild as on a fine day in the late Eng-
lish spring; there was none of the oppressive heat or humidity one
might have expected.

The metal cans became more and more full of fish, mostly ruby
barbs and golden rasboras. One of them contained at least a thou-
sand of the tiny creatures, forming a compact, milling ball like a
whirling swarm of bees. It was curious to see the way in which
those in the glass jars kept at a constant distance from the invisible
walls, as if repelled by some mysterious force.

The largest fish which Rodney caught were three fresh-water
gars—slim, grass-green needles about six inches long. When they
concealed themselves among the weeds placed in the tank, they

matched the long fronds so perfectly that they were almost invisible.

The use of the face mask, Rodney explained to me, had revolutionized the catching of small fresh-water fish. No longer was it necessary to make blind jabs with a net at shapes seen blurrily through the wrinkled surface. By putting his head underwater, the hunter could now see everything that was happening in the river as he waded along it, and could scare the fish straight into his gaping net.

The world of rivers and lakes, though less glamorous and less colorful than that of the sea, is almost as crowded with life and is a good deal safer to explore. At is best, visibility is unlimited—you can see as far as there is anything to be seen. I have taken underwater photographs in Florida rivers that looked faked because there was no way of telling that they had not been made in the open air.

Visibility in the little stream up which Rodney was working his profitable way was about forty feet, which was as good as infinity for all practical purposes. He had chosen the time with care; had there been any heavy rains, the water would have been too polluted with mud for him to have seen more than a few inches.

There is always a possibility that, sooner or later, Rodney will come across a crocodile as he wades upstream, but he does not let the prospect disturb him. The Ceylon crocodiles eat a couple of careless villagers every year, but if one of them encounters Rodney, even though he may be armed only with a butterfly net, I am quite sure who will come off second best. There will be another item on the Vavasseur export list to present the air-line officials with a headache.

After half an hour's wading, over little waterfalls and through quiet pools, Rodney decided we had gone far enough upriver and we started to retrace our steps down the stream, which we had now

rather thoroughly muddied, not to mention depleted. (Though of course any inroads which could be made by a couple of men with nets would be fully restored in a few weeks.) Most of the time we were accompanied by an active and friendly mongrel which the villagers informed us was named White, and it was a pleasure to meet a dog that obviously enjoyed life and was in good condition. Most of the dogs one sees when traveling around Ceylon are miserable, scrawny beasts which it would be a mercy to kill—but no good Buddhist would think of doing that, with the result that every year a couple of dozen people die a horrible death from hydrophobia.

When we had made our way back through the paddy fields to the van (and I had detached another leech which had managed to have a good meal at my expense) Rodney sorted the fish out into their different tanks so that, as soon as they had recovered from their shock, they would not start eating each other with gusto. He was particularly careful to isolate the fierce gars; they could have cut down the profits of the trip by quite a few rupees. To keep the the little tanks aerated until the specimens could be placed in proper aquaria, rubber tubes were connected to a small pump driven from the van's batteries, and soon streams of air were bubbling briskly through the water.

A few hours later, the hundreds of little fish were getting accustomed to the strange environment of rows and rows of glass tanks neatly laid out in a large shed. After a bucolic existence for untold generations, they had become apartment-house dwellers. But this was nothing to what would happen to them when, in a few days' time, they took to the air.

The key to the air transportation of tropical fish, I was surprised to discover, is the ubiquitous polyethylene film which is now used to wrap everything from sandwiches to stratosphere balloons. Fish which are to be sent by air are placed in a plastic bag containing a

gallon or so of water, and the bag is then packed in a suitably-padded cardboard box. In this way, the use of heavy or easily broken containers is eliminated; to make quite sure that there will be no leakage, one plastic bag is enclosed in another to give double-walled protection.

However, fish need oxygen to breathe just as badly as we do, and most of them would soon suffocate even in a tank which was open to the air. Accordingly, the plastic bags are blown up with pure oxygen before they are sealed, so that they form tight little balloons half full of oxygen and half full of water. As long as the fish reach their destination inside two days (some consignments have survived for longer) there is no danger of their suffocating.

As Rodney was at pains to point out to me, there is much more to the tropical-fish business than this. Some fish are very hardy and will put up with all kinds of rough treatment; others will die if one as much as touches them with one's fingers. Some will live in any tap water; others will be killed by the slightest impurity. As I realized the equipment and know-how that existed behind the scenes to ensure that all these strange and beautiful little creatures arrived safely in far corners of the world, I decided that it was not, after all, an easy or a simple way of making money. It may be just the job for Rodney—but, personally, I haven't the patience to sit up all night nursing a sick scorpion fish.

23

FORTRESS IN THE SKY

THERE is always a feeling of letdown or anticlimax at the conclusion of any enterprise, however successful it may have been. And apart from the fiasco of the pearl banks—a matter which we intend to rectify at some future date—Mike and I both considered that our little expedition had been a success. It had produced far more material than we could reasonably have anticipated, for how could we have expected to discover a submerged Hindu temple or a gigantic floating dock that no longer lived up to its name?

We had certain reasons for being less exuberant than might have been expected as we wound up our affairs in Ceylon. Mike had a little matter of two or three hundred photographic enlargements to make in the darkroom, while the sun was shining gloriously outside and the surf was roaring against the beach at the bottom of our road. I had to write this book; and we both had to pack all our equipment in such a way that it would arrive back in New York in no worse a state than when it left Ceylon. As a good deal of our gear was now badly bent and battered, this was not a job to which we looked forward in the least, and we each kept putting it off in the hope that the other would do it.

We were also very conscious of the fact that though we had spent five months in one of the world's most fascinating countries our view of it had been highly restricted and from a very odd angle. All that we had seen of Ceylon, indeed, had been accidental

glimpses caught when hurrying from one wreck to another, from
one promising reef to the next.

It was not surprising, therefore, that I jumped at the opportunity
when one evening Lionel Amarasinghe, the Director of the Tourist
Bureau, dropped around at the flat and said: "I'm going to Sigiriya
tomorrow—would you like to come?" The glimpse of that fantastic
rock fortress from the air, and the stories I had read about it, had
fired my imagination and made me determined to visit Lion Rock
sooner at later, but I had assumed that it would have to be on some
future trip to Ceylon.

We drove out of Colombo at the unprepossessing hour of six,
when I am not usually at my best, and were well into the middle
of the country by the time I woke up. After three hours of driving
through the now familiar Ceylonese landscape—much of it badly
parched by drought so that the paddy fields had lost their lovely
rich green—the enormous overhanging boulder of Sigiriya began
to loom above the trees. At first glance the rock appeared to show
no signs of human handiwork; then closer inspection revealed
enigmatic markings on the face of the cliff, the most prominent
being a horizontal yellow band a couple of hundred feet from the
ground, immediately underneath the overhang of the rock. Until
I saw tiny white dots moving around this band, I did not realize
that it was actually a huge wall protecting the gallery which led up
to the fortress.

For at least a mile in every direction around the base of the rock
there were ramparts, moats and the foundations of a great palace
which the king presumably occupied when he felt that the political
situation did not require his presence on the top of the rock four
hundred feet higher. The outer wall of the ground defenses has
not yet been uncovered; it lies somewhere in the jungle which dur-

ing medieval times reconquered this land, and it is at least three miles in length.

The wide moat—whose hungry crocodiles must have been worth several regiments to the beleaguered king—was now almost empty because of the drought. We passed into the fortifications through a breach in the great ramparts and started the slow climb up to the rock itself.

The Archaeological Commission has done a tremendous amount of work on Sigiriya, and there are still hundreds of laborers excavating sites and keeping the grounds tidy. The approach to the fortress is now easy; where the original stairways have been destroyed, iron ladders and gangways have been built so that even if one has no head for heights the climb presents no difficulties.

For most of the way, the steps and flagstones on which the visitor treads are still those carved by Kasyapa's masons fourteen centuries ago. As we slowly ascended the stairways—walking diagonally to conserve energy and to get a better footing on the narrow steps—more and more of the plain around us came into view. We could see the outlined foundations of the lower palace, lying inside the inner rampart. We could look down upon the great boulders around the foot of the mightier one which we were ascending, and could see how they had been carved so that there were tanks and assembly halls on their upper surfaces. Many of these rocks were fifty feet across, smoothly shaped like the pebbles from a beach. All over their surfaces small steps and ledges had been cut, which could serve no other purpose but to provide footing for spectators on state or ceremonial occasions.

Two hundred feet from ground level we came to the great gallery which nestles beneath the overhang of the rock and is protected from the sheer space below by the yellow wall which I had noticed when approaching Sigiriya. (See Plate XIV.) Despite its age,

this wall appears to be almost new; it is smooth as glass, keyed into the rock so that it is virtually a continuation of the cliff face. Behind this nine-foot-high barrier, itself inaccessibly high above the ground, the king could move his men in secrecy and safety.

We walked along this narrow slot in the side of the cliff, climbed some more stairs, and found ourselves on a flat grassy space which had one disturbing feature—a large wire-mesh cage bearing the notice in English, Sinhalese and Tamil, PROTECTION FROM BEES. Looking up the cliff we could see the reason; below the overhang of the rock, like swallows' nests clustering under the eves of a roof, was a group of ominous black hives. Their occupants were very large and ferocious bees, so Lionel told me, quite capable of killing a man if they caught him. Fortunately they had now grown accustomed to the thousands of visitors ascending the rock, but the cage was still kept here as a safety precaution which sometimes had to be used. It would hold about twenty people at a squeeze, and I hated to think what would happen if a party of say fifty was attacked up here on this lonely little plateau.

From here on, the ascent to the top of the rock was a steep series of ladders and stairs which we felt disinclined to tackle, deciding to leave the closer inspection of the ruined palace and fortifications covering the entire summit until such time as we had a helicopter. The view from our vantage point was sufficiently impressive; we could see across twenty or thirty miles of open plain, broken only by one nearby hill and a few groups of more distant mountains. There had been a time, more than a thousand years ago, when everything that we could see was cultivated land—part of the immense acreage of rice and coconut needed to support a population as great as that of modern England. One reason why Kasyapa chose this isolated fortress rock was that he could see an enemy approaching from many miles away across the open plain.

With a backward look at the bees, we retraced our steps to the gallery and from that started on another short climb, up a spiral staircase to the famous Sigiriya frescoes. They are painted on the plaster-covered walls of a niche or cave thirty feet above the gallery and excavated in the face of the overhanging rock. Why such a hair-raisingly inaccessible spot was chosen for them, and how they were even reached by the king when he wished to visit his art collection, are two more to add to the many mysteries of Sigiriya. But today the shallow cave has been enclosed by wire mesh so that one feels quite secure despite the fact that the iron plates on which one is standing project out from the face of the cliff and have two hundred feet of air beneath them.

For half a million days the painted figures on the plaster wall have been exposed to the direct light of the afternoon sun, yet the colors are still clear even though they may have faded from their original brilliance. The ladies of the king's court, with their duskier and less revealingly clad maidservants, are grouped in graceful, formalized poses; some of them hold a lotus flower in one hand, and all are as well developed as any of the current beauties of the Italian or Hollywood screens. (See Plate XV.)

It was late in the afternoon by the time we had come down from the fortress and had a meal at the excellent Rest House at the foot of the rock. As we drove away into the sunset, I wondered if anywhere in the world there could be a greater monument to one man's paranoia and megalomania, and I wished there could be some way of looking back into the past to see the fortress palace as it must have been when Kasyapa completed it at the cost of such labor as staggers the imagination.

And all that labor was in vain; the fortress was never taken by direct assault, but by the subtler weapons of psychological warfare,

when Kasyapa's vengeful brother taunted him with cowardice and
goaded him out into battle.

Sigiriya ceased to dominate the landscape, and was no more
than a strange hump on the horizon when we stopped at Dambulla,
about ten miles away, to visit the rock temples of a still earlier age.
The last light of the day was failing as we climbed up the granite
slopes, accompanied by a guide carrying candles and electric torch.
Dambulla is another great isolated rock like Sigiriya, but not so
precipitous, and in the first century B.C. it was chosen as a hiding
place by one of the Sinhalese kings during a Tamil invasion of
the country. When he won back the throne, he built the temple in
gratitude, enlarging a series of natural caves to accommodate it.

We took off our shoes and walked through the entrance of the
first cave, where we were confronted at once by an awe-inspiring
recumbent Buddha, more than forty feet long. This statue, Lionel
told me, was unique in that it departed from the strictest canon
of Ceylon's religious art. The dying Master is shown not as a
bland, timeless being but as a man whose brow is furrowed with
wrinkles and whose lips are slightly parted as his last breath
leaves his body. One leg is ever so slightly drawn back; beneath
the draperies the diaphragm is contracted with the final exhalation.
It is a man, not an already almost supernatural being, carved here
from the solid rock of the mountain, and one cannot help wonder-
ing who the unknown genius was who defied all the traditions of
his art to create this masterpiece—and who left no successors.

The next cave was considerably larger, and dimly lit by dozens
of candles and oil lamps. Worshipers were chanting before a long
row of seated Buddhas, larger than life, which were ranged the
length of the cave in an imposing perspective. Mingled with
them were many statues of the Hindu gods, and it seemed in-
congruous to meet these demonic monsters in the company of the

gentle and rationalistic Buddha. Overhead, the roof was completely covered with brightly painted scenes from both religions and from the ancient history of Ceylon. Some of the frescoes in these caves predate the birth of Christ, but others (usually much inferior) are quite modern, and I gather that the Archaeological Commission has a constant battle on its hands preventing "improvements" of the type once prevalent in English churches.

The entire atmosphere of the temple-cave, with its smell of incense, its chanting pilgrims, its flickering illumination, its long ranks of portentously looming idols, was as mysteriously exotic as the imagination could conceive. My scientific skepticism was bludgeoned into momentary abeyance by the sheer impact of two thousand years of accumulated art and worship. As I looked at the fresco showing the landing of Vijaya in 543 B.C., I felt that by comparison my own country had no history worth speaking of.

When we left the temple and started our descent down the hill, it was completely dark. There was no moon to light our way over the rocks worn smooth by twenty centuries of pilgrimage, and without the electric torches it would have been a difficult and dangerous journey. Nowadays, I mused, the East does not hesitate to use the wisdom of the West; there was even fluorescent lighting inside the caves, but it is only used on holy days and I had no chance of seeing the statues and frescoes illuminated with a brilliance beyond the dreams of the artists who had created them.

This haunted hillside, with the equatorial stars burning above it, was to be my last glimpse of the ancient but unchanged Ceylon before I returned to the modern city of Colombo, and thence to the familiar Western world. I was in the exact center of the country, as far as I could possibly get from the sea which Mike and I had come here to explore. I thought of the tasks which we had left undone, and which would have to wait until our next visit.

Eighty miles to the northwest lay the pearl banks of Manaar, still unphotographed by us. Sixty miles northeast, on the other coast, lay Trincomalee with its submerged relics of many races, from the temple builders of the thirteenth century B.C. to the naval architects of the twentieth century A.D. And a hundred and thirty miles to the south was the wreck-studded coast which so many ships had failed to negotiate during four thousand years of maritime commerce.

Yes, we will be back—with better equipment and, I hope, better luck. But that will not be important; we will be happy enough to be once more in Ceylon, whether above or below the surface of her warm and endlessly surprising waters.

PHOTOGRAPHIC NOTE

ALL the underwater photographs in this book were taken either by a Leica with an f/3.5 Summaron lens in a Lewis Photomarine case or by a Rolleiflex Automat with f/3.5 Xenar in a Rolleimarin housing.

For black-and-white work near the surface with the Leicas, Kodak Plus X was used at 1/60 second and f/8. For the Rolleiflex, Kodak Super XX was used at 1/100 second and f/11. These basic exposures were modified according to depth, cloud cover and water clarity. The film was overdeveloped about 20 per cent in Promicrol.

All the color shots were taken on Ektachrome and processed by ourselves. A standard exposure of 1/60 and f/5.6 was used except when poor lighting conditions required greater apertures. The flash bulbs used in taking the color photographs were Phillips FP.45s for the Leicas and Sylvania 24s for the Rolleiflex. Since these bulbs were required to restore the missing red end of the spectrum, white and not blue ones were employed.

Many of the black-and-white illustrations were made from 35mm or 2¼" x 2¼" Ektachromes by rephotographing them on Plus X; the results were so satisfactory that in future we expect to take all our underwater photographs in color, converting them to black-and-white when necessary. Excellent results can be obtained even from a color original much too dark for projection.

The surface photographs were taken with Rolleiflex, Leica and Exacta VX. Ektachrome or Kodachrome film was normally used, and black-and-white copies made when necessary.

Set in Linotype Fairfield
Format by John Rynerson
Manufactured by The Haddon Craftsmen, Inc.
Published by HARPER & BROTHERS, *New York*

p. 143

CPSIA information can be obtained
at www.ICGtesting.com
Printed in the USA
BVHW052238090223
658263BV00003B/43